6/94

American Painters in the Age of Impressionism

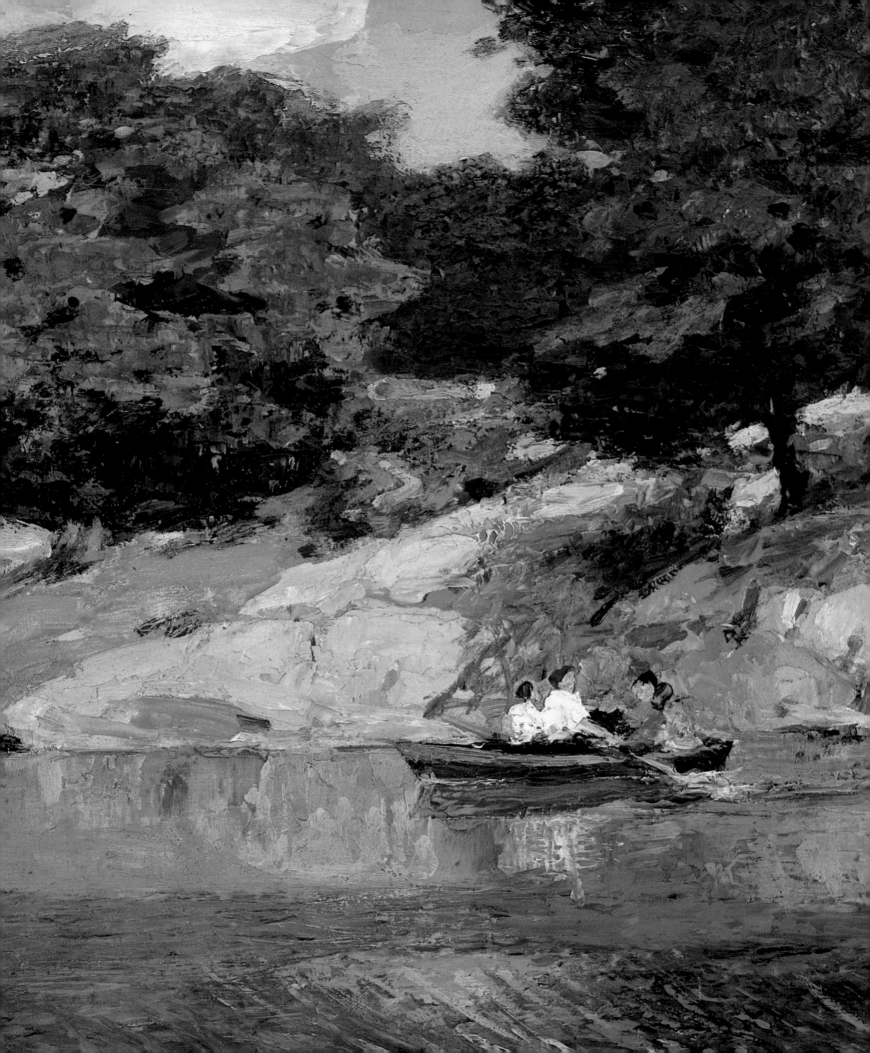

American Painters
in the Age of Impressionism

Emily Ballew Neff

✣

George T.M. Shackelford

THE MUSEUM OF FINE ARTS, HOUSTON

Published by the Museum of Fine Arts, Houston in conjunction with the exhibition *American Painters in the Age of Impressionism*, held at the museum from December 4, 1994 through March 26, 1995.

American Painters in the Age of Impressionism is made possible through the generous support of:

Conoco

Frank J. Hevrdejs

Kidder, Peabody

Burlington Resources/Meridian Oil

Union Texas Petroleum

Panhandle Eastern Corporation

Mr. and Mrs. Meredith J. Long

Merrill Lynch & Co.

Mr. and Mrs. Pat Rutherford

Texas Commerce Bank

The Cullen Foundation

Library of Congress Cataloging-in-Publication Data

Neff, Emily Ballew, 1963–
 American painters in the age of Impressionism / Emily Ballew Neff,
George T.M. Shackelford.
 p. cm.
 Published on the occasion of an exhibition at the Museum of Fine
Arts, Houston, Dec. 4, 1994–Mar. 26, 1995.
 Includes bibliographical references and index.
 ISBN 0-89090-064-7 (pbk.) : $35.00
 1. Impressionism (Art)–United States–Exhibitions. 2. Painting,
Modern–19th century–United States–Exhibitions. 3. Painting–
Collectors and collecting–Texas–Exhibitions. 4. Painting–Texas–
Exhibitions. 5. Exhibitions–History–19th century–Exhibitions.
I. Shackelford, George T. M., 1955– . II. Museum of Fine Arts,
Houston. III. Title.
ND210.5.I4N44 1994
759.13'09'0340747641411–dc20 94–40856
 CIP

Printed in the United States of America

Cover: Frederick Frieseke. *Lady with a Parasol* (detail). c. 1908. Oil on canvas. Private collection (see pl. 56).

Frontispiece: Edward Henry Potthast. *Boating in Central Park* (detail). c. 1900–05. Oil on board. The Museum of Fine Arts, Houston, Wintermann Collection of American Art, gift of Mr. and Mrs. David R. Wintermann (see pl. 60).

CONTENTS

After the Civil War, American art underwent a radical shift in orientation. No longer bent on creating a "national" art that would define the unique qualities of the American experience, American artists cast their eyes and minds across the Atlantic, eager to absorb European currents of artmaking. To our great pleasure, the story of internationalism in American art can be told through the outstanding private and public collections of American art in Houston, Dallas, and San Antonio. *American Painters in the Age of Impressionism* surveys American art from the 1870s to the 1920s, encompassing both the Philadelphia Centennial of 1876 and the Armory Show of 1913, as it celebrates the extraordinarily rich collections of late-nineteenth- and early-twentieth-century American art in Texas.

The legendary names of Winslow Homer, George Inness, Mary Cassatt, William Merritt Chase, John Singer Sargent, Childe Hassam, and Maurice Prendergast, among others, all find their places here in a gallery setting meant to evoke the almost kaleidoscopic exhibition experience of the late-nineteenth-century viewer. The generosity of the collectors who have agreed to lend their paintings to this exhibition has allowed us to assemble a stunning gallery of late-nineteenth- and early-twentieth-century American paintings rarely or never seen by Houston audiences, until now.

The exhibition was organized by Emily Ballew Neff, assistant curator of American painting and sculpture, in collaboration with George T. M. Shackelford, curator of European painting and sculpture, and head of the department of painting and sculpture at the museum. We are grateful to them as well as to our colleagues at the Dallas Museum of Art, the Marion Koogler McNay Art Museum, and the San Antonio Museum of Art.

I would also like to thank the generous funders of the exhibition: Conoco; Frank J. Hevrdejs; Kidder, Peabody; Burlington Resources/Meridian Oil; Union Texas Petroleum; Panhandle Eastern Corporation; Mr. and Mrs. Meredith J. Long; Merrill Lynch & Co.; Mr. and Mrs. Pat Rutherford; Texas Commerce Bank; and The Cullen Foundation.

To the trustees of the Museum of Fine Arts, Houston, led by Alfred C. Glassell, Jr., chairman, and by Isaac Arnold, Jr., chairman of the subcommittee of American painting and sculpture, I extend my sincerest thanks for making this handsome catalogue and exhibition possible.

Peter C. Marzio
Director

LENDERS TO THE EXHIBITION

Dallas Museum of Art	Meredith Long and Company
Mrs. Langdon Dearborn	Mary Ralph Lowe
The collection of Mr. and Mrs. James W. Glanville	Marion Koogler McNay Art Museum
	Mrs. Leonard F. McCollum
Mr. and Mrs. Hugh Halff, Jr.	Ms. Betsy Mullins
Frank Hevrdejs Collection	Edward Redfield Richardson
William Hill Land and Cattle Company	Mr. and Mrs. Pat Rutherford
Mr. and Mrs. James L. Ketelsen	San Antonio Museum of Art
Mr. and Mrs. William S. Kilroy	Mr. and Mrs. Fayez Sarofim
Mr. and Mrs. John H. Lindsey	Ann Gordon Trammell
Mr. and Mrs. Meredith J. Long	Estates of James and Ella Winston

ACKNOWLEDGMENTS

In 1992, the Museum of Fine Arts, Houston first decided to organize an exhibition that would highlight the splendid private collections of late-nineteenth-century American art in Houston. The core group of paintings were to come from the museum's own holdings, particularly the Wintermann Collection of American Art, as well as from local private collections. The exhibition soon grew, however, to include paintings from a distinguished private collection in San Antonio, as well as loans from the Dallas Museum of Art, the Marion Koogler McNay Art Museum, and the San Antonio Museum of Art. First and foremost, the lenders to the exhibition deserve a special salute for their support and encouragement of the exhibition and its catalogue, and, above all, for the generous loan of their paintings. Their cooperative spirit has made this project an enjoyable one in every respect, and it is to them that this catalogue is dedicated.

We have benefited greatly from the help and advice of many individuals. A lifelong enthusiast of American art, Meredith J. Long shared his knowledge generously; to him and to Cornelia Long, we are deeply grateful. Eula and David Wintermann, whose 1985 gift of sixty-two American paintings has greatly enhanced the museum's collections, offered the exhibition their eager endorsement. Frank J. Hevrdejs, museum trustee and collector, helped make this project a reality, unselfishly sharing his time and energy as well as his infectious enthusiasm for American art. Finally, we would like to thank Sandy Parkerson for his constructive advice and encouragement.

In preparing this exhibition and its catalogue, we have been helped by our colleagues at other Texas institutions, including: Jay Gates, Eleanor Jones Harvey, Jeanne Lil Chvosta, and Kevin Comerford at the Dallas Museum of Art; William Chiego, Lyle Williams, and Heather Hornbuckle at the Marion Koogler McNay Art Museum; and Douglas Hyland, Don Bacigalupi, and Gabriela Truly at the San Antonio Museum of Art. Scholars of the period have generously shared their expertise with patience and good humor: Doreen Bolger, Museum of Art, Rhode Island School of Design, Providence; Nicolai Cikovsky, Jr., National Gallery of Art, Washington, D.C.; David Park Curry, the Virginia Museum of Fine Arts, Richmond; Margaretta M. Lovell, University of California, Berkeley; Dale Neighbors, The New-York Historical Society; and Ronald Pisano, independent scholar, New York. For their efforts in assisting us with this project, we thank: Judy Throm, Archives of American Art, Smithsonian Institution, Washington, D.C.; Gloria Groom, the Art Institute of Chicago; George E. Mazeika, The William Benton Museum of Art, The University of Connecticut; William Stout, The Frick Collection, New York; Shepherd Holcombe, Hill-Stead Museum, Farmington, Connecticut; Gary Tinterow, The Metropolitan Museum of Art, New York; Eric Zafran, Museum of Fine Arts, Boston; John Leighton, National Gallery of Art, London; Ione Saroyan, The New-York Historical Society; Alicia Longwell and Diana Barnes, the Parrish Art Museum, Southampton, New York; Christopher Riopelle, Philadelphia Museum of Art; Rachel Dvoretzky, slide curator for the art and art history department, Jet Prendeville, art and architecture librarian at the Alice Pratt Brown Library of Art, Architecture, and Music, and the staff of the Woodson Research Center, all at Rice University, Houston; Veronique Gunner, Sotheby's London; and Katherine Ross, Sotheby's New York.

At the Museum of Fine Arts, Houston, special thanks go to A. Thereza Crowe and Clifford Edwards, as well as to Elizabeth Ann Coleman and our curatorial colleagues, and to Lori Thornton Allen, Randi Bollenbach, Charles Carroll, Tommy Chingos, Kathleen Crain, Jeannette Dixon and the Hirsch Library staff, Suzanne Decker, Thomas R. DuBrock, Jack Eby, Alison Eckman, Gwendolyn H. Goffe, Shannon Halwes, Diane P. Lovejoy, Christine W. Manca, Frances Marzio, Peter C. Marzio, Barbara Michels, Hope Namken, Wynne Phelan, Lisa Reed, Beth B. Schneider, Ashley Scott, Margaret C. Skidmore, Marcia K. Stein, Tracy Stephenson, Engeline Tan, Chris Tice, Karen Bremer Vetter, and the preparations staff. Don Quaintance of Public Address Design in Houston deserves special thanks for the catalogue's elegant design.

Emily Ballew Neff
George T.M. Shackelford

Introduction: American Art and Impressionism

EMILY BALLEW NEFF

"IT WAS TIME FOR THE HUDSON RIVER SCHOOL . . . TO DIE."[1] SO WROTE Clarence Cook, the sharp-tongued art critic, in 1883. For almost sixty years, since the 1820s, the meticulously painted pictures by Hudson River School artists from Thomas Cole to Albert Bierstadt had demonstrated American culture's developing sense of national pride in the landscape. But by 1883, the work of these artists had begun to appear provincial and naive to Cook and other promoters of a young generation of artists who were receiving artistic inspiration and training from abroad. Cook's blunt words reveal the radical shift in thought about America and its art that took place in the last decades of the nineteenth century, as cultivated cosmopolitanism replaced cultural nationalism.[2]

The extravagant international expositions organized during the nineteenth century contributed in large part to America's growing internationalism after the Civil War. At fairs from the 1867 Exposition Universelle in Paris to the 1893 World's Columbian Exposition in Chicago, participating countries flexed their cultural and technological muscle before a worldwide audience, presenting displays that celebrated national artistic and industrial achievement as they invited comparison and competition. Contemporary critical responses to these lavish displays identify the changing concerns of artists, patrons, and critics who were to define and sustain American culture as well as to determine its place in the world order.

At the 1867 Exposition Universelle (fig. 2), critics were concerned that American art should express what was "American" about the United States. The critics reviewing the installation of American art, for example, found the display of paintings by artists such as John Kensett and Bierstadt not "American" enough: "There should have been a prairie, a sierra, and some views of New England home life and pioneer life," wrote a critic in *Harper's*.[3] Critics and commentators, in other words, wanted to see more paintings that glorified their notions of American geographic diversity and hearty frontier life—despite the large number of paintings that did just that, from Frederic Church's *Niagara* to Eastman Johnson's *Old Kentucky Home–Life in the South*. Regardless of the appeal of the critics for

fig. 1. *The World's Columbian Exposition, gallery 3, north and east walls.* From C.D. Arnold, *Official Photographs of the World's Columbian Exposition,* vol. 8, pl. 83. The Chicago Public Library, Special Collections Department.

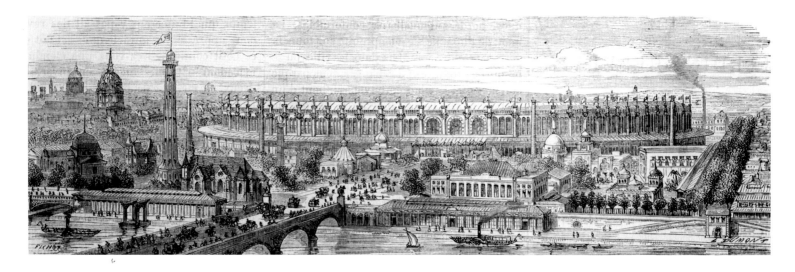

fig. 2. *View of the 1867 Exposition Universelle*. From *L'Exposition Universelle de 1867*, Paris.

more characteristically "American" paintings, the 1867 Exposition marked the last time that such an abundance of American paintings proudly celebrating America's uniqueness with blunt national pride would go on display in the international arena. By the 1876 Philadelphia Centennial, American artists began to demonstrate their interest in and allegiance to foreign styles. And the shift in allegiance and style, ironically, was for the most part born of the 1867 Exposition.

The collecting practices of the nouveau riche encouraged the new loyalty to foreign, particularly French, artistic modes. Post-Civil War fortunes provided the means for new collectors to announce their cosmopolitan flair by owning and displaying French paintings, which, in late nineteenth-century America, signified elite taste.[4] The American patrons of the 1867 Exposition, in the course of their exhibition-related activities in Paris, began collecting European art in mass quantities and bringing it back to be displayed in their salons in New York, Philadelphia, or Boston, where even the public might be admitted on certain days.[5] Further increasing the influence of French art, American collectors provided young American artists aspiring to go abroad for artistic training with introductions to Parisian artists whose works they owned. Before long, an extraordinary number of American artists entered the ateliers of such academic artists as Jean-Léon Gérôme (1824–1904) and Alexandre Cabanel (1824–1889), whose paintings Americans eagerly collected.[6]

The American painters Mary Cassatt (1844–1926, see pls.13–15), Winslow Homer (1836–1910, see pls. 1–9), and Theodore Robinson (1852–1896, see pls. 38–40), for example, who made their first trips to France in the late 1860s and early 1870s, followed the pattern of six generations of American artists who had been crossing the Atlantic since the mid-eighteenth century. In Italy, the ultimate destination of painters and sculptors before the Civil War, the study of picturesque ancient monuments and magnificent Renaissance art collections formed the core of the traveler's artistic education. By the mid-nineteenth century, many more artists were including Germany and England in their itineraries, and painters began flocking to Paris in ever greater numbers. Unlike their eighteenth-century predecessors, most of these artists sought instruction in the prestigious Ecole des Beaux-Arts or the ateliers of the French masters, where the drawing of antique casts and of the nude model, together with lessons in anatomy, perspective, and history, provided the rigorous education lacking in the curriculum of American academies until later in the nineteenth century.[7]

Stimulated by the Paris exhibition of 1867, American collectors learned to appreciate what they perceived as the sophisticated patina of contemporary European painting, and American art seemed immature in comparison. If the most significant result of the 1867 Paris Exposition was the change in collecting practices of American millionaires, it could be said that the most important consequence of the 1876 Centennial in Philadelphia was bringing foreign art to the attention of the masses (fig. 3). Critics of the day instantly recognized the Centennial's power to cultivate the taste of the average middle class American and to stimulate young Americans to pursue careers as artists. The Centennial represents the first time Americans were exposed to large international displays of art on our shores; after all, only five museums in the United States existed in 1876.[8] As millions of visitors poured through the doors of Memorial Hall to view the largest exhibition of art the world had ever seen, they had their first chance to compare American artists' production with the works of foreigners. The American art display included over one thousand examples of painting and sculpture from John Singleton Copley (1738–1815) and Charles Willson Peale (1741–1827) to Albert Bierstadt (1830–1902) and Winslow Homer. The so-called native styles of Copley and, later, Homer, contrasted with the contemporary academic paintings of, for example, Frederick Arthur Bridgman (1847–1928), whose Moorish scenes betrayed American artists' interest in the academic style of Gérôme and his "oriental" themes. American art at the 1876 Centennial celebrated the "native" school of painting but also bore prophetic marks of the increasingly international character of American art to come.

The resounding note in the critics' response to the 1876 art display is one of optimism—that American artists could hold their own before their foreign contemporaries. Although the majority of critics believed France made a poor showing, they seemed to be unanimous in their praise of England, whose display included a distinguished selection of works by the Pre-Raphaelite artists and their followers. Like many other critics, William

fig. 3. View of the 1876 Centennial, Philadelphia. From *Illustrated Historical Registrar of the Centennial Exposition, 1876.* Courtesy Woodson Research Center, Rice University, Houston.

Dean Howells sounded a cautious note of enthusiasm about the "progress" of American art. He believed "that American Art had made vast advances on the technical side, but that it lacked what English art [had] got from its intimate association with literature; that it was not poetical; that generally its subjects were seen, not deeply felt and thought;" in sum, that "it wanted charm."[9] Of the French, he said of the preponderance of nudes in their display only that it was "as if the subjects had been surprised before they had time to dress for the Centennial, so strongly is the habit of being clothed expressed in the modern face."[10] Another critic, commenting on the Memorial Hall exhibition of painting and statuary, saw its popularity as a sign that there was "an innate love of art—of the beautiful in picture and sculpture—in the average American, from which it only needs time and opportunity to reap grand harvests of achievement and appreciation."[11] Further, the critic, who expressed the feelings of many, foretold that the next quarter century would bring the development of art education, "the soil from which will naturally and inevitably spring a thousand interests and industries that will minister to American prosperity, comfort, luxury, and refinement."[12] The idea that art would be good for Americans (and good for America, both philosophically and materially) was the critics' battle cry of the 1876 Centennial.

As the 1876 Centennial predicted international recognition of American achievement in the arts, the 1893 World's Columbian Exposition sought to prove that notion true. Held in Chicago, where elaborate beaux-arts buildings erected for the occasion triumphantly announced a revival of classical taste, the Fair's American display was organized to show that American art could compete—and win—in an aesthetic contest with France (fig. 1).[13] In order to invite comparison and solicit comment, the display of over one thousand American paintings was placed purposely next to the French galleries. In an effort to appear no longer provincial and naive, the organizers of the 1893 show delivered the message that what was "American" about American art was its marvelous democratic diversity. William Merritt Chase (1849–1916, see pls. 24–27, 31–32) expressed the mood of the jury when he said that "In this country, if anywhere, we should be superior to narrowing notions about schools and styles. The individual merit of a picture," he argued, "is the only final standard."[14] Endorsing Chase's notion, the jurors of the American display included paintings of widely varied subjects and types, representing a similarly diverse range of styles from the hands of "Old Guard" artists, Orientalists, and Impressionists. The 1893 Fair marked a pivotal moment for the Impressionists in particular, as it provided their first major opportunity to display work to an international audience. Until the 1893 show, American Impressionist paintings were not the usual fare of the international expositions, where selections of conventional art usually reflected a desire to appeal to a broader audience. The American contributions to the Paris Exposition Universelle of 1889, for example, included entries from Theodore Robinson (see pls. 38–40) singularly marked by a conservative, academic composition and surface, despite the fact that he had been working in a looser, broader manner akin to his French Impressionist contemporaries before the Exposition.[15] By contrast, the 1893 World's Fair and its celebration of pictorial diversity allowed American artists such as John Twachtman (1853–1902, see pl. 42), Edmund Tarbell (1862–1938, pl. 30) and Robert Reid (1862–1929, pl. 55) to announce their Impressionism to the world. Buttressed by the attendant display of French Impressionism organized by the indefatigable Chicago collector and philanthropist Mrs. Potter Palmer (who recognized that the French Impressionists were underrepresented in the French galleries),

American Impressionism could be said to have arrived to an international audience, with a context for understanding it in a nearby gallery. At the time of the Fair, the term "Impressionism," however, was both controversial and widely misunderstood.

From the middle to the final decades of the nineteenth century, the terms "impression," "Impressionist," and "Impressionism" used by American artists, critics, and commentators suggested various meanings. In 1878, for example, George Inness (1825–1894) used the term "impression" to indicate the "poetic truth" of the French Barbizon painters he emulated (see pls. 10–11). For Inness, the term "impression" suggested the emotional and spiritual content of his work because it emphasized his personal approach to landscape painting— to "reproduce in other minds the impression which a scene has made upon him."[16] Inness's use of the term, then, indicates a subjective strain of Impressionism born of the Barbizon school of artists in France and uniquely interpreted by Inness and his contemporaries William Morris Hunt (1824–1879) and John La Farge (1835–1910).

But Inness had unkind things to say regarding the work of the vanguard painters whom he might have seen during his 1874 stay in Paris—painters such as Claude Monet (1840–1926) and Camille Pissarro (1830–1903), who exhibited outside the official Salon in that year, and were promptly christened "Impressionists." The term "Impressionist" was subsequently applied to this group of French artists who exhibited their work together from 1874 to 1886, even though the style and method of their work differed widely. Inness believed they were "shams," and their work "the original pancake of visual imbecility."[17] While the French Impressionists saw themselves as the standard-bearers of the Barbizon painters he so admired, Inness found their emphasis on optical sensation precluded the inner spirituality he felt was part of the painterly process.

Nonetheless, by the last decades of the nineteenth century, many American artists were most strongly influenced by the French Impressionist painters, even though the patterns of influence are complex and difficult to trace. Although the American public was familiar with the work of the Barbizon painters as early as the 1850s, the work of the French Impressionists was not exhibited in large numbers in the States until the 1883 "Foreign Exhibition" in Boston, the 1883 "Pedestal Fund Art Loan Exhibition" at the National Academy of Design in New York, and most importantly, the 1886 exhibition of about three hundred paintings by the French Impressionists organized by the French dealer Paul Durand-Ruel in New York.[18] American critics and commentators of these exhibitions defined French Impressionism variously, depending on whether they recognized its validity as an art movement. While some recognized a progressive tendency in their art ("the Impressionist movement means change, if not progress"), others saw only "French smears."[19] Still others associated "Impressionism" with technique, considering almost any broadly painted surface to be "Impressionist." With this inclusive definition, critics would combine as "Impressionist" the work of James McNeill Whistler (1834–1903), and the Munich-trained artists, such as Frank Duveneck (1848–1919, see pl. 23) and William Merritt Chase, who adopted the looser handling of their mentor Wilhelm Leibl (1844–1900).[20] But using the term to indicate technical style could also have negative connotations. The collector Andrew Carnegie, for example, criticized paintings for being "impressionistic," attributing loose brushwork to artistic indolence.[21]

Therefore, just as the term "Impressionism" has no monolithic meaning within French art, its meaning also shifts when applied to the work of the Americans who adopted

and synthesized the various styles represented by the Impressionist artists along with other European trends. For the sake of art-historical convenience, the American Impressionists, in general, represent those artists who shared with their French contemporaries an interest in rendering the effects of light through dabs and dashes of loosely applied and brightly colored paint, and in treating those effects by depicting themes of modern life. While this practical but incomplete definition glosses the nineteenth-century confusion surrounding the term, it does serve to help distinguish two tendencies of Impressionism in America, both rooted in responses to French painting—the "emotionalism" associated with the Barbizon artists, and the interest in the optical effects of light and in scenes of modern life associated with the French Impressionists.[22]

After the 1893 Fair, American Impressionism and later, Realism, both considered to be vanguard movements, dominated the art scene and continued to generate widespread commentary. But American confidence in art matters that was evident at the 1893 Fair was to be shaken twenty years later at the New York "International Exhibition of Modern Art" in 1913 (fig. 4). The Association of American Painters and Sculptors, a newly founded group opposing the staid National Academy of Art, decided to raise funds privately in order to mount an enormous exhibition of contemporary American and foreign art. The president of the Association was Arthur B. Davies (1862–1928), a member of the group of independent Realist painters known as The Eight; the association's organizers included Walt Kuhn (1877–1949), Elmer MacRae (1875–1955), and Jerome Myers (1867–1940). This small group of American artists mounted what was among the most ambitious privately held exhibitions of American and foreign art ever to have taken place. From the beginning, the exhibition was dubbed the Armory Show because its site was the Armory of the 69th National Guard Regiment, on Lexington Avenue between 25th and 26th Streets.[23]

For the first time, mass audiences in New York, and later in Chicago and Boston, caught their first glimpses of Fauve and Cubist art by Henri Matisse (1869–1954), André Derain (1880–1954), Pablo Picasso (1881–1973), Georges Braque (1882–1963), and Marcel Duchamp (1887–1968), whose radical pictorial innovations shook American artists out of aesthetic complacency. The Armory Show generated enormous popular and critical response—both positive and negative, signalling an end to the absolute dominance of late-nineteenth-century style in American art. As "mad" or "insane" as the works of the French Moderns may have appeared, many recognized that "American art [would] never be the same."[24] From now on, American artists who considered themselves "progressive" would no longer seek the approval of academic institutions. The World's Columbian Exposition of twenty years before, which had aimed to show the diverse achievements of formally trained artists, now appeared just as provincial, naive, and limited as the Hudson River School artists had to Clarence Cook in 1883.

When the lavish international expositions closed, the disparate voices of the artists, critics, and patrons did not disappear with the dismantled displays. Their concerns continued in an ebb and flow that characterizes late-nineteenth-century American art—either ignoring or cultivating what was "American" in art, educating the masses about the salutary effects of art as a civilizing agent, measuring American artists against their European contemporaries and, finally, demonstrating to the world that American art was as engaged with current aesthetic and philosophical issues as its European counterparts.

fig. 4. *Interior of the Armory Show, New York City.* Walt Kuhn–Armory Show papers, Archives of American Art, Smithsonian Institution.

NOTES

1. Clarence Cook, "Art in America in 1883," *Princeton Review* 11 (May 1883):312, quoted in Bruce Weber, "A Sense of Light and Air in Landscapes," *American Artist* (April 1987):101 n. 36.

2. See H. Barbara Weinberg, "Late Nineteenth-Century Painting: Cosmopolitan Concerns and Critical Controversies," *Archives of American Art Journal* 23, no. 4 (1983):19–26.

3. M.D. Conway, "The Great Show at Paris," *Harper's New Monthly Magazine* 35 (July 1867):248, quoted in Carol Troyen, "Innocents Abroad: American Painters at the 1867 Exposition Universelle, Paris," *The American Art Journal* 16, no. 4 (Autumn 1984):13. I am indebted to Troyen's article which both describes the American section at the Exposition and, more importantly, assesses the impact of the show on American art.

4. Ibid., 19–20.

5. Ibid. Troyen lists the New York home of A.T. Stewart as one example. Stewart's home displayed over two hundred paintings, the overwhelming majority of which were contemporary European paintings bought after the Civil War and before his death in 1876. As Troyen suggests, these "public" installations did much to kindle enthusiasm for contemporary European art, and they also "enshrine[d] the collector's taste," 20.

6. Ibid., 21. Also, see H. Barbara Weinberg, *The Lure of Paris: Nineteenth-Century American Painters and Their French Teachers* (New York: Abbeville Press Publishers, 1991) for the most comprehensive research to date on the subject of American artists in French ateliers.

7. See Weinberg, *The Lure of Paris*, 1–23, for an overview of the Ecole des Beaux-Arts curriculum and the atelier training American artists would have received.

8. John Maass, *The Glorious Enterprise: The Centennial Exhibition of 1876 and H. J. Schwarzmann, Architect-in-Chief* (Watkins Glen, New York: American Life Foundation, 1973), 44–59.

9. William Dean Howells, "A Seminight at the Centennial," *Atlantic* 38 (July 1876):94.

10. Ibid., 95.

11. "American Art," *Scribner's* 13 (November 1876):126.

12. Ibid., 127.

13. See, in particular, Carolyn Kinder Carr, "Prejudice and Pride: Presenting American Art at the 1893 Chicago World's Columbian Exposition," in Carr et al., *Revisiting the White City: American Art at the 1893 World's Fair* (Washington, D.C.: Smithsonian Institution, 1993), 62–113. Carr's discoveries form the basis of this section on the 1893 Fair.

14. *New York Herald* (September 18, 1892), quoted in Carr, 98.

15. See Annette Blaugrund et al., *Paris 1889: American Artists at the Universal Exposition*, exh. cat. (Philadelphia: Pennsylvania Academy of Fine Arts in association with Harry N. Abrams, Inc., Publishers, New York, 1989), 202–3; catalogue entry by Maureen C. O'Brien.

16. "A Painter on Painting," reprinted from *Harper's New Monthly Magazine* 56 (February 1878):458–61 in Nicolai Cikovsky, Jr. and Michael Quick, *George Inness*, exh. cat. (Los Angeles: Los Angeles County Museum of Art, 1985), 205.

17. George Inness, Jr., *Life, Art, and Letters of George Inness* (New York: The Century Co., 1917), 174.

18. See Hans Huth, "Impressionism Comes to America," *Gazette des Beaux-Arts* 29 (1946):225–52. It is important to note that when French Impressionist paintings were introduced en masse to the American public in 1886, the loosely knit group itself had disbanded as a unit, its commitment to independence fragmenting into different groups of artists called Synthetists, Neo-Impressionists, and, by the first decade of the twentieth century, Fauves—all later designated Post-Impressionists by the English critic Roger Fry. See *Post-Impressionism: Cross-Currents in European Painting*, exh. cat. (London: Royal Academy of Arts in association with Weidenfeld and Nicolson, London, 1979).

19. *Art Amateur* 10 (1884):42, quoted in Huth, "Impressionism Comes to America," 234. John Smith, "Some Plain Words on American Taste in Art," *Magazine of Art* 2 (1888):114, quoted in Huth, 243.

20. Ulrich W. Hiesinger, *Impressionism in America: The Ten American Painters* (Munich: Prestel-Verlag, 1991), 10.

21. "The day was pleasant and the Galleries comfortably filled with nice people. Mr. Carnagie [sic] made me mad by slandering the show for being impressionistic. Saw no good in it, trying to do things without work. Ugh." (J. Carroll Beckwith Diaries, April 25, 1891, quoted in Ulrich W. Hiesinger, "Impressionism and Politics: The Founding of The Ten," *The Magazine Antiques* 140 (November 1991):785, 793 n. 29).

22. The unparalleled English language source on French Impressionism is Robert Herbert, *Impressionism: Art, Leisure, and Parisian Society* (New Haven and London: Yale University Press, 1988). For among the more original interpretations of Impressionism and its technique, see Richard Shiff, *Cézanne and the End of Impressionism* (Chicago: University of Chicago Press, 1984). See also, *The New Painting: Impressionism 1874–1886*, exh. cat. (San Francisco: The Fine Arts Museum of San Francisco, 1986). For American Impressionism, see William H. Gerdts, *American Impressionism* (New York: Abbeville Publishers, 1984) and, more recently, H. Barbara Weinberg, Doreen Bolger, and David Park Curry, *American Impressionism and Realism: The Painting of Modern Life, 1885–1915*, exh. cat. (New York: The Metropolitan Museum of Art, 1994).

23. See Milton W. Brown, *The Story of the Armory Show* (New York: The Joseph H. Hirshhorn Foundation), 1963.

24. Ibid., 86, 88.

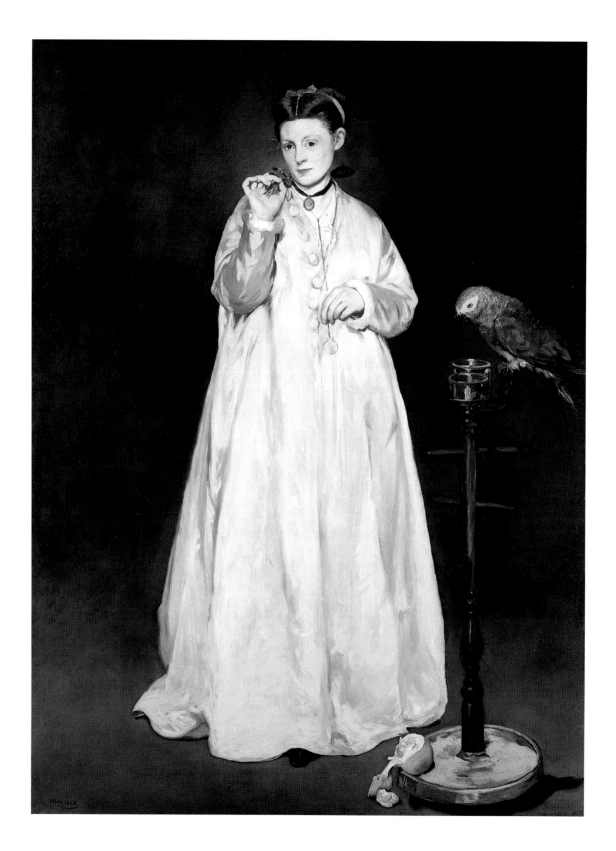

The Age of Impressionism

"It is delightful . . ."
Jules Castagnary, *Le Siècle*, 1874

"It was worse than the Chamber of Horrors."
J. Alden Weir, 1877

GEORGE T.M. SHACKELFORD

W HEN IMPRESSIONISM FIRST CAME ON THE ARTISTIC SCENE in the 1870s, there were relatively few critics as favorable toward the movement as Jules Castagnary. Studying in Paris, American painters like J. Alden Weir reacted negatively, if at all, to the new painting. But in the decades that followed, Castagnary's delight in the novelty of the Impressionist style would gradually become widespread; Weir and many of his American contemporaries would eventually embrace the stylistic possibilities of a lightened palette and a loosely applied brushstroke; and American collectors would find themselves among the most distinguished and enthusiastic patrons of Impressionist painting.

Today, readers of this catalogue and visitors to this exhibition still live in an age of Impressionism, for in the United States, the love affair with this exuberant style still endures. The roll call of Impressionism's major figures is a familiar one to many: Gustave Caillebotte (1848–1894), Mary Cassatt (1844–1926), Paul Cézanne (1839–1906), Edgar Degas (1834–1917), Edouard Manet (1832–1883), Claude Monet (1840–1926), Berthe Morisot (1841–1895), Camille Pissarro (1830–1903), Pierre-Auguste Renoir (1841–1919), and Alfred Sisley (1839–1899). Together, these painters represent the pantheon of early modern art, and their names attract visitors to blockbuster exhibitions and fill lecture halls to overflowing.

The tale of the origins of the word "Impressionism" has often been told, but it bears repeating here, for the story is a complex one, with twists and turns and changes of heart. In 1874, a *Société Anonyme des artistes peintres, sculpteurs, graveurs* held an exhibition in the former studio of Nadar, the fashionable photographic firm. The youngish painter Monet sent a painting titled *Impression: Sunrise*, a sketchy view of the port of Le Havre. In the month following the exhibition's opening, the term "Impressionist" seeped into critical usage. Reviewers, both friendly and hostile, seized on the word "impression," common in artist's parlance for many decades to describe a quickly obtained visual or mental perception, to draw attention to the seemingly unfinished quality of the curious range of styles

fig. 5. Edouard Manet. *Young Lady in 1866 (Woman with a Parrot)*. 1866. Oil on canvas, 72⅞ x 50⅝ in. (185.1 x 128.5 cm). The Metropolitan Museum of Art, New York, Gift of Erwin Davis, 1889 (1889.21.3).

that they saw in the painters' submissions to the independent exhibition.

In the decades that followed the first Impressionist exhibition, the issue of which artists might be called Impressionist became particularly touchy. But this should come as no surprise, since from the very beginnings in Paris, the terms "impression," "Impressionism," and "Impressionist" have been subject to a bewildering variety of interpretations, applied to a welter of varying stylistic and political approaches to the making of paintings. Even among the participants in the eight group exhibitions held between 1874 and 1886, radical disjunctions of manner and content emerged, between, for instance, Renoir and his friend Cézanne, or between Monet and his rival Degas.[1] "It is hard to understand why Edgar Degas characterized himself as an Impressionist," wrote one reviewer at the time, underscoring the diverse styles and subjects that were grouped under the general banner of Impressionist art.[2] To further complicate the issue, the subsequent use of the word "Impressionism" in discussing the art of Europe and North America is tainted with nationalist sentiments.

Impressionism, at first glance, would seem to be a Francocentric phenomenon: indeed, the age of Impressionism can be securely inaugurated with a work like Manet's bustling *Music in the Tuileries Gardens* (1862, The National Gallery, London), and its period of creativity might logically come to a close with the last works of Monet in the teens and twenties—the lyrical waterlily decorations, for example, installed in the Orangerie of the Tuileries Gardens in Paris in 1927. The first chroniclers of the history of Impressionism in France characterized the movement as a struggle, and in the succeeding century Impressionism was seen as an almost holy war waged by a small and circumscribed group of adherents to a vanguard aesthetic agenda. According to these historians, the painters set themselves in fierce opposition to the Salon and the Academy, and triumphed in the end over conventional taste to prepare the way for modern art.[3] The most observant of contemporary critics realized, as we may today, that so unifying a view of the Impressionists in Paris tells only part of the story. The Impressionists were not necessarily of one accord when it came to stylistic manner or subject matter, and Impressionism meant and means much more than the work of the central core of artists who participated in the group exhibitions.

What was the early critical reaction to Impressionism? As Jules Castagnary's confession of delight would suggest, not every critic used the word "Impressionism" in ridicule. Castagnary (1830–1888), the distinguished champion of the Naturalist movement, was not convinced that the artists could ever constitute a true school of painting, but was struck by the innovative "way of understanding nature" that the young landscape painters in the group demonstrated. "It is lively, sharp, light," he wrote, "it is delightful. What quick intelligence of the object and what amusing brushwork! True, it is summary, but how just the indications are!" Concentrating on the paintings of Monet, Pissarro, Renoir, Sisley, and Morisot, Castagnary told his readers that

> the common concept which united them as a group and gives them a collective strength . . . is the determination not to search for a smooth execution, but to be satisfied with a certain general aspect. . . . If one wants to characterize them with a simple word that explains their efforts, one would have to create the new term of *Impressionists*. They are impressionists in the sense that they render not a landscape but the sensation produced by the landscape.[4]

Whether hostile or favorable, critics often coupled "Impressionists" with "intransigents," a politically charged term that suggested the painters' "hatred for classical traditions and [their] ambition to reform the laws of drawing and color."[5] Following the second exhibition of the group, in 1876, the French poet Stéphane Mallarmé (1842–1898) discussed "the works of those then styled the Intransigents, now the Impressionists," in a London journal. His essay, titled "The Impressionists and Edouard Manet," characterized these paintings as "a collection of pictures of strange aspect, at first view giving the ordinary impression of the motive which made them, but over and beyond this, a peculiar quality outside mere Realism." That quality, motivated by "the search after truth, peculiar to modern artists, which enables them to see nature and reproduce her, such as she appears to just and pure eyes," led Manet and his followers, in Mallarmé's analysis, to ignore "all that has been done in art by others," and to declare "that painting [should] be steeped again in its cause, and its relation to nature." That part of nature preserved "by the power of Impressionism is not the material portion which already exists, but the delight of having recreated nature touch by touch."[6]

Contrasting the new painting with the formulaic works of academics, writers such as Castagnary and Mallarmé stressed the ways in which the Impressionists' individual response to natural phenomena was manifested in extremely personal, original stylistic devices. By the time of the third exhibition of these independent painters, in 1877, the word "Impressionism" was thus inextricably linked with works that, even at first glance, stressed the quality of the painter's touch, challenging accepted norms of finish and composition. The 1877 exhibition marked the first time that the artists—although they were never organized as a movement or school in the conventional sense—would describe themselves as Impressionist. The organizers of the 1877 exhibition—a team that included Caillebotte, Degas, Monet, Pissarro, Renoir, and Sisley, advised by the nonexhibiting Manet—decided to publish a journal in conjunction with the show, proudly called l'Impressionniste, which was edited by Renoir's friend Georges Rivière.[7]

That same year, the American painter J. Alden Weir (1852–1919), who had come to Paris in 1873 to study with the academic painter Jean-Léon Gérôme, went to see the Impressionist exhibition. Weir wrote home to his parents "of a new school which call themselves 'Impressionalists.' I never in my life saw more horrible things. . . . They do not observe drawing nor form," he wrote, "but give you the impression of what they call nature. It was worse than the Chamber of Horrors."[8] Predictably Weir, who had learned straight-laced academic methods in the atelier of Gérôme, railed against the new painters when he first confronted "what they [called] nature," in such works as the curiously unfocused landscapes of Pissarro—perhaps the brilliantly complex Côte des Boeufs at l'Hermitage, near Pontoise (fig. 6). Renoir showed figure paintings filled with what reviewers called "trembling flashes" of sunlight, "specked with round spots and . . . striped like a tiger here and there."[9] Degas showed two beach scenes, but the greater part of his display was made up of his newly perfected monotypes, most devoted to nocturnal themes. Monet, Pissarro, Cézanne, and Sisley had sent to the exhibition groups of landscape paintings that employed broken light and color in a way that far exceeded the most adventurous canvases of the previous generation. Monet's series of views of the Gare Saint-Lazare (fig. 7), with their insistent avoidance of all that was picturesque, their glorification of evanescent steam and rigid iron, must have seemed truly radical—intransigent, as the

critics of the day said—to the young American in Paris, both in their painterly facture and in their suggestion of an obscure political agenda.

Despite his initial utter rejection of Impressionist art, eventually Weir joined many critics and artists in accepting the Impressionists' originality. He never chose, however, to communicate in his pictures the sense of potent modernism that Monet discovered in his views of the Gare Saint-Lazare. On the contrary, he seems throughout his life to have avoided all such radical content when he dealt with subjects that were not conventionally picturesque.[10] But the landscape he sent to the 1889 Exposition Universelle in Paris, a recent canvas titled *Lengthening Shadows* (fig. 8), revealed in its lightened palette and elevated horizon line not only a sympathy towards some of the more advanced tendencies of Barbizon painting, but also a sensibility for the kind of abstracting compositional formats Monet was exploring at this time (fig. 9).[11] And by the end of his career in the early twentieth century we find Weir painting, in the *Ravine near Branchville* (pl. 35), a work that seems every bit as heedless of Gérôme's recipes for draftsmanship as does any picture of Pissarro's or Monet's, and a work which is unquestionably part of the history of Impressionism.

The story of Impressionism in France is, in fact, only one aspect of a phenomenon that has an international pattern of development. In almost every country in Europe, and in the United States, we can point out paintings dating from as early as 1860–75 that in their heightened chromatic range, their loosely applied brushwork, and their insistence on the primacy of light effects, resemble the work of French painters whose pioneering works first became known internationally only in the last years of the 1870s. This being the case, not all paintings that we might describe as Impressionist in style were directly inspired by profound knowledge of the works of the Impressionist inner circle in Paris. In some cases, as in the instance of Winslow Homer (see pls. 1–9), we may be able to point to shared sources of inspiration in the more advanced works of Barbizon artists such as

fig. 6. Camille Pissarro. *Côte des Boeufs at l'Hermitage, near Pontoise.* 1877. Oil on canvas, 45 1/4 x 34 1/2 in. (114.0 x 87.6 cm). The National Gallery, London.

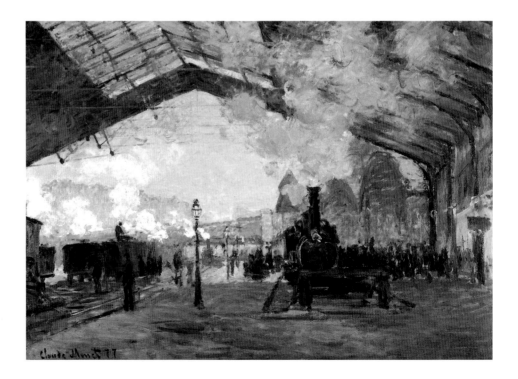

fig. 7. Claude Monet. *Arrival of the Normandy Train, Saint-Lazare Station.* 1877. Oil on canvas, 23 1/2 x 31 1/2 in. (59.6 x 80.2 cm). The Art Institute of Chicago, Mr. and Mrs. Martin A. Ryerson Collection.

fig. 8. (left) J. Alden Weir. *Lengthening Shadows.* 1887. Oil on canvas, 20¾ x 25 in. (53 x 63.5 cm). Private collection.

fig. 9. (right) Claude Monet. *Field of Poppies.* 1885. Oil on canvas, 25⅝ x 31⅞ in. (65 x 81 cm). The Museum of Fine Arts, Boston, bequest of Robert J. Edwards in memory of his mother.

Jean-François Millet (1814–1875) or Camille Corot (1796–1875). In others, for example the Italian painters called the Macchiaioli, effects that resemble those sought by the Impressionists in France seem to have risen entirely from native sources.[12]

Still, the rise of Paris as the world center for the study of painting in the later nineteenth century made it possible for many painters from outside France to encounter the works of the Impressionists firsthand. If Weir was horrified by what he saw, others, such as Mary Cassatt, were captivated. But Parisian dominance of the world of art also made it possible for foreign artists to see—and to be inspired by—the works of a wide variety of French painters who in the wake of the Impressionists' critical successes had adopted a looser execution and a more chromatically diverse handling of paint. By the 1880s, in fact, Paris abounded with painters whose works could be called Impressionist—whether or not they actually were displayed in one of the eight Impressionist exhibitions.

In the United States, in fact, the work of the French Impressionists was rarely seen in isolation from other tendencies in contemporary French art. Until the mid-1880s, Impressionist paintings were regularly seen in the context of works by other French painters, by painters of the Barbizon school, or even by Academics. As early as 1866, a beach scene by Monet was shown with paintings by his friends the "proto-Impressionists" Eugène Boudin (1824–1898) and Johan-Berthold Jongkind (1819–1891) in an exhibition of French paintings presented in New York and Boston.[13] During the 1870s, relatively few pictures by French Impressionist painters were seen in the United States.[14] On the other hand, a variety of painters who did not exhibit with the Impressionists in Paris were *called* Impressionists by the American press: in 1879, an article on Adolphe Monticelli (1824–1886), an eccentric painter from Marseilles, was titled "An Impressionist's Work . . . ," and Edward Strahan's *Art Treasures of America* referred to Antoine Vollon (1833–1900)—named an officer of the Legion of Honor in 1878—as "the most distinguished of the 'impressionist' painters."[15]

In the autumn of 1883, the "Foreign Exhibition" in Boston included seventeen paintings by Manet, Monet, Pissarro, and Sisley, hung among so many Salon-style pictures that

they seem to have gone totally unnoticed.[16] The American public took notice, however, when a small group of Impressionist paintings was presented in the exhibition held in New York in December 1883 to raise funds for the construction of a pedestal to support the Statue of Liberty. The "Pedestal Fund Art Loan Exhibition"—a display of some five thousand objects—included a section of nearly two hundred modern paintings selected by William Merritt Chase (see pls. 24–27 and 31–32) and James Carroll Beckwith (1852–1917) from private collections in New York.[17] According to one critic, the exhibition represented

> the proximate outcome of the great romantic movement which, under Géricault and Delacroix, burst the fetters of academic tradition . . . and proclaimed that *individuality* was, in truth, the chief claim of an artist to the world's respect.[18]

Ignoring altogether the idealizing compositions by vaunted Salon masters such as William Adolphe Bouguereau (1825–1905), Alexandre Cabanel (1823–1889), or Rosa Bonheur (1822–1899), the pride of New York's millionaires, Chase and Beckwith sought out what one critic described as "a certain ultra-artistic class of work," in short, *painterly* paintings.[19] Chase and Beckwith stressed the continuity of a non-narrative, painterly tradition in which they felt they themselves held a place. Among the paintings by such well-known French Barbizon and Realist masters as Millet, Corot, Courbet, Constant Troyon (1810–1865), and Charles-François Daubigny (1817–1878), were works by the moderns Jean-Jacques Henner (1829–1905), James Tissot (1836–1902), Alfred Stevens (1823–1906), and by the Italians Giuseppe de Nittis (1846–1884) and Giovanni Boldini (1845–1931). The French school thus dominated the Pedestal Fund exhibition as it dominated the international politics of art. Chase and Beckwith also installed the exhibition, giving places of honor to a handful of pictures that were frequently scorned by critics but which were universally recognized at the time as the most modern in a group of works chosen to champion the cause of "art for art's sake": three paintings by Edouard Manet and a canvas by Edgar Degas.

Two of the paintings by Manet, *Boy with a Sword* of 1861 and *Young Lady in 1866 (Woman with a Parrot)* of 1866 (fig. 5), are now counted among the finest works of the painter, who had died in the spring of 1883, months before the New York exhibition. Together with the Degas *Ballet Dancers (Dancers in Pink)* of c. 1876 (fig. 10), the Manets were lent from the collection of the financier Erwin Davis, who contributed thirty-seven pictures to the exhibition. In the early 1880s Davis was an enthusiastic collector of modern French masters (he lent, for instance, four pictures by Courbet and three by Corot to the Pedestal Fund exhibition). Davis had purchased through his agent, J. Alden Weir (who also served on the exhibition's selection committee), a contemporary picture, *Joan of Arc* (fig. 11), by Weir's friend Jules Bastien-Lepage (1848–1884), a work that had been shown to considerable acclaim at the 1880 Salon.[20]

William Merritt Chase may have played a role in Davis's acquisition of the early masterpieces by Manet, for it is thought that he recommended their purchase to Weir. Apparently, when Weir met Chase in Paris in the summer of 1881, Chase told him of two paintings by Manet, which Weir then bought for Davis from the Galerie Durand-Ruel. Emboldened by his purchase, Weir went to Versailles to call on Manet, and bought directly from the painter's studio still another picture, a light-filled, broadly brushed 1864

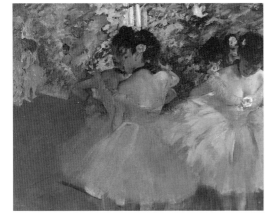

fig. 10. Edgar Degas. *Ballet Dancers (Dancers in Pink)*. c. 1876. Oil on canvas, 23 x 28½ in. (58.4 x 72.40 cm). Hill-Stead Museum, Farmington, Connecticut.

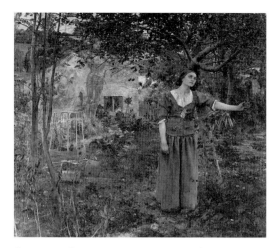

fig. 11. Jules Bastien-Lepage. *Joan of Arc.* 1879. Oil on canvas, 100 x 110 in. (254 x 279.4 cm). The Metropolitan Museum of Art, New York, Gift of Erwin Davis, 1889 (89.21.1).

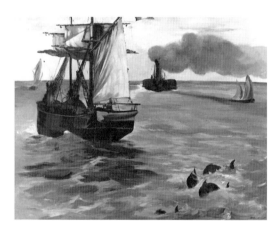

fig. 12. Edouard Manet. *Marine.* 1864. Oil on canvas, 32 x 38½ in. (81.3 x 100.3 cm). The Philadelphia Museum of Art, bequest in memory of Frank Thomson and Mary Elizabeth Clarke Thomson by the daughter Anne Thomson.

Marine (fig. 12).[21] These purchases represent a distinct departure from Weir's previous acquisitions for Davis, which included, in addition to the Bastien-Lepage, paintings by Diego Velázquez (1599–1660), Sir Joshua Reynolds (1723–1792), and Thomas Gainsborough (1727–1788), as well as etchings by Rembrandt (1606–1669).[22]

Manet's *Young Lady in 1866* and Bastien-Lepage's *Joan of Arc* seem an incongruous pair to find in the Davis collection, and indeed they must have seemed so in the 1880s. It is hard to imagine Manet's flattened but exuberantly painted *parisienne*, in her pink peignoir, hanging beside Bastien-Lepage's atmospheric yet painstakingly Naturalist depiction of a country girl's encounter with the angels of God. In fact, they may never have been seen together in the Davis collection, because Davis regularly lent the Bastien-Lepage to exhibitions between 1880 and 1882, and between 1882 and 1888 left it on loan at Boston's Museum of Fine Arts.[23] (Perhaps for this reason, *Joan of Arc* was not included in the Pedestal Fund exhibition, although there was a more sketchily finished watercolor by Bastien on view.)[24] Both paintings went unsold at the disastrous auction of the Davis collection conducted in February, 1889, and along with *Boy with a Sword* (also unsold) were presented to the Metropolitan Museum of Art in March.[25] The paintings by Manet were, for nearly twenty years, the only Impressionist works in the Metropolitan's collection, now the greatest treasury of Impressionist art in America. Not until after the turn of the century would the museum acquire a painting by Renoir (*Portrait of Mme. Charpentier and Her Children*, purchased in 1907), another painting by Manet (*The Funeral*, purchased in 1910), or a work by Cézanne (a landscape, purchased in 1913).[26]

But American collectors began in earnest to purchase Impressionist paintings after 1886, when the famed Parisian dealer Paul Durand-Ruel mounted an unprecedented exhibition in New York of about three hundred "Works in Oil and Pastel by the Impressionists of Paris."[27] This exhibition, which represented the first time that important numbers of French Impressionist paintings had been seen together in the United States, set the stage for the broad appreciation of the Impressionists' work by the American public. Durand-Ruel exhibited a score of paintings by both Degas and Manet, about twice that many by both Renoir and Pissarro, and nearly fifty canvases by Monet, along with works by Sisley, Caillebotte, Cassatt, Morisot, and other painters associated with the Impressionist enterprise.[28] Monet emerged in American eyes as the leader of the movement, and indeed much of what we consider Impressionist in American painting of the later nineteenth century is more closely akin to his art than to that of any other member of the original Impressionist group. (By as early as 1887 Monet's home and studio at Giverny became a mecca of sorts for a group of American painters that eventually included Willard Leroy Metcalf [pl. 36–37], Theodore Robinson [pls. 38–40], John Leslie Breck [1860–1899], and Lilla Cabot Perry [pl. 41].[29]) Monet's leadership can be attributed in part to the avidity with which his paintings were purchased by American collectors, and to the frequency with which large numbers of his paintings were exhibited in the United States following the Durand-Ruel exhibition of 1886.[30]

It is seldom recognized, however, that the 1886 Durand-Ruel exhibition of "the Impressionists of Paris" included paintings by artists whose names are never mentioned in the history of the movement—including popular painters such as John Lewis Brown (1829–1890), who specialized in sporting subjects, Jean-Paul Laurens (1838–1921), a well-known history painter, or Paul Albert Besnard (1849–1934), who had just begun

his successful Salon career. Such forgotten figures as Edouard-Armand Dumaresq (1826–1895) and Louis-Emile Benassit (1833–1902), painters of military themes, and the Orientalist Victor-Pierre Huguet (1835–1902) were also participants.[31] Works by these painters were doubtless included to appeal to collectors who liked for pictures to tell stories, and who were befuddled by the absence of narrative or sentiment in most Impressionist works.

Few of the non-Impressionist paintings in the 1886 exhibition have yet been identified, so it is difficult to determine how they might have related to the works of Monet, Pissarro, Renoir, or Degas that were on view. From the perspective of a century later, we can distinguish between the aims of Monet on the one hand and on the other Besnard, the decorative "fantasist of modernity."[32] Yet in 1893, Albert Besnard was the critical success of a group exhibition in New York in which he was joined by none other than Alden Weir, John Twachtman (see pl. 42), and Claude Monet.[33] In fact, the incongruities that we now see between the work of the avant-garde—as typified by Manet or Monet— and the more conservative factions of the Salons—as typified by Besnard or Bastien-Lepage—were not so easily discerned in the 1880s and 1890s. Thus Weir could comfortably assimilate elements of Millet, Monet, and Bastien-Lepage in his works of the later 1880s, and collectors who had begun by buying modern masterpieces of the Barbizon school or even the Salon would begin to purchase, in ever greater numbers, landscapes by Monet.[34]

The extraordinary painter and teacher William Merritt Chase is a paradigm of American artists' assimilation of diverse Impressionist modes. Like many of his fellow American painters, he developed his own particular version of Impressionism based on a lifetime of encounters and influences. Chase trained at the Munich Academy in the studio of Wilhelm Leibl, in the years before Leibl abandoned his bravura style and aimed to paint in the manner of the Renaissance master Hans Holbein.[35] Chase's works from this period of study in Europe, such as *The Apprentice: Boy with an Apple*, 1876 (fig. 13), reflect his interpretation of the broadest brushwork of the Old Masters he most admired, particularly Velázquez, whom he frequently cited as the most important influence on his art. He named a daughter, born in 1895, Helen Velasquez Chase; and in later years, in fact, he was to compose paintings and photographs of her and others in direct homage to Velázquez's seventeenth-century portraits of the Spanish royal family.[36]

In the later 1870s and early 1880s, a number of factors contributed to the development of Chase's style. His contact with Parisian high-society painters, most notable among them the Belgian-born painter Alfred Stevens (see fig. 17), influenced his decision to establish a fashionable salon in his Tenth Street studio on his return to New York from Munich in 1878. Established as the most cosmopolitan painter in the city, he was, as noted previously, responsible for the selection of works for the Pedestal Fund exhibition, and presented there in 1883 a virtual manifesto of painterly styles across Europe, from the hands of French painters but also by such painters as the Spaniard Mariano Fortuny (1838–1874) and the Hungarian Michael Munkacsy (1844–1900), whose works reveal many parallels with Chase's own.[37] Two years later, Chase met and befriended the American expatriate painter James McNeill Whistler (1834–1903) in London. The two artists quickly struck up a friendship, and agreed to paint portraits of each other.[38] They quarreled, eventually, over Whistler's disdain for Bastien-Lepage, whom Chase admired,

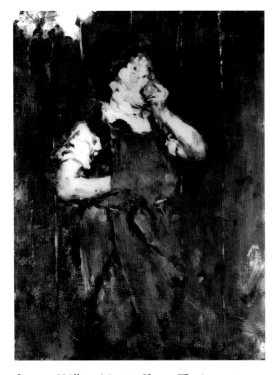

fig. 13. William Merritt Chase. *The Apprentice: Boy with an Apple*. 1876. Oil on canvas, 18¼ x 13 in. (46.3 x 33 cm). The Museum of Fine Arts, Houston, Wintermann Collection of American Art, gift of Mr. and Mrs. David R. Wintermann.

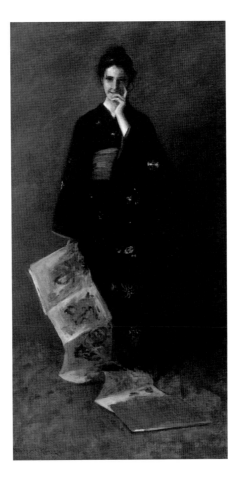

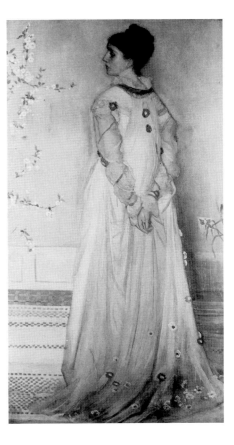

fig. 14. (left) William Merritt Chase. *The Japanese Book.* c. 1900 (see pl. 32).

fig. 15. (right) James MacNeill Whistler. *Symphony in Flesh Color and Pink: Portrait of Mrs. Frederick R. Leyland.* 1871–74. Oil on canvas, 77⅛ x 40¼ in. (195.0 x 102.2 cm). The Frick Collection, New York.

but the encounter with Whistler was to have a lasting effect on Chase's painting in the later 1880s and 1890s (see pls. 24, 31, and 32).

A work such as *The Japanese Book* (pl. 32; fig. 14) reflects Chase's imaginative assimilation of these various stylistic influences. The full-length figure, emerging from a dark background, recalls not only Velázquez's Infantas but also Manet's *Young Lady in 1866* (fig. 5). The Manets that Chase had convinced Weir to buy for the Davis Collection in 1881 were, as he told his students when he brought them to the Metropolitan Museum's galleries, "the only pictures here that could hang with the Old Masters."[39] It seems likely that the work of John Singer Sargent (see pls. 16–20), the great contemporary exponent of exuberant Old Master brushwork and himself an admirer of both Velázquez and Manet, may also have inspired Chase in this portrait of his daughter Alice.

The Japanese Book also shows the powerful imprint of Whistler, whose atmospheric full-length portraits were paraphrased by Chase in the years following their 1885 encounter—the c. 1888 *Mother and Child (The First Portrait)* (pl. 31) in this exhibition illustrates Chase's fascination with Whistler's example. Both *Mother and Child* and *The Japanese Book* may have been inspired by a work such as Whistler's *Symphony in Flesh Color and Pink: Portrait of Mrs. Frederick R. Leyland* (fig. 15), begun in 1871 but still in Whistler's studio in the 1880s, with its elegant figure clad in an unusual dress of Whistler's design against a monochrome background—in this case not a dark void but a rosy white wall.[40] The theme of a Western woman's bemused encounter with the art of Japan also echoes Whistler's works of the 1860s, such as the *Caprice in Purple and Gold: The Golden Screen* of 1864 or *The Princess of the Land of Porcelain* of the same year, among the earliest

fig. 16. James Tissot. *The Japanese Scroll.* c. 1873–75. Oil on panel, 15½ x 22½in. (39 x 57 cm). Courtesy Sotheby's London.

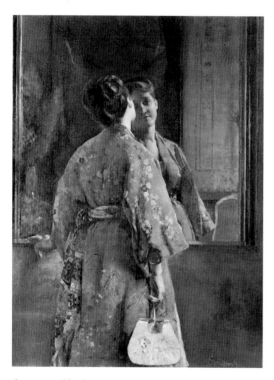

fig. 17. Alfred Stevens. *The Japanese Robe.* c. 1872. Oil on canvas, 36½ x 25⅛ in. (92.7 x 63.7 cm). The Metropolitan Museum of Art, New York, bequest of Catharine Lorillard Wolfe, 1887; Catharine Lorillard Wolfe Collection (87.15.56).

treatments of this theme common in the paintings of Stevens and Tissot (see fig. 16) in the 1860s and 1870s.[41] The stylish costume and exotic accessories, in fact, suggest Chase's continuing fascination around 1900 not only with Whistler, but also with the work of Stevens, whose *Japanese Robe* (fig. 17) he would have known from the collection of Catharine Lorillard Wolfe, one of the lenders to the Pedestal Fund exhibition, who bequeathed her pictures to the Metropolitan in 1887.[42]

In composing his particular strain of Impressionism Chase thus drew, as any artist must, on what he had seen and admired in the work of other artists. Some of the artists he most admired—Manet or Whistler—participated in the founding of Impressionist style. Others—Stevens, Fortuny, or Munckazy, for example—were instead participants in the general movement towards lightened color and stylish brushwork in the 1880s, a movement in which Chase himself played a pivotal part.

The complex history of Impressionism in Europe and America records many such instances of parallel and interrelated development. Monet painted groups of related pictures by the River Epte or in the gardens and fields of Giverny, and encouraged his adherents Robinson and Perry to do the same (pls. 38–41). Whistler and Sargent charted the canals and squares of Venice in oil, pastel, and watercolor (pl. 19). Twachtman explored with similar persistence the winter landscapes he could see from his house at Greenwich, Connecticut (pl. 42). And Chase returned again and again to paint the unmodulated dunes and fields of Shinnecock on Long Island (pl. 25). These intertwined artistic paths, constantly intersecting and diverging, trace the history of the age of Impressionism.

NOTES

1. See Richard Schiff's discussion of "Defining Impressionism" in "The End of Impressionism," in *The New Painting, Impressionism 1874–1886*, exh. cat. (San Francisco: The Fine Arts Museums of San Francisco, 1986), 67–70.

2. Paul Mantz, quoted in *The New Painting, Impressionism 1874–1886*, 219.

3. See, for example, Théodore Duret, *Les Peintres impressionnistes* (Paris: 1878), and Gustave Geffroy, *Histoire de l'impressionnisme*, *La Vie artistique*, third series (Paris: 1894). The preeminent history of the movement's critical fortunes is John Rewald, *The History of Impressionism*, 4th rev. ed. (New York: The Museum of Modern Art, 1973). First published in 1946, Rewald's history attempted to construct a rigid, fact-based definition of the movement. For an important critical review of Rewald's contribution, see John House, "Impressionism and History: The Rewald Legacy," *Art History* 9, no. 3 (September 1986):369–76.

4. Jules Castagnary, "Exposition du boulevard des Capucines—Les impressionnistes," *Le Siècle*, April 29, 1874, quoted in Rewald, *The History of Impressionism*, 38. See Rewald for a thorough discussion of the early criticism of the exhibition.

5. Marius Chaumelin, "Actualités: L'exposition des intransigeants," *La Gazette [des Etrangers]*, April 8, 1876, quoted in Stephen F. Eisenman, "The Intransigent Artist or How the Impressionists Got Their Name," *The New Painting, Impressionism 1874–1886*, 51–59.

6. Stéphane Mallarmé, "The Impressionists and Edouard Manet," *The Art Monthly Review and Photographic Portfolio . . .* I, no. 9 (September 30, 1876), 117–21, reprinted in *The New Painting, Impressionism 1874–1886*, 27–35.

7. Georges Rivière, *L'Impressionniste, journal d'art*, April 6–28, 1877 (five issues). See also Richard R. Brettell, "The 'First' Exhibition of Impressionist Painters," in *The New Painting, Impressionism 1874–1886*, 189–202.

8. Doreen Bolger Burke, *J. Alden Weir: An American Impressionist*, (Newark, Del.: University of Delaware Press, 1986), 188.

9. See reviews by Phillipe Burty and Roger Ballu, quoted in *The New Painting, Impressionism 1874–1886*, 236, 235.

10. See, for example, Weir's factory views, discussed in H. Barbara Weinberg, Doreen Bolger, and David Park Curry, *American Impressionism and Realism: The Painting of Modern Life, 1885–1915*, exh. cat. (New York, The Metropolitan Museum of Art, 1994), 25–27.

11. Compare, for example, Jean-François Millet's *In the Auvergne*, 1867–69, The Art Institute of Chicago; this painting was presented in the exhibition *The Works of Antoine-Louis Barye . . . his Contemporaries and Friends* at the American Art Galleries, New York, in 1889 (see Robert L. Herbert, *Jean-François Millet*, exh. cat. [London: Hayward Gallery, 1976], 192–93). Monet's *Field of Poppies* (fig. 9) was exhibited in New York in 1886; see note 27 below.

12. See Henry Adams, "Winslow Homer's 'Impressionism' and Its Relation to His Trip to France," *Winslow Homer: A Symposium, Studies in the History of Art* 26 (Washington, D.C.: National Gallery of Art, 1990), 61–89; see also Norma Broude, *The Macchiaioli: Italian Painters of the Nineteenth Century* (New Haven: Yale University Press, 1987).

13. The *First Exhibition in New York of Pictures, the Contributions of Artists of the French Etching Club*, was presented by the firm of Cadart and Luquet. See Lois Marie Fink, "French Art in the United States, 1850–1870: Three Dealers and Collectors," *Gazette des Beaux-Arts*, September 1978: 87–100, 89. Fink proposes the *Vue de la côte près du Havre*, 1864, in the Minneapolis Institute of Arts as the type of work that might have been shown by Cadart and Luquet; the painting might as easily have been a more conventional seaside view such as *Le Chantier de petits navires, près de Honfleur*, 1864 (which was bought by Durand-Ruel in 1915 from an American collection), or *La Pointe de la Hève*, 1864. See Daniel Wildenstein, *Claude Monet, Biographie et catalogue raisonné* (Lausanne and Paris: La Bibliothèque des arts, 1974), I, nos. 22, 26, and 39.

14. Louisine Waldron Elder, later Mrs. Henry O. Havemeyer, lent her Degas *Ballet Rehearsal* (Kansas City, Nelson-Atkins Museum) to an exhibition of the American Water Color Society in 1878. See Frances Weitzenhoffer, *The Havemeyers: Impressionism Comes to America* (New York: Harry N. Abrams, Inc., 1986), 23.

15. "An Impressionist's Work: The Pictures of Monticelli, *The New York Times*, May 20, 1879, cited in Maureen C. O'Brien, *In Support of Liberty: European Paintings at the 1883 Pedestal Fund Art Loan Exhibition*, exh. cat. (Southampton, N.Y.: The Parrish Art Museum, 1986), 172 n. 6; for Vollon, see Edward Strahan [Earl Shinn], ed. *The Art Treasures of America*, (Philadelphia: Gebbie & Barrie, 1879), 133.

16. See Weitzenhoffer, *The Havemeyers*, 35.

17. See O'Brien, *In Support of Liberty*. In addition to O'Brien's essay "European Paintings at the Pedestal Fund Art Loan Exhibition: An American Revolution in Taste," this invaluable catalogue also contains essays by Ronald G. Pisano, "William Merritt Chase: Innovator and Reformer," and Lois Dinnerstein, "When Liberty was Controversial," all of which address aspects of the collection and exhibition of French paintings in the United States in the later nineteenth century.

18. Mariana Griswold Van Rensellaer, quoted in Lois Dinnerstein, "When Liberty Was Controversial," in O'Brien, *In Support of Liberty*, 78.

19. "The Pedestal Fund Art Loan Exhibition," *The Art Amateur* 10, no. 2 (January 1884): 43, quoted in Pisano, "William Merritt Chase," in O'Brien, *In Support of Liberty*, 65.

20. Charles Sterling and Margaretta M. Salinger, *French Paintings: A Catalogue of the Collection of the Metropolitan Museum of Art, II: XIX Century* (New York: The Metropolitan Museum of Art, 1966), 207–10.

21. For the history of Weir's purchase of the Manets, see Dorothy Weir Young, *The Life and Letters of J. Alden Weir* (New Haven: Yale University Press, 1960), 145–46; see also Frances Weitzenhoffer, "First Manet Paintings to Enter an American Museum," *Gazette des Beaux-Arts*, March 1981: 125–29.

22. Young, *The Life and Letters of J. Alden Weir*, 145.

23. Sterling and Salinger, *French Paintings*, 210.

24. O'Brien, *In Support of Liberty*, 132.

25. Weitzenhoffer discusses the sale and gift in "First Manet Paintings," 126–28.

26. See Sterling and Salinger, *French Paintings*, 149–52, 44–45, 115–17.

27. Hans Huth, "Impressionism Comes to America," *Gazette des Beaux-Arts*, April 1946: 225–52; Rewald, *The History of Impressionism*, 529–32; Weitzenhoffer, *The Havemeyers*, 39–42.

28. See Huth, "Impressionism Comes to America," 239 n. 22.

29. The most complete study of American artists in Monet's sway is William H. Gerdts, *Monet's Giverny: An Impressionist Colony* (New York: Abbeville Press, 1993).

30. His works were exhibited in large numbers at the Union League Club in New York in 1891 and at the St. Botolph Club in Boston in 1892. See Weitzenhoffer, *The Havemeyers*, 82–84.

31. I am grateful to Charles F. Stuckey for access to the catalogue of the 1886 exhibition as presented at the American Art Association.

32. Gabriel Mourey, *Albert Besnard* (Paris, 1906), 95.

33. The exhibition was held in 1893 at James Sutton's American Art Galleries. See Weitzenhoffer, *The Havemeyers*, 89.

34. Erwin Davis was among the first American collectors to buy a work by Monet; see Weitzenhoffer, "First Manet Paintings," 126. Monet's work was particularly popular with collectors in Boston; see Alexandra R. Murphy, "French Paintings in Boston: 1800–1900," in *Corot to Braque: French Paintings from the Museum of Fine Arts, Boston*, exh. cat. (Boston: Museum of Fine Arts, Boston, 1979) xli–xliv.

35. See *Munich & American Realism in the 19th Century*, exh. cat. (Sacramento: E.B. Crocker Art Gallery, 1978). See also Ulrich Finke, *German Painting from Romanticism to Expressionism* (Boulder, Colorado: Westview Press, 1975), 145–51.

36. See, for example, *An Infanta, A Souvenir of Velazquez*, 1899 (Private Collection), in Ronald G. Pisano, *A Leading Spirit in American Art: William Merritt Chase, 1849–1916*, exh. cat. (Seattle: Henry Art Gallery, University of Washington, 1983), 127. See also Ronald G. Pisano and Alicia Grant Longwell, *Photographs from the William Merritt Chase Archives at The Parrish Art Museum*, exh. cat. (Southampton, N.Y.: The Parrish Art Museum), nos. 91, 123–26.

37. See Ronald G. Pisano, "William Merritt Chase: Innovator and Reformer," in O'Brien, *In Support of Liberty*, 68–69, and nos. 33, 68, and 79–82.

38. For Chase's portrait of Whistler, see Pisano, *A Leading Spirit in American Art*, 77–81. Whistler's portrait of Chase is unlocated: see Andrew McLaren Young, Margaret MacDonald, and Robin Spencer, *The Paintings of James McNeill Whistler* (New Haven and London: Yale University Press, 1980), no. 322.

39. The remark was overheard by Walter Pach during Chase's tenure at the Pennsylvania Academy, between 1896 and 1909. See Weitzenhoffer, "First Manet Paintings," 128.

40. See Young, MacDonald, and Spencer, *Whistler*, no. 106. Another source of inspiration for *The Japanese Book* might be *Symphony in White, No. 1: The White Girl* (Washington, D.C., National Gallery of Art), exhibited in New York in the 1880s and 1890s; see Young, MacDonald, and Spencer, no. 38.

41. See Young, MacDonald, and Spencer, *Whistler*, nos. 60, 50 (both Washington, Freer Gallery of Art). See also Tissot's *Young Women Looking at Japanese Objects*, 1869 (private collection), in Michael J. Wentworth, *James Tissot* (Oxford: Clarendon Press, 1984), pl. 59.

42. Stevens's painting seems to have been the direct inspiration for Chase's *The Mirror*, c. 1900, in the collection of the Cincinnati Art Museum. See Carolyn Kinder Carr, *William Merritt Chase: Portraits*, exh. cat. (Akron: Akron Art Museum, 1982), 33, fig. 25, 36.

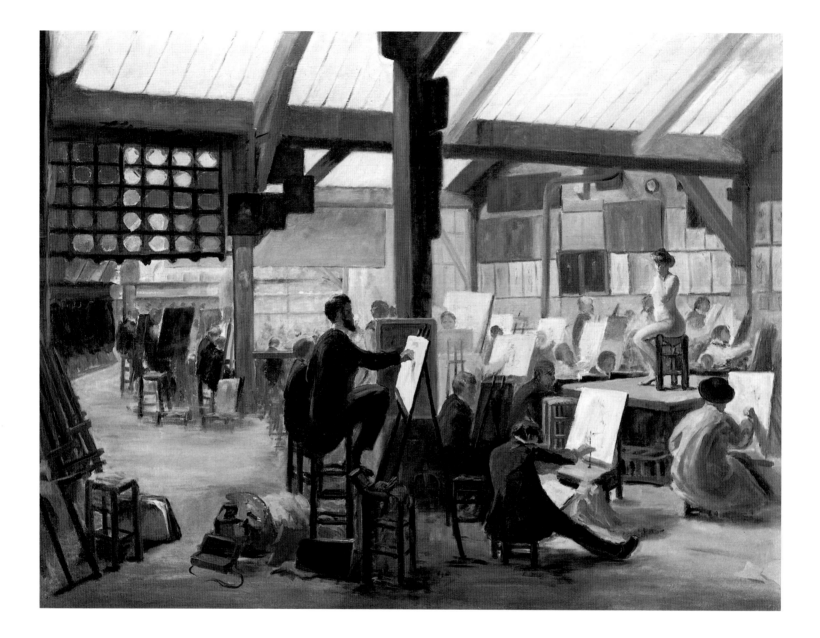

"Europe" or "Heaven"?: American Painters and European Trends

EMILY BALLEW NEFF

WILLIAM MERRITT CHASE EXPRESSED THE MOOD OF MANY of his contemporaries when he insisted that he would "rather go to Europe than go to heaven."[1] For American artists traveling to France, Germany, and England looking for rigorous artistic training, camaraderie, sources of patronage and, above all, inspiration, Europe offered a veritable kaleidoscope of artistic modes to study and absorb. American artists found appeal in the tranquil landscapes of the Barbizon artists, the poetic vision and ethereal atmosphere of the Pre-Raphaelites, and the highly finished surfaces of Jean-Léon Gérôme and Jules Bastien-Lepage and their interest in Oriental themes and sentimentalized peasant subjects, respectively. In Germany, Wilhelm Leibl inspired American artists to study the Baroque art of Diego Velázquez and Frans Hals, as well as the more recent French art of Gustave Courbet and Edouard Manet. In England, the expatriate James McNeill Whistler emulated the decorative patterns of Japanese art, and shared his artistic vision of "art for art's sake" with the many American artists who made the pilgrimage to London to see him. Finally, American artists responded to the French Impressionists and the group's dedication to exhibiting their work independently rather than in the government Salons that represented official taste.

The French Impressionists' preference for painting themes of daily life in rural retreats or city streets, and for using brightly colored unmixed paint to suggest the transitory effects of light and atmosphere, inspired a long and distinguished lineage of American painters interested in similar ideas and effects. It is important to note, however, that American artists did not respond to European trends in unison or uniformly. Rather, they appropriated European impulses when they felt they had a place in their own artistic vision, producing a corpus of American painting that can be described, simply, as rich in diversity and catholic in its taste and admiration for European styles. No longer loudly proclaiming the beneficial effects of cultural isolation, American artists embraced the European experience and showed the signs of that affection in their art.

fig. 18. Caleb Arnold Slade. *Atelier at the Académie Julian, Paris.* n.d. Oil on canvas, 42 x 57 in. (106.7 x 144.8 cm). Collection The William Benton Museum of Art, The University of Connecticut, Alumni Annual Giving Program.

The tendency to see Winslow Homer (1836–1910) as an indigenous Impressionist emerged during his lifetime and has remained a constant theme in most subsequent accounts of his career. Among his contemporaries, critics often believed that Homer "seem[ed] to move in a world of his own," and that his version of Impressionism was "entirely homemade, and to American soil indigenous."[2] More recently, Homer has been described as an artist who "initiated certain types of native impressionism," as if Impressionist tendencies in his art generated spontaneously instead of developing as an intelligent response to his exposure to European painting both at home and abroad.[3] In 1865, Homer saw the work of the Barbizon painters as well as works by Johann Barthold Jongkind, Claude Monet, and Eugène-Louis Boudin in Boston and New York exhibitions. During a trip to Paris in 1867, he probably saw the many works of the Barbizon artist Jean-François Millet displayed at the Paris Salon, and may have seen the works of Gustave Courbet (1819–1877) in an independent exhibition. Indirectly, Homer would have known the work of the Barbizon school in Boston collections through his fellow artists William Morris Hunt and John La Farge.

The hesitation on the part of historians and critics to acknowledge Homer's familiarity with vanguard French painting of the 1850s and 1860s and the importance of Impressionist ideas in his work may stem from their inability to reconcile Homer's "Americanness" with the foreign influences that inform his art.[4] Trained as an illustrator, Homer was quick to master both the oil and watercolor media, new to him after his stint as an artist-correspondent during the Civil War.[5] Homer painted oils and watercolors in the 1870s (see pls. 1–4) that amply demonstrate how the artist appropriated foreign styles, reworking them to accommodate contemporaneous concerns about depicting typically "American" subject matter.[6]

Girl in a Hammock of 1873 (pl. 1), part of an early series depicting young women reclining in hammocks out-of-doors, suggests Homer's affinity for Barbizon painting through its free brushwork, its overall brown-and-green tonality, its dappled sunlight, and its depiction of an isolated figure in an outdoor, rural setting. During the 1870s, Homer's subjects tended toward pleasant images of rural American life and leisure, particularly featuring children at play or in the schoolroom. In these images of docile home life, Homer both endorsed the nationalist cultural reform that encouraged a national style and subject matter in American art, and asserted a nostalgic view of American life vastly different from the profound social change actually taking place in the post-Civil War era.[7] The nostalgic quality of Homer's subject matter is also conveyed in two of his early watercolors, the 1873 *Gloucester Harbor* and *Girl on a Garden Seat* of 1878 (pls. 3 and 4), where images of children at play or at leisure suggest an innocent historical past.[8]

Compared to the more tonally restrained image of the painting of a young girl, *Houses on a Hillside* (1879, pl. 2, fig. 19) suggests Homer's sensitive response to the blinding light of the countryside, as he may have experienced it at Houghton Farm in Mountainville, New York, where he visited his friend and patron Lawson Valentine. Homer's light-filled canvas, with its broadly painted sky, truncated composition, and unmixed areas of saturated paint, shows its spiritual affinity to Monet's work of the 1870s, for example, *Poppies at Argenteuil* of 1873 (fig. 20). Just as Monet's audience in Paris would see his picture as radically inept, Homer's audience accused him of childlike naiveté. The ultimate cosmopolite Henry James was especially critical:

We frankly confess that we detest his subjects—his barren plank fences, his glaring, bald skies, his big, dreary, vacant lots of meadows, his freckled straight-haired Yankee urchins, his flat-breasted maidens, suggestive of a dish of rural doughnuts and pie, his calico-sun bonnets, his flannel shirts, his cowhide boots. He has chosen the least pictorial features of the least pictorial range of scenery and civilization; he has resolutely treated them as if they were pictorial, as if they were every inch as good as Capri or Tangiers; and, to reward his audacity, he has incontestably succeeded.[9]

For an urban sophisticate such as James, the so-called primitivism of Homer's art came dangerously close to affirming—perhaps even endorsing—the perceived provincial status of American art. Yet even James recognized the "audacity" of Homer's achievement.

In 1881, Homer diverged from his contemporaries then flocking to Paris by seeking out transatlantic subject matter in the bleak and isolated English fishing villages of Tynemouth and Cullercoats.[10] Here, Homer began exploring themes of monumental, idealized figures of women gazing at or confronting the ominous forces of the sea, the source of both sustenance and danger to those who relied on the ocean's bounty for their livelihood. In his Cullercoats watercolors, Homer presented a personal vision of peasant life, in which the hardship of the English fisherfolk is generally conveyed by somber colors and the suggestion of a mist-filled, heavy atmosphere; the vivid colors of *Waiting for the Return of the Fishing Fleet* (1881, pl. 5), by contrast, lend an optimistic note to Cullercoats daily life. Exhibited in the American Water Color Society show in Boston in 1883, four of the English watercolors he displayed earned him immediate success as well as a reputation for being "the historian and poet of the sea and sea-coast life," a distinction he would earn many times over in his later secluded years in Prout's Neck, Maine.[11]

While the Cullercoats watercolors recall the idealized, monumental peasants popular in French painting, the broadly brushed fishing and hunting watercolors Homer executed between 1889 and 1902 evoke no such obvious foreign counterpart.[12] The many wilderness excursions Homer and his brother Charles took to the North Woods Club in Minerva, New York, or later to Canada, follow a late nineteenth-century trend for aristocratic males who firmly believed that deep woods experiences were good for their mental well-being.[13]

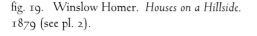

fig. 19. Winslow Homer. *Houses on a Hillside.* 1879 (see pl. 2).

fig. 20. Claude Monet. *Poppies at Argenteuil (Les Coquelicots).* 1873. Oil on canvas, 19⅝ x 25⅝ in. (50 x 65 cm). Musée d'Orsay, Paris.

Rather than painting the fraternal group of like-minded businessmen Homer often accompanied on these trips, Homer chose to paint either young children, guides, or solitary anglers. In one of his most haunting and powerful watercolors, *Fishing the Rapids, Saguenay* (1902, pl. 9), Homer captures a sense of nature's awesome power by posing the angler and guide on a distant rock, placing the turbulent whitewater passage between the viewer and the subjects, and enveloping the scene with ominous storm clouds. The fly rod and line barely discernible in the distance suggests the graceful, rhythmic movements of the sport played out amid turbulence and chaos.

Encouraged by Presidents Grover Cleveland and Theodore Roosevelt, the cult of the American wilderness experience then sweeping the nation is implicit in images from Homer's vacations in the Adirondacks or Canada such as *Casting in the Falls* (1889), *Boy Fishing* (1892), *The Guide* (1895), and *Fishing the Rapids, Saguenay* (pls. 6–9). In this regard, Homer, again, asserts his interest in "American" subject matter, while the stunning passages of loose, suggestive brushwork, and unusual perspectives find their corollaries in the work of the French Impressionists.

While Homer's contemporaries, and subsequent students of his art, have often cultivated the notion that the painter reached Impressionism without French or other European influences, it is generally acknowledged that George Inness (1825–1894) "carried on what may be called the tradition of French naturalistic landscape," and that he announced his allegiance to French tendencies more overtly.[14] At the moment in the 1870s when Homer was just beginning his series of "national" pictures, Inness had already traveled three times to Europe. There he absorbed tenets of the Barbizon school as represented in the art of the landscape painters Théodore Rousseau, Charles-François Daubigny, and Camille Corot, together with Jean-François Millet, the group's greatest figure painter. Centered around the village of Barbizon in the Forest of Fontainebleau, these painters showed American artists such as Inness, Hunt, and La Farge an alternative to the meticulously detailed and literal transcription of nature perceived in Hudson River School paintings. From these artists, American painters learned to work out-of-doors, to eliminate minor details in order to project an image of unity and cohesion, and to favor a brown-gold palette of limited tonal range.[15] The tenets of Barbizon painting, then, encouraged a subjective rather than a literal approach to nature, one that produced a poetic or even mystical effect that, in the paintings of Inness, translated into dissolving masses, eerie light effects, and unusual topographical forms.

Inness's landscapes are rarely without traces of human activity. Both *Sunset at Etretat*, painted on the coast of Normandy around 1875, on Inness's third trip to Europe, and an 1878 *Landscape* show miniscule humans enveloped by their natural surroundings (pls. 10 and 11). They inhabit what Inness would call a "civilized landscape," one marked by human activity: "Every act of man, every thing of labor, effort, suffering, want, anxiety, necessity, love, marks itself wherever it has been," he wrote. "In Italy I remember frequently noticing the peculiar ideas that came to me from seeing odd-looking trees that had been used, or tortured, or twisted—all telling something about humanity. . . . everything in nature has something to say to us."[16] Inness does not so much anthropomorphize nature as he allows its peculiarities to suggest human moods and emotions. Inness's dialogue with nature helps to elucidate what he means by "impression," a term he used to signify the emotional aspect of his work, as the painter tries to "reproduce in other minds

the impression which a scene has made upon him."[17] The artist is charged with communicating feeling, not transcribing a factual record or imparting a moral message.

Inness's Impressionism, then, has more to do with the subjective tendency of art-making and is carried on in the work of his follower, Homer Dodge Martin (1836–1897), who, like Inness, is a bridge between the detailed paintings of the Hudson River School and early forays into French Impressionism. During a trip to Europe in 1876, Martin studied the work of Corot and the other Barbizon artists, and befriended James McNeill Whistler (1834–1903) in London. In response to their art, Martin adopted the freer handling of his European contemporaries and a simple palette with limited gradations of tone. *Low Tide, Villerville* (1884, pl. 12), a work from Martin's four-year sojourn in the Normandy fishing village, demonstrates how somber, restrained, and elegant his style became.

"I Keep My Twang": The Expatriate Americans

Mary Cassatt (1845–1926) and John Singer Sargent (1856–1925) forged the earliest alliances between American art and French Impressionism. From 1877, Cassatt exhibited with the group of independent Parisian artists known as the Impressionists at the invitation of Edgar Degas, an invitation that, in her words, marked the time she first "began to live."[18] Degas soon became her great mentor and friend. In response to his work, Cassatt adopted Degas's abrupt diagonals and off-center compositions that lent his paintings the appearance of fragments from daily life. At the same time, she broadened the facture of her surfaces to more closely resemble the works of Degas's friend Edouard Manet.

John Singer Sargent, born to Americans residing in Florence, first trained with the Parisian painters Carolus-Duran (1838–1917) and Léon Bonnat (1834–1923) in the 1870s, and visited the Impressionist exhibitions of the decade. Sargent's light-filled canvases of outdoor beaches, public parks in Paris, and other subject pictures from his travels to Italy, rural England, Spain, and Northern Africa in the 1870s and 1880s mark his early sympathy with the Impressionist group's concerns. Like his friend Claude Monet, Sargent painted scenes of city and country life out-of-doors. The dramatically cropped compositions, the suggestion of spontaneity achieved by the flickering application of paint, and the areas of saturated, unmixed pigments seen in Impressionists' works soon made their appearance in Sargent's. While most of Cassatt and Sargent's American contemporaries studying in Paris initially preferred to emulate the style of their academic masters, Cassatt and Sargent early on adopted, however loosely, the Impressionist idiom.

Cassatt, the first American woman artist to gain international distinction, became famous for her intimate yet unsentimental scenes of women and children in domestic or outdoor settings. While most of her contemporaries painted tender images of genteel women going about a daily routine of tending children and sipping tea, Cassatt portrayed women as self-sufficient and independent in similar situations. *The Nurse*, 1878, *Susan Comforting the Baby*, c. 1881, and *Mother and Children*, 1901 (pls. 13–15), in fact, suggest the different ways Cassatt approached the theme of child-rearing and maternity in her work, a theme whose complexity multiplies when we remember that Cassatt viewed motherhood from an outsider's perspective; she was childless at a time when women were regularly expected to be mothers.

Cassatt portrays children in natural, often awkward, poses that convey the common mannerisms of childhood. Not one to overlook or sentimentalize the realities of child

behavior, Cassatt reveals the fussiness of the child, and the firm but tender response of the child's mother or caregiver in *Susan Comforting the Baby*. Cassatt achieves the sense of each subject's self-absorption and independence by rarely allowing her sitters to meet one another's gaze in the picture.[19] In *The Nurse*, the caregiver, sleeping baby, and busy child attend to their business and exist in their own private worlds. Cassatt makes the state of absorption her theme again in *Mother and Children*. The infant stares at something outside the picture plane, and the young daughter gazes at her mother who, rather than returning the gaze, appears lost in her own thoughts.

Cassatt's greatest influence on American artists of her time did not emerge from her work itself, but from the wealthy and cosmopolitan upbringing that brought her into contact with America's greatest collectors of modern French art. The collections of French Impressionism amassed by Louisine and Henry O. Havemeyer in New York and Mrs. Potter Palmer in Chicago owe much to the encouragement of Cassatt. As early as 1877, Cassatt first advised Louisine to purchase a Degas pastel, consequently among the first known Impressionist works bought by an American collector.[20] Through American collectors such as these, the French Impressionists gained the enthusiastic audience for their work they often lacked in Paris.

Cassatt's loyal friends and mentors included Degas, Manet, and Whistler, the dandified American proponent of the English Aesthetic movement. Sargent, however, was not among her intimates, as he, according to Cassatt, only wanted "fame and great reputation."[21] At one time, however, both Cassatt and Berthe Morisot had encouraged Sargent—in the end, to no avail—to join what she termed the "band of little independents."[22] Skeptical of high society, Cassatt was critical of Sargent's inclination to flatter his fashionable clientele with dazzling, radiant portraits that announced loudly the sitter's affluence and good taste. After training in Paris in the atelier of the flamboyant artist Carolus-Duran, and befriending the great nineteenth-century intellectual aesthetes Henry James, Robert de Montesquiou, and Oscar Wilde, Sargent emerged the portraitist of choice for the aristocracy of England and America. Sargent had ambition, affability, social connections and, above all, an extraordinary artistic talent. Consequently, as one critic put it, "Before his eyes pass[ed] in continuous procession the world of art, science, letters, the world financial, diplomatic, or military, and the world frankly social;" everyone of importance found "a place in this shifting throng."[23] Raised a perpetual tourist virtually without national roots, Sargent nonetheless maintained, ". . . I keep my twang . . . I am an American."[24]

Sargent's early academic training, manifest in the sensitive draftsmanship and application of watercolor in *The Model* (c. 1876, pl. 16), was refined during study trips in 1879–80 to Spain and Holland. There he studied the paintings of the seventeenth-century artists Diego Velázquez and Frans Hals, whose virtuoso surfaces soon found parallel in his own work.[25] His shockingly glamorous portrait of Madame Pierre Gautreau (fig. 21), exhibited with the title *Madame X* at the Paris Salon of 1884, raised such critical ire that Sargent withdrew to London, where his lucrative portrait practice became the nineteeenth-century equivalent of Anthony Van Dyck's in the court of Charles I, or Sir Joshua Reynolds's and Thomas Gainsborough's during the reign of George III.

Beneath staggering surface displays of paint, Sargent succeeded in capturing psychologically penetrating portraits of his sitters. In his portraits of women in particular, Sargent

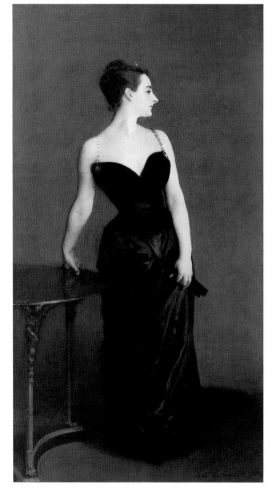

fig. 21. John Singer Sargent. *Madame X (Madame Pierre Gautreau)*. 1884. Oil on canvas, 82⅛ x 43¼ in. (208.6 x 109.9 cm). The Metropolitan Museum of Art, New York, Arthur Hoppock Hearn Fund, 1916.

tried to "retain . . . some look of intelligence in a face, besides amiability."[26] In 1899, Sargent painted *Mrs. Joshua Montgomery Sears*, a painter, photographer, spiritualist, and patron of the arts in her native Boston (pl. 18).[27] Sarah Choate Sears traveled in a circle that included such celebrated patrons as Isabella Stewart Gardner, the Havemeyers, and Gertrude and Leo Stein (to whom she introduced Cassatt, who reportedly found their art collection and friends appalling).[28] Casually posed, but radiating intensity and alertness, Mrs. Sears as represented by Sargent embodies the quality the painter's critics found in his portraits, which one called the "nervous tension of the age."[29]

The lush passages of white on white paint tinged with lavenders and blues in the portrait of Mrs. Sears are echoed in the c. 1906–07 portrait of Adela Grant Capel, the Countess of Essex, one of the many New York heiresses who married English nobility at the turn of the century (pl. 17). Posing her beside a column and against a pale blue sky, Sargent recalls the portrait conventions of eighteenth-century English painting, yet revitalizes the formula, offering his sitters the respectability associated with the Old Masters combined with modern style.

While Sargent demonstrated from an early age his intention to make his career as a painter of portraits (he is said to have painted over eight hundred in his career), he also painted many subject pictures and landscapes, most of which reveal his interest in plein-air painting. Sargent's experiments with painting out-of-doors began in the English countryside in 1885, and received encouragement during the course of three visits to Claude Monet in Giverny between 1887 to 1891. In the first two decades of the new century, on frequent visits to Italy, Sargent painted both the popular tourist sites he encountered and the ordinary narrow streets and alleys of villages and cities, particularly Venice. Where Sargent conveys blinding Italian light in his *View of Venice* (1910, pl. 19), he creates a bold pattern of broad strokes of white paint touched with lavender to suggest the dappled effects of sunlight peeking through leaves in a garden courtyard in *Granada, Sunspots* (1912, pl. 20).[30] In both paintings, Sargent preferred the oblique or odd vantage point and off-center compositions that gave his outdoor subjects the effect of fragments or "painted diaries" of his travels.[31]

Sargent's bravura painting earned him many admirers, notably Irving Wiles (1861–1948) and Cecilia Beaux (1863–1942), both of whom carried on his fashionable portrait style. Wiles's *The Storybook* echoes Sargent with its casually posed, genteel sitter, fluid brushwork, and prominent reflective surfaces suggested by dabs of unmixed paint (1917, pl. 21).

Like Sargent, Beaux pursued academic training in Paris, studying under Adolphe-William Bouguereau and other French masters at the Académie Julian (fig. 18). Noted for its bohemian reputation and raucous atmosphere, the Académie Julian was popular among American and French artists, especially women artists, who could not receive training at the Ecole des Beaux-Arts. In her diaries, Beaux alluded to the frantic atmosphere of the women's studio: "The room was always filled 'to capacity' as we say, and it was necessary to mark each easel and chair with white chalk and to look out for encroachments. We had scarcely elbow room."[32] Returning to America, Beaux divided her career between her native Philadelphia and New York, teaching art classes and painting genteel society in portraits distinguished by their immediacy, fluid paint application, and rich color schemes. Critics lauded Beaux for her sensitive portrayals of children. Beaux's portrait of *Cynthia Sherwood* (1892, pl. 22), the daughter of a fellow artist and friend Rosina Emmet

Sherwood, was admired by fellow artists William Merritt Chase and Robert Reid, and exhibited to acclaim at the Society of American Artists in New York in 1895 and the Champs de Mars Salon in Paris in 1896.

The "Painter Gods" in Germany

While American artists such as Cassatt, Sargent, and Beaux sought opportunities to present their paintings both in vanguard and official exhibitions in Paris, France's claim as the major art capital of Europe—from the American perspective—was not laid until the latter decades of the nineteenth century. For American artists starting their careers just before the mid-nineteenth century, Germany offered what was considered the best in artistic training: the prestigious art academy in Düsseldorf, attended by the American artists Emanuel Leutze, Richard Caton Woodville, and Albert Bierstadt, among others.[33] Under the guidance of Carl Friedrich Lessing and Andreas Achenbach at Düsseldorf, American artists learned how to paint grand, theatrical history paintings, artfully composed and meticulously finished. After the Civil War, however, Americans' attention shifted to Munich, where the German Realist Wilhelm Leibl attracted a growing number of American followers, including Frank Duveneck (1848–1919) and William Merritt Chase. Turning away from the academic principles of the Düsseldorf academy, Leibl promoted the study of Velázquez and Hals (as Sargent himself would do in the late 1870s), as well as the French Realists Edouard Manet and Gustave Courbet. In general, artists trained in Munich were encouraged to depict ordinary subject matter, and to employ broad handling of paint and a limited, dark palette enlivened with minimal spots of bright color.

After three years of training in Munich, Kentucky-born Duveneck returned to the United States in 1873, setting up his studio in Cincinnati, and showing his work in Boston. With the encouragement of the Boston tastemaker and artist William Morris Hunt, who championed American artists training abroad, Duveneck returned to Munich where by 1876 he began painting out of doors in the Bavarian town of Polling. With Chase, John H. Twachtman, and Joseph DeCamp, otherwise known as the "Duveneck Boys," Duveneck traveled to Italy, where his own work began to show increasing concern for light, color, and

fig. 22. *William Merritt Chase in his Tenth Street studio, New York, with copies after Hals, Velázquez and other Old Masters on the wall.* c. 1895. Albumen print, 4¹/₂ x 7¹/₈ in. (11.4 x 18.1 cm). The William Merritt Chase Archives, The Parrish Art Museum, Southampton, New York; Gift of Jackson Chase Storm.

fig. 23. William Merritt Chase. *Seashore.*
c. 1886–89 (see pl. 24).

fig. 24. James McNeill Whistler. *Variations in Pink and Grey: Chelsea.* 1871–72. Oil on canvas, 24¼ x 16 in. (62.7 x 40.5 cm). Courtesy of the Freer Gallery of Art, Smithsonian Institution, Washington, D.C. (02.249).

atmospheric effects. His extended stay in Europe ended in 1888 after the tragic death of his wife and fellow artist Elizabeth Boott. Duveneck's *Portrait of Maggie Wilson* (1898, pl. 23) was painted after his return to Cincinnati, where he devoted the rest of his career to painting and teaching, returning seldom to Europe.

Duveneck and Chase were called the "painter-gods"—artists who "descended upon the Munich exhibitions, with work so fine it stood out as noteworthy even there . . . They stand for much in America's artistic achievement; they were the force behind a great forward-moving epoch."[34] They were, in fact, among the earliest American artists to gain exposure to contemporary styles both in Germany and France, and to disseminate what they had learned through long and distinguished teaching careers.

Chase, however, also relished the role of flamboyant tastemaker, witty comedian, and devoted father, who often depicted his wife and nine children in his paintings. Operating in large part from two bases, his richly appointed Tenth Street studio in New York and the outdoor school of art at Shinnecock, Long Island, Chase orchestrated a stunning career that encompassed dramatic portraits executed in his dark, Munich style, as well as Impressionist-inspired light-filled paintings and pastels. His taste for fame and his flair for comedy may have been encouraged by his encounter with Whistler, whom he befriended briefly during a trip to London in 1885. In the following years, he embarked upon a series of seascapes and coastal scenes inspired by the elder painter; in *Seashore* (c. 1886–89, pl. 24, fig. 23), muted tones with little tonal gradation suggest the elegant and deceptively simple surfaces of Whistler's own paintings of the same subject (fig. 24).

Back in the States, Chase was a highly visible artist and teacher in the New York art scene. In 1878, he joined the teaching staff of the Art Students League as well as the newly founded Society of American Artists, a group of European-trained artists who disdained the conservative tendencies of the art establishment represented by the National Academy

fig. 25. *Mother and Child (The First Portrait)* (see pl. 31) in William Merritt Chase's studio at Shinnecock. c. 1892. Ex-collection Mrs. Wayne Morrell, present location unknown.

fig. 26. *William Merritt Chase giving a landscape demonstration before a group of people, probably Shinnecock Hills.* c. 1902. Gelatin silver print, 6¼ x 8⅛ in. (15.88 x 20.64 cm). The William Merritt Chase Archives, The Parrish Art Museum, Southampton, New York.

of Design. He was renowned for the decoration of his Tenth Street studio, where exotic fabrics, bric-a-brac, copies of Old Master paintings, plants, studio props, and print portfolios were skillfully arranged, as in a picture (fig. 22).[35] "A vast, darkish place containing beautiful spots of color," Chase's early biographer Katherine Metcalf Roof recalled it, in a phrase that could almost suggest the painter's full-length portrait of *Mother and Child (The First Portrait)* (c. 1888, pl. 31, fig. 25).[36] Exhibited in the 1889 Exposition Universelle in Paris, Chase's portrait displays the artist's interest in the various subtle tones of black contrasted with stark white, both mediated by, in the words of his student Kenyon Cox, "the one note of vivid scarlet that cuts through this quiet harmony like a knife."[37] Chase's brilliant eclecticism can be further demonstrated by another intimate family portrait dated slightly later than *Mother and Child*, the luminous pastel *Mrs. Chase and Child*. Here, his keen eye for the exquisite details of his well-appointed home contrast with the earlier dramatic full-length portrait, combining the elegance of Whistler's full-lengths with the restraint associated with seventeenth-century Spanish portraiture (c. 1889, pl. 26).[38]

Chase, an avid proponent of plein-air painting, taught at one of the early outdoor schools for painting in Shinnecock, located on the eastern tip of Long Island where the noted architect Stanford White built Chase's summer home (fig. 26). Here, Chase extended his teaching responsibilities into the summer months, and between 1891 and 1902 the Summer Art School at Shinnecock under Chase's guidance became something of a summer art camp for men and women, noted for the high-spirited antics of its students. Chase's lively instructions to his students ("It usually takes two to paint . . . One to paint and the other to stand by with an axe to kill him before he spoils it") guaranteed a loyal following.[39] The artist Louise Cox's memoirs include an enduring verbal portrait of Chase the teacher:

> He held forth in high revel being as unable to suppress his bubbling spirits in the class-room as anywhere else. His startling personality, his straight brimmed hat, frock coat, cane, and flamboyant necktie carried all before him . . . I feel now that some of his sparkling criticism was not always constructive, but it was highly diverting.[40]

In Shinnecock, Chase produced a coherent series of luminous landscapes inspired by the rather ordinary sandy and flat Shinnecock countryside, as seen in *Sunlight and Shadow, Shinnecock Hills* (c. 1895, pl. 25). Here, Chase demonstrates his remarkable ability to make the ordinary extraordinary and, in the words of Cox, to find "in the humblest things as in the finest . . . beauties we had else not thought of."[41]

In the last decade of his life, Chase painted more than one hundred still lifes, roughly half of which represented the iridescent surfaces of fish alongside humble copper pots and bowls.[42] Often painted during his summer trips to Europe, pictures such as *Still Life* recall the traditions of Old Master paintings from Spain or the Netherlands—works he would have encountered on his travels—as well as those of Manet (c. 1915, pl. 27). The earlier work of the Danish emigré Emil Carlsen (1853–1932) offers quiet contrast to Chase's dramatic display of dead fish, as in *Still Life with Lemons* (1881, pl. 28) and *Still Life with Yellow Roses* (c. 1885, pl. 29).[43] Trained in Paris in the 1870s, Carlsen sought dramatic contrasts of shapes, textures, and colors (particularly yellow) which he delicately balanced in infinitely varied arrangements, all intended, Carlsen wrote, to be "strong, vital . . . every touch full of meaning and for the love of beauty."[44]

"Let Us Live up to It!": Japanism and the Exotic

With the opening of Japan to the West in 1854, Japanese export items, from prints and porcelains to garments, fans, and screens, found eager markets in Europe and America. Japanism, or the fascination for things Japanese, made its presence felt to an unprecedented degree in America and France by the late nineteenth century. The appropriation of Japanese cultural effects by Americans provided the perfect antidote to increasing Victorian concerns about the effects of modern urban "problems"—such as rapid industrialization and the rising immigrant population—on American life.[45] The escape into the cultural "other" offered by Japanese artifacts neutralized the seemingly unsolvable social problems that gained in urgency at the turn of the century. With Japanese *objets d'art* gracing the living spaces of the upper and middle classes, Americans were made to feel elegant, refined, and tasteful—in a world apart from the gritty urban streets just outside their door. As an 1880 cartoon in *Punch* suggests, Westerners were concerned with both the aesthetic qualities and philosophies they perceived in Asian art (fig. 27). While the "Aesthetic Bridegroom" admires the aesthetic qualities of the Oriental teapot, his "Intense Bride" (surely a parody of Jane Morris, the Pre-Raphaelite muse) expresses her desire to "live up to" and emulate the refined, elegant, and seemingly untroubled world the teapot represents to her.

Both references to Japanese artifacts and outright *japonaiseries* abound in nineteenth-century American art, as seen here in three works by Chase—*Mother and Child (The First Portrait)* (c. 1888, pl. 31), *Mrs. Chase and Child* (c. 1889, pl. 26), and *The Japanese Book* (c. 1900, pl. 32), Frederick Frieseke's *Girl Reading* (c. 1900, pl. 34) and Edmund Tarbell's *Girl Cutting Patterns* (1907–08, pl. 30). The porcelain doll in *Mrs. Chase and Child*, the Japanese-inspired robe and kimono worn by Mrs. Chase and her daughter in *Mother and Child*, and *The Japanese Book*, respectively, the elegant scroll that forms the background of *Girl Reading*, and the panoply of Japanese art objects in *Girl Cutting Patterns*—the kimono, screen, and elegant vase—all would have signified refinement and elegance to a Victorian audience.

Not confined to representing Japanese artifacts in their work, American artists, like their French contemporaries, incorporated Japanese print design into their compositions.

fig. 27. *The Six-Mark Tea-Pot.*
Aesthetic Bridegroom. "It is quite consummate, is it not?"
Intense Bride. "It is, indeed! Oh, Algernon, let us live up to it!" *Punch* magazine, 1880.

fig. 28. Toyokuni III (Kunisada Utagawa).
Courtesans Entertaining. Mid-nineteenth century.
Woodblock on mulberry paper, 14¼ x 9⅝ in.,
14 1/4 x 9⅝ in., 14¼ x 10⅞ in. (36.2 x 24.1 cm,
36.2 x 24.1 cm, 36.2 x 27.8 cm). The Museum of
Fine Arts, Houston; Gift of Peter C. Knudtzon.

Painters imitated elements of the off-center compositions, high horizon lines, sharp recessions into and rectilinear divisions of space, and a flat, patterned surface effect that characterized the Japanese print design of such popular *ukiyo-e* artists as Ando Hiroshige, Katsushika Hokusai, and Kunisada Utagawa (fig. 28). In Frieseke's *Girl Reading*, the sharp, rectilinear recessions into space are balanced by the serpentine patterns of her skirt. Tarbell's *Girl Cutting Patterns* suggests the artist's own efforts to create a patterned composition by using the asymmetrically arranged flat tapestry to contrast with the even, rectilinear divisions of the background screen.

Landscape, too, could incorporate the principles of Japanese form. Chase's *Seashore*, for example, suggests the asymmetrical compositions and elegant surfaces of Japanese prints (c. 1886–89, pl. 24). In a work by J. Alden Weir (1852–1919), *Ravine Near Branchville*, shallow space and a high horizon line hint at Japanese design, and even the limited palette dominated by greens and blues suggests Weir's interests in Japanese coloration (c. 1905–15, pl. 35).[46] In his diaries, Theodore Robinson attested to Weir's fascination with Japanese art:

> It is very pleasant to sit with Weir at a table and look over proofs, etchings, or Japonaiseries together.... I imagine the best men have been influenced for the better by Japanese art, not only in arrangements, but in their extraordinary delicacy of tone and color.[47]

In general, American and French artists believed the "delicacy" they found in Japanese art (and Asian art in general) reflected a pure and untroubled artistic spirit. In this regard, Japanism was an outgrowth of Aestheticism, the notion that art should be appreciated on its own terms, that it existed in a pure and sacred realm untouched by the "outside world." This might help explain why the otherworldly paintings of Thomas Wilmer Dewing (1851–1938), such as *The Singer* (pl. 33), have been perceived to reflect an Oriental sensibility. "Dewing has loved finesse and elegance with intense devotion," one critic wrote. "His spirit is, perhaps, most in sympathy with the Oriental creators whose works

always possess the rare quality of refinement."[48] Dewing's greatest patron, the Detroit industrialist Charles Lang Freer, saw in his art the same qualities he found in the Asian objects he collected so assiduously, and Dewing may have been exposed, in fact, to a wider spectrum of Asian objects than his contemporaries, precisely through his association with Freer. The delicate tonal schemes in Dewing's *The Singer*, for instance, may have a corollary in the glazes of Asian ceramics or the techniques of China's Sung Dynasty brush and ink paintings.[49]

The "Monet Gang"

In 1890, J. Carroll Beckwith recorded in his diaries the increasing friction among the exhibition jury of the Society of American Artists in New York. Of particular concern was "a crowd of new radicals . . . the Monet gang back from Europe [who] want anything pale lilac and yellow."[50] Beckwith's disparaging remarks were undoubtedly directed to a group of American artists finding artistic inspiration in Giverny, a farming village located about thirty miles outside of Paris on the Seine, where the foremost Impressionist Claude Monet had been a resident since 1883. During the summer months of the mid-to-late 1880s, Willard Metcalf, Theodore Robinson, Theodore Wendel, John Leslie Breck, John H. Twachtman, and Lilla Cabot Perry, among others, traveled to Giverny where they sought instruction from Monet. During these years, a lively colony of American artists interested in Impressionist aesthetics was formed around the Hôtel Baudy. As the individual artists either returned to their studies in Paris, or returned home to America, their experiences in Giverny concentrated Impressionist tendencies already present in their art, and they themselves acted as conduits of Impressionism to other artists.

Perhaps the earliest to visit Giverny, Metcalf (1858–1925) spent his summers there after training at the Académie Julian in Paris. Just several years after the first major exhibitions of French Impressionist painting had been mounted in the States, Metcalf exhibited his work in 1889 at St. Botolph's Club in Boston, a display that included the earliest examples exhibited in the United States of an American artist's direct response to a French Impressionist. Included in this Boston exhibition, *Sunlight and Shadow* numbers among the small experimental sketches on wood panel Metcalf executed in Giverny and brought back to the States to develop (1888, pl. 36).[51] The tight control of *Sunlight and Shadow*, an early experiment in the dramatic contrasts of light and dark, would give way in Metcalf's later work. Reportedly dismayed by the startling work of the Cubists at the Armory Show of 1913, Metcalf fled to Italy where he spent several weeks working alone at Pelago, near Florence. "I am having a wonderful treat," he wrote to his friend J. Alden Weir, "my first visit to Italy and the wealth of fine things quite paralyzes me."[52] During this sojourn, Metcalf painted the bright light and steep village road of the Italian countryside in *Old Mill, Pelago, Italy* (1913, pl. 37).

Trained at the Ecole des Beaux-Arts, at the ateliers of both Carolus-Duran and Gérôme, Theodore Robinson (1852–1896) traveled to and eventually settled in Giverny. Between 1887 and 1892 his work increasingly showed the mark of Monet's advice and encouragement. While *Italian Landscape with a Fountain* (c. 1891, pl. 38) indicates something of his academic background with its strong draftsmanship and strong linearity, his sketch of the *Bridge at Giverny* (1891, pl. 39) and *View of the Seine* (c. 1892, pl. 40) show the unmistakable imprint of Monet's flickering brushwork, expansive landscapes, and atmospheric effects. During his final summer abroad, when he painted *View of the Seine*,

fig. 29. Claude Monet. *Village of La Roche-Blond.* 1889. Oil on canvas, 29⅝ x 36¹¹/₁₆ in. (74.9 x 93.3 cm). Lent to the Museum of Fine Arts, Houston by the R.H. and Esther F. Goodrich Foundation.

Robinson undertook a related series of panoramas of the Seine Valley at various times of the day. He was clearly inspired by Monet's serial landscapes, in which motifs were depicted from different vantage points at different times of the day and year (fig. 29). Robinson recorded three of his Seine Valley scenes in his diary; one was to be a gray landscape, one filled with sunlight, and the third a combination of clouds and light. His diary entries indicate that he patterned his series on Monet's, and like Monet, was cautious about "not work[ing] beyond the hour chosen for the effect."[53]

Compared to the muted tones and limited tonal range of Robinson's Seine Valley scenes, Lilla Cabot Perry's (1848–1933) *The Old Farm, Giverny* (1900, pl. 41) shares with Monet's art its bold coloration and sparkling sunlight effects. Related by marriage to the artist John La Farge, Perry studied in Paris at the Académie Julian. In 1889, she met Monet, who would have a profound effect on her work. For the next twenty years, Perry would travel to Giverny nine times to paint the Seine Valley and visit Monet, often residing next door to the Monet family. Perry recounted that Monet would "sometimes stroll in and smoke his after-luncheon cigarette in our garden before beginning on his afternoon work."[54] Her memoir of Monet, published after his death in 1927, remains the most comprehensive personal account of the artist by an American.

Of all the Americans who derived inspiration from Monet at Giverny, John Henry Twachtman (1853–1902) may come nearest to emulating both Monet's particular facture and his interest in serial imagery. Formerly a "Duveneck Boy," Twachtman pursued training at the Académie Julian, where he met a number of American artists who would later experiment with Impressionism. After several years abroad, training and traveling to Holland and through the French countryside, Twachtman returned to the States in 1885. Envisioning prospects of painting out-of-doors in New England rural retreats similar to Monet's in France, Twachtman assumed the life of a country farmer and artist, purchas-

ing property in Greenwich, Connecticut, around 1889, improving it, and painting its stunning physical features in various seasons for over a decade.[55]

In Greenwich, Twachtman's radical painting style developed. He preferred to paint his canvases out-of-doors, applying and mixing pigment directly on the canvas, and sometimes exposing it to blinding sun or torrential rain in order to effect a dry appearance.[56] Twachtman found solace and beauty in the New England winter landscape, a theme that dominated his painting from 1889 to 1901. Twachtman's *Winter* reveals a specific site near the Holley House in Cos Cob, Connecticut, that he painted repeatedly and with limitless nuance (c. 1898, pl. 42). Twachtman—the "Shelley of our painting; incommunicable, elusive, seeing ever the soul of landscape"—more than any other American Impressionist instilled his landscapes with the emotionalism and spirituality long associated with Inness.[57] This quality of quietism and mood equally applied to Lowell Birge Harrison (1854–1929) who, like Twachtman, preferred to paint winter landscapes and to experiment with the expressive qualities of white as a color. In *A Puff of Steam*, Harrison explores the different possibilities of suggesting the reflective surfaces of the river, the snow-topped roofs, and the billowing puffs of steam, using only various tones of blue and white, with accents of pale pink (before 1914, pl. 43).

J. Alden Weir's (1852–1919) strong academic background in art made him slow to adopt Impressionist style. He first reacted to French Impressionism, which he knew from his four-year stay in Paris, with utter disbelief, calling the 1877 Impressionist exhibition a "Chamber of Horrors."[58] Like Twachtman, Weir's Impressionism developed once he returned to the States and spent his summers secluded in the countryside of his rural retreat in Branchville, Connecticut. As seen in *Ravine Near Branchville*, Weir preferred the delicate color schemes and high horizon lines he appreciated in Japanese art (c. 1905–15, pl. 35). Another late work in Weir's career, *The Letter*, demonstrates his strong draftsmanship as well as his interest in depicting women in quiet, peaceful moments (c. 1910–19, pl. 50).

Ironically, Frederick Childe Hassam (1859–1935), the one artist most often compared to Monet and described as the "greatest exponent of American Impressionism," appears never to have visited Giverny, nor to have met Monet.[59] Further, he found the term "impressionism" to be "abused" and "perverted," interpreting it broadly to mean "going straight to nature for inspiration, and not allowing tradition to dictate your brush, or to put brown, green, or some other colored spectacles between you and nature as it really exists."[60] And yet, of all the American Impressionists, Hassam's vision most closely parallels French Impressionist modes in style and subject matter.

Having received early artistic training in his native Boston, Hassam left for Paris in 1886 for three years of study at the Académie Julian. In Paris in the late 1880s, Hassam's paintings first reveal his interest in the work of the Impressionists, with its broken brushwork, sparkling light effects, and subjects taken from daily life—flower stalls and fashionably dressed men and women on the streets of Paris. When Hassam returned to the States, he relocated to New York City, which he painted repeatedly in the 1890s, finding its streets and buildings even more beautiful and interesting than the boulevards of Paris. "The very thing that makes New York irregular and topsy turvy," he wrote, ". . . makes it capable of the most astounding effects."[61]

Evening in New York (1890s, pl. 45) and *Dewey Arch* (1900, pl. 44) reveal the different aspects of the city that fascinated Hassam. *Evening in New York* shows the sparkling

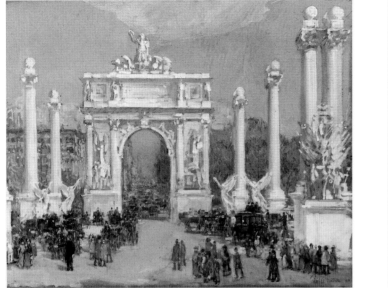

fig. 30. (left) Childe Hassam. *Dewey Arch.* 1900 (see pl. 44).

fig. 31. (left) *Dewey Arch.* 1899. Photograph by Pach Brothers. Collection of The New-York Historical Society.

effects of nocturnal New York in the rain, an ordinary slice of city life made dazzling and mysterious by Hassam's deft strokes of pink and white to suggest the glow of street lamps. In *Dewey Arch*, however, Hassam focuses on a prominent city landmark aligned with Washington Arch along Fifth Avenue, which created a triumphal thoroughfare similar to those in London and Paris (fig. 30). *Dewey Arch* celebrates New York's most recent architectural and sculptural achievement, a monument constructed in 1899 to celebrate the 1898 victory of Admiral George Dewey in the Spanish-American War, including sculptures by Daniel Chester French, Karl Bitter, and John Quincy Adams Ward, among others. Here, Hassam's picture displays patriotic pride, a theme that he would resurrect in his post-1916 flag series after the United States entered World War I. In an effort to convey the optimistic spirit, bustling energy, and patriotic sentiment of New York at the turn of the century, as well as the grand triumphal arch, Hassam has obscured one of the most prominent landmarks in the city, visible in the contemporaneous photograph: the Siegel-Cooper department store billboard featuring the slogan, "Meet Me at the Fountain" (fig. 31). Hassam may have thought that "New York is the most beautiful city in the world" and that "there is no boulevard in all Paris that compares to our own Fifth Avenue," but he nevertheless edited it to suit the artistic enterprise.[62]

Hassam, like his colleagues and close friends Weir and Twachtman, sought subject matter in rural retreats and summer resorts, particularly in Gloucester, Massachusetts, north of Boston, and on Appledore Island, one of the Isles of Shoals off the coast of New Hampshire. *At Gloucester* is a watercolor from one of his early visits to this commercial port, whose townsfolk and summer residents, and harbor and town views supplied Hassam with ample, colorful imagery from which to choose (1890, pl. 46). Appledore, however, inspired Hassam to create among his most stunning and powerful pictures, imaging both the island's lush gardens as well as its severe, rocky terrain. Hassam visited Appledore repeatedly between the mid-1880s and 1916; during the summers the home of his friend and student Celia Laighton Thaxter served as an artistic and intellectual retreat for musicians, writers, and artists. In *Hollyhocks, Isles of Shoals* (1902, pl. 47), Hassam pictures

Thaxter's glorious garden of larkspurs, hollyhocks, and poppies. Hassam integrates the horizontal bands of foreground garden and distant sea, executed in a loose, sketchy manner, with towering, vertical hollyhocks whose colorful blossoms are suggested through blotches and scribbles of pastel. In her book *An Island Garden* (1894), illustrated by Hassam and published the year of her death, Thaxter described this garden paradise in terms suggestive of *Hollyhocks*: "Open doors and windows lead out on the vine-wreathed veranda, with the garden beyond steeped in sunshine, a sea of exquisite color swaying in the light."[63]

Hassam continued to visit Appledore after Thaxter's death, finding it "filled with ghosts" but nonetheless ripe for suitable subjects to paint.[64] Even away from Appledore, he may have been haunted by memories of Thaxter's garden rooms, with their arrangements of bud vases sprinkled throughout to dramatic effect. *The Sonata* (1911, pl. 49), although not painted at Appledore, suggests Thaxter's interiors there.[65] Like Dewing's *The Singer* (pl. 33), it affirms Aesthetic Movement ideals, which saw parallels between art and music. Likeminded painters often showed women in relaxed, contemplative poses as the vehicle for conveying this spiritual harmony. In this regard, Dewing and Hassam participated in a symbolist continuum beginning with Whistler and extending through the French Nabi artists, all of whom pictured women in decorative, often musical, environments as a means of conveying moods and emotions.

The viability of the Impressionist aesthetic for American artists continued well into the twentieth century, long after French artists began to experiment with newer developments such as Fauvism and Cubism. After training in Paris at the Académie Julian, Frederick Frieseke (1874–1939) began visiting Giverny, eventually moving next door to Monet in the home formerly occupied by Theodore Robinson in 1906. Yet he seems never to have established a relationship with Monet, preferring instead the work of Pierre-Auguste Renoir whose sensuous paint surfaces he admired and soon emulated. His earlier works, such as *Girl Reading* (c. 1900, pl. 34), mark his interest in Japanese print design and the limited tonal palette of his teacher Whistler, with whom he studied in 1898. Shortly after locating to Giverny, however, Frieseke's palette took on the high-key color associated with his long career in France. In *Lady with a Parasol* (c. 1908, cover illustration and pl. 56), Frieseke creates a patterned effect in the reflective surface of the water using a palette dominated by various tones of greens and blues, and playing off the curves of the parasol, boat, and figure's pose with the vertical foreground reeds.

Frieseke, "par-excellence a mural decorator," was attracted to figured surfaces: the sumptuously patterned wall decorations of his home in Giverny, which often find themselves repeated in works such as *Lady in Rose* (c. 1910–15, pl. 51, fig. 32), echo the densely patterned works of the Nabi painters Pierre Bonnard (1867–1947) and Edouard Vuillard (1868–1940, fig. 33), or the portraits of the Austrian Gustav Klimt (1862–1918).[66] Frieseke's colleague Richard Emil Miller (1875–1943), who like Frieseke studied at the Académie Julian and painted in Giverny, shared his taste for decorative images of women in ornamental boudoir settings (c. 1906, pl. 53).

Over several decades, Frieseke concentrated on intimate images of women either indoors or in the lush gardens his wife created. Both *Sunbath* (c. 1910, pl. 54) and *Sewing in the Garden* (c. 1915, pl. 52) depict women bathed in brilliant sunlight and surrounded by richly colored foliage, illustrating Frieseke's claim that "it is sunshine, flowers in sun-

fig. 32. Frederick Frieseke. *Lady in Rose.*
c. 1910–15 (see pl. 51).

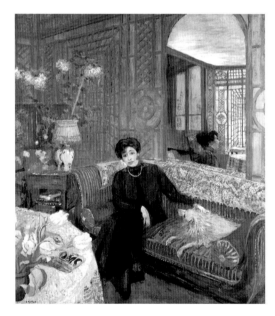

fig. 33. Edouard Vuillard. *Madame Tristan
Bernard.* 1914. Oil on canvas, 71 x 61¹/₂ (180.3
x 156.2 cm). Private collection, San Antonio.

shine, girls in sunshine, the nude in sunshine, which I have principally been interested in. . . ."[67]

Many of the artists who visited Giverny acted as a conduit of Impressionist ideas to other American painters once they returned to the States. Frederic Remington (1861–1909), for example, who traveled to Europe only once and did not know the Impressionists, learned a great deal about Impressionist style through his friendship with Metcalf, and from Weir, who had been his instructor at the National Academy of Design in 1886. His *Fight for the Waterhole*, an icon in the art of the American West, demonstrates that Remington, too, responded to the lighter palette and looser handling of his colleagues, applying it to the quintessentially "American" subject matter he set out to paint for his entire career (1903, pl. 59). In conversation, Remington repeatedly downplayed the influence of French Impressionism on his work, noting that he had "two aunts . . . that can knit better pictures than those [French Impressionist paintings]."[68] But Remington's bravado sounds more like overcultivated patriotism; he admired and loudly praised the Impressionist landscapes painted by *American* artists such as Weir and Hassam.

Still another, Edward Henry Potthast (1857–1927), received training in Munich as well as Paris, but did not embrace an Impressionist aesthetic until after he returned to the States around 1896. Potthast's *Boating in Central Park* (c. 1900–05, pl. 60) and *Ring Around the Rosie* (c. 1910–15, pl. 61) suggest the artist's sensitivity to vividly colored paint, layered to an almost sculptural effect, and his interest in the gaiety of holiday subject matter. *Ring Around the Rosie*, a characteristic theme of Potthast's, conveys a nostalgic mood not unlike that in Homer's scenes of young children in rural settings. Henry Ossawa Tanner (1859–1937), an African-American student of Thomas Eakins (1844–1916) in Philadelphia, dallied with Impressionism along with other French styles while

attending the Académie Julian from 1891 to 1893, and during the summers in Concarneau and Pont-Aven where his friend Paul Sérusier (1864–1927) investigated Symbolist tenets of design—advocating bold color and flat, decorative surfaces. After his Paris 1897 Salon success with *The Resurrection of Lazarus*, which was purchased by the French government for the collection of the Musée du Luxembourg, Tanner devoted himself to religious painting for the rest of his career.[69] A painting of Tanner's late career, *The Flight into Egypt* (1921, pl. 58), suggests the direction Impressionist modes might take in the first decades of the twentieth century. By then, Tanner's surfaces take on a brooding, luminescent quality achieved through layers of thin, saturated glazes.

At the turn of the century, artists' colonies loosely based on the American Impressionists' in Giverny appeared in Old Lyme, Connecticut (where Hassam painted from 1903); New Hope, Pennsylvania; Nashville, Indiana; the Ozark Mountains in Missouri; and in San Francisco.[70] Edward Willis Redfield (1869–1965), along with Daniel Garber (1880–1958), Robert Spencer (1879–1931), and Walter Elmer Schofield (1867–1944), represent the strongest talents of the New Hope School, founded in 1898. Trained at the Pennsylvania Academy of Fine Arts, the Académie Julian, and the Ecole des Beaux-Arts, Redfield was recognized for his "fresh, alive and truthful" color, "laid on with a crisp, trenchant touch that bespeaks a robust, manly vigor."[71] Painted at his summer home in Boothbay Harbor, Maine (fig. 34), *October Breeze* demonstrates Redfield's bold hand in suggesting the clear light and blue sea sharply contrasted with the fiery foliage of Maine in autumn (c. 1928, pl. 48). While Redfield associated himself with the Impressionists, friendships with Robert Henri and other members of the so-called Ashcan School and the "masculine" quality of his brushwork suggest a closer association with the American Realists. Redfield indeed appears to have revitalized American Impressionism with something of the Realists' preference for a vigorous surface. His critics often admired the athletic quality of Redfield's handling, as if he almost sculpted his surfaces. As one critic wrote, "Redfield's brush effects also include amazing feats in the exact placing of fat gobs of color lifted into paint peaks by pulling the brush away."[72]

fig. 34. Edward Redfield painting out-of-doors, Boothbay Harbor, Maine. 1928. Collection of Edward Redfield Richardson.

During the winter of 1897–98, a group known as The Ten seceded from the Society of American Artists (fig. 35). The Society, originally formed by Chase and Weir, among others, in protest against the conservative tendencies of the National Academy of Design, had now itself become the enemy of advanced art. "With its large leaven of business and society painters, art in the best sense is getting to be a more and more vanishing quantity, and the shop element is coming more and more into the foreground. As the organization has been managed for the last two years it might . . . be called the Society of Mediocrity," wrote the *Commercial Advertiser*.[73] Ten artists, loosely connected by their interest in Impressionism and their desire to mount their own work in collective exhibitions, decided that the clique warfare within the Society was no longer tenable and that its large yearly exhibitions were like "a child's bouquet—all higgledy-piggledy with all the flowers that can be picked."[74] In consequence, Weir, Twachtman, Hassam, Metcalf, Dewing, Joseph DeCamp, Edmund Tarbell, Frank Benson, Robert Reid, and Edward E. Simmons formed The Ten, exhibiting their work together from 1898 to 1917. After the death of Twachtman in 1902, Chase, who had served as President of the Society of American Artists for over ten years, joined in their exhibitions.

Critics recognized that several of the group, including Tarbell, Reid, and DeCamp, rarely painted landscapes, preferring instead to paint women, usually fashionably dressed and posed languorously in elegant, quiet interiors or sun-drenched landscapes. The muralist and figural painter Robert Reid (1862–1929), for example, familiarized himself with Impressionist aesthetics during his four-year stay in Paris but, after his return, favored monumental images of women in ornamental settings, such as *Woman on a Porch with Flowers* (c. 1906, pl. 55). Dandified, flamboyant, and affecting "boulevardier mannerisms"

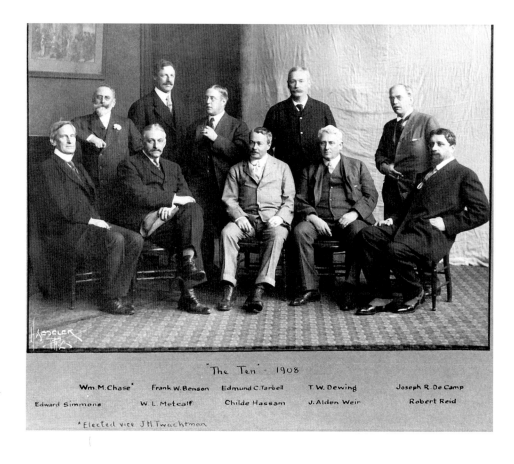

fig. 35. *The Ten in 1908.* (Seated, left to right) Edward Simmons, Willard L. Metcalf, Childe Hassam, J. Alden Weir, and Robert Reid; (standing, left to right) William Merritt Chase, Frank W. Benson, Edmund C. Tarbell, Thomas Wilmer Dewing, and Joseph R. DeCamp. MacBeth Gallery records. Archives of American Art, Smithsonian Institution.

Emily Ballew Neff

(the artist Louise Cox called him "a small edition of Chase"), Reid pursued a successful career as a muralist, stained-glass designer, and easel artist.[75] His interests earned him the name "Decorative Impressionist," a phrase that suggests his interest in patterned design and in conveying atmospheric effects in his paintings.[76]

Reid received his earlier training in Boston with both Tarbell and Benson. After their Paris sojourn, Reid settled in New York while Tarbell, Benson, DeCamp and others returned to Boston, where Tarbell (1862–1938) was soon to lead the "Boston Impressionists" or "Tarbellites," a term coined by Sadakichi Hartmann, an art historian and critic of the day.[77] Tarbell's early work usually depicts women in brilliant, outdoor settings similar to those of his Impressionist contemporaries, but after around 1904, Tarbell's paintings increasingly show the influence of Jan Vermeer (1632–1675) and other Dutch Old Masters, to the extent that a critic of the period recognized and dubbed his style "Vermeerian Impressionism."[78] Tarbell's *Girl Cutting Patterns* (1907–08, pl. 30) represents the painter's specialty at this period: intimate scenes of well-dressed women in refined surroundings, strongly modeled and softly lit. Despite the overt nod to the aesthetics of Japanism in *Girl Cutting Patterns*, Tarbell's affinity to Vermeer shows in the calm, quiet setting in which a strongly modeled female figure appears absorbed in her own world.

The maids and prostitutes that frequent the world of Vermeer's art were considered by Tarbell's generation to be healthy, virtuous housewives. As one scholar has suggested, Tarbell and his colleagues were attracted to Vermeer because they saw in his women the image of New England ideals.[79] Thus, a critic remarked of a Tarbell painting that "the young girls are as characteristically American as Pieter de Hooch's housemother is Dutch."[80] Given the cultural anxiety over women's increasing independence culminating in the suffragette movement, Tarbell's pictures of quiet, demure women asserted more traditional roles of womanhood.

Joseph DeCamp (1858–1923), formerly a "Duveneck Boy" in Munich and then a "Tarbellite" after his Paris training and return to Boston, also preferred subject pictures of strongly modeled women painted with gentle, precise brushstrokes rather than the bravura manner of his colleagues in New York. *September Afternoon* (1894, pl. 57) is one of DeCamp's relatively rare landscape paintings—made even more rare when many of DeCamp's paintings burned in a studio fire. Even in his landscapes, DeCamp retains some of the tight control and strong draftsmanship of his interiors, choosing here to experiment with bold color applied with short, crisp strokes.

THE "VIRILITY" PAINTERS

In his account of the founding of The Ten, Simmons noted that "We were accused of starting [The Ten] as an advertisement, and, indeed, it proved a big one, but there was no such idea in the mind of any one of us. Many others took it up, and a group followed us, calling themselves 'The Eight' in an attempt to boil the egg over again."[81] In 1908, The Eight "boiled the egg over again" by exhibiting their paintings together in an independent exhibition at MacBeth Gallery in New York. Like The Ten, The Eight attracted the attention of the media, who quickly turned the event into a controversial affair (fig. 36). By refusing to exhibit their work in the time-honored tradition of the large, public exhibitions at the National Academy of Design or the Society of Artists, both The Ten and The Eight announced their "modernity" and radical edge. By keeping the group of artists small and stylistically similar, both The Ten and The Eight could make dramatic

pronouncements about their work than they could if their paintings were evenly dispersed throughout the grand display rooms of the yearly exhibitions.

The group included Robert Henri (1865–1929), Arthur B. Davies (1862–1928), William Glackens (1870–1938), Ernest Lawson (1873–1939), George Luks (1867–1933), Maurice Prendergast (1859–1924), Everett Shinn (1873–1953), and John Sloan (1871–1951). Never exhibiting with The Eight, George Bellows (1882–1925), a student of Henri's, is often associated with the group, which has also been popularly called the "Ashcan School." The "Ashcan School" was a term coined in the 1930s and has no basis in contemporary parlance, although it does suggest the preferred subject matter of the group, discovered in the grittier, seamier side of cities, particularly New York, at the turn of the century.[82] They portrayed the "city in undress," as one critic wrote.[83]

By 1908, when The Eight first exhibited together, the work of their precursors among The Ten would have appeared to them tame, refined, genteel, and sadly lacking the vigorous painting style that suggested the modern pace of city life. As early as 1900, however, the Realists (many of whom would join The Eight) had already demonstrated their differences with the older generation, indicating their preference for the bold painting techniques of Manet as opposed to the refinements of Monet, a darker rather than high-keyed palette, and subjects that included "drunks, slatterns, pushcart peddlars and coal mines, bedrooms and barrooms," rather than elegantly appointed interiors in New York or the gentle countryside of Shinnecock, Long Island.[84] Critics quickly recognized the differences, finding the work of the Realists to be more truthful, hard-hitting, and significant. One critic wrote, "There is virility in what they have done, but virility without loss of tenderness; a manly strength that worships beauty, an art that is conceivably a true echo of the significant American life about them."[85] The media characterized the Realists as alert, youthful, and bold, their paintings "teem[ing] with the rapid fire suggestion of newspaper art work . . . they are visibly responding to the new and unhackneyed influences of a new period."[86] (All except Henri and Bellows, in fact, had backgrounds in news illustration.)

How different their work was from that of another artist represented by MacBeth Gallery, Frederick Frieseke. For almost two decades, Frieseke had been a popular and distinguished artist, having received several awards for his paintings as well as the French Legion of Honor. By the late teens and early 1920s, however, appreciation for Frieseke began to waver. William MacBeth complained that for the buying public, his works were "perhaps a bit 'Frenchy;'" a caustic reviewer at the 1925 Paris Salon complained that "there are some of his canvases . . . that look as though a good bath in hot water and a lavish appliance of soap would do no harm."[87] Frieseke, cut off from the grittier art of his colleagues as represented in the so-called Ashcan School, and openly disdainful of politics and current events, was singularly out of character with his younger contemporaries in New York, who believed that social change should be registered in their art. The garden paradise and elegant interiors that illuminate Frieseke's art affirmed a pleasant, leisured world that, for the Realists and their enthusiasts, appeared retrograde.

Yet the foundation of their training was not so very different from Frieseke's. A brilliant teacher and charismatic leader of the Realists, Robert Henri, like countless other American artists, received training at the Académie Julian before returning to Philadelphia, where he befriended William Glackens and Everett Shinn. During his third sojourn in Paris, between 1899 and 1900, Henri's work attracted the attention of the French gov-

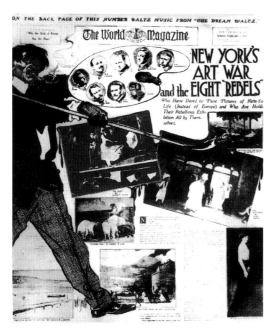

fig. 36. "New York's Art War . . ." *The World Magazine* (New York), February 2, 1908.

ernment, which purchased one of his paintings displayed at the Salon.[88] Both *Fête de Dieu–Concarneau* (1899, pl. 63) and *The Model* (1899, pl. 64) date from this two-year period in France, and reflect Henri's continued study and emulation of the manner of the seventeenth-century Realists Hals and Velázquez, as well as the work of Manet. Henri developed an affinity for what he called "grave colors, which were so dull on the palette that [they] become the living colors in the picture. . . . They are not fixed," he wrote, "they are indefinable and mysterious."[89] At Concarneau, near Pont-Aven in Brittany, Henri painted the village celebration, the *Fête de Dieu*, in somber hues, with splotches of blues, browns, whites, and blacks punctuated by reds and greens in the banners and umbrellas. Likewise, *The Model*, thought to be a representation of his bride, emerges from a black background, her outlines delineated in broad patches of beige and red.

Henri's friend Everett Shinn, an artist, illustrator, and scenic designer, traveled to Paris shortly after Henri and, true to his training as a newspaper illustrator in Philadelphia and New York, painted the ordinary streets and alleys of Paris with speed and economy of means. In *Paris, Horse and Carriage* (c. 1900–05, pl. 67) Shinn used a dark palette like Henri's. Working this time in pastel, Shinn deftly captures a fragment of an aged Parisian street, suggesting the bleak skyline behind the wall, but enlivening the foreground with red and green accents in the poster and door.

William Glackens, on the other hand, rejected his friend Henri's "Old Master" tonalities, and developed a style and coloration more closely modeled on the French Impressionist he so admired, Pierre-Auguste Renoir. After travel abroad in 1895–96, including visits to Henri who was on his second stay in Paris, Glackens returned to Philadelphia in 1896, finally relocating in New York City shortly thereafter. There he became a successful newspaper illustrator, joining Remington in the ranks of artist-correspondents sent to cover the Spanish-American War in Cuba. He advised his former schoolmate, the great collector Dr. Albert C. Barnes, to purchase the work of the French moderns—especially Renoir. In 1912, in fact, Glackens traveled to Paris with Alfred Maurer (1868–1932) to act as Barnes's agent and buyer. Renoir's style exerted a profound influence on the painter, as seen in such works as *The Captain's Pier* (c. 1913, pl. 68), with its high-keyed palette and feathery brushstrokes. From 1911 to 1914, Glackens and his family spent their summers in Bellport, Long Island, where he delighted in painting beachside revels, using colors that should, as he said, be "closely connected with life."[90] Critics such as Guy Pène du Bois found that the lively gestures and poses of the figures, reinforced by Glackens's feathery paint application, captured the "quickness of the rhythm of modern life . . . He is undoubtedly a portrayer of life's most pleasant occupations, of the picnic spirit."[91] Indeed, of all the Realists, or members of The Eight, Glackens preferred to illustrate the temporary escapes from urban life rather than urban life itself.

Like Glackens, Ernest Lawson developed a painting style more in keeping with the Impressionists than with the bold, rapid manner of Henri. After study with both Twachtman and Weir at the Art Students League, then a three-year stay in Paris—where he shared a studio with the English novelist Somerset Maugham and visited the French Impressionist Alfred Sisley in Moret-sur-Loing—Lawson devised his own Impressionist manner and applied it to urban subject matter, particularly the rapidly changing cityscape near the High Bridge over Harlem River. In this corner of Manhattan, clamorous boat and train traffic formed a striking contrast to the elegant arches of the classically designed

bridge. Among these scenes, a 1910 painting of *High Bridge, Harlem River* (c. 1910, pl. 66) exhibits Lawson's characteristically dense layers of highly colored pigments—a critic once remarked that the painter used a palette of "crushed jewels," and a sculptor friend asked if he could make a cast of one of his high-relief canvases.[92]

George Bellows enjoyed a brief but prolific career marked by sensational success. Although he never exhibited with The Eight, Bellows's bold style and preference for city subjects earned him subsequent recognition as a member of the Ashcan School. Despite his protestations against the conservative tendencies of the National Academy of Design and academic strictures on painting, Bellows was admired both by "independent" artists and by academicians and, in fact, was in 1909 the youngest man to be elected to the Academy. As one scholar has recently noted, Bellows appealed to both conservatives and progressives because, while he carried the trappings of artistic rebellion, the images he delivered were understood to be without a political agenda.[93] He might picture images that resonated with political overtones—illegal prize fighting, poverty-stricken neighborhoods, or delinquent children, for example—but he did so without presenting a particular political point of view. "No pitying socialistic note spoils his virile art," one critic wrote.[94]

An enthusiastic participant in the Armory Show of 1913, Bellows spent the following summer in Monhegan, Maine, where he was to experiment with the bold colors and design that he had seen in the works of Henri Matisse and André Derain. Among the finest of the works he produced in that summer were a coherent group of portraits of friends and residents in the area—numbering 15 of the approximately 140 portraits he executed during his career. Among them, the *Portrait of Florence Pierce* (1914, pl. 62) demonstrates the intensity of this group, with its striking color, dramatic lighting, and impasto surface. In contrast to the dazzling elegance of a likeness by Sargent, this work by Bellows rejects the notion that a portrait should be conventionally beautiful, "as if Shakespeare," he wrote, "had always gone around writing love sonnets."[95]

By May of 1920, when he painted *Gramercy Park* (pl. 65), among the few genre pictures of this late period in his career, Bellows was experimenting with the sharp colors and geometric compositions of Hardesty Maratta and Jay Hambidge, theorists who had had a profound impact on the artists surrounding Henri. Here, Bellows's daughter Anne is the central focus of a garden scene in which the brightly lit garden pathway mimics the orthogonal perspective lines that seem to rush back into space.

While Bellows late in his career was preoccupied with experiments in depth and perspective, Maurice Prendergast, an original member of The Eight, preferred the flat, patterned effect he admired in the Post-Impressionist paintings he knew from his years of study in Paris—works by Paul Gauguin (1848–1903) and his Nabi followers Bonnard and Vuillard. While Prendergast, with his merry subject matter and festive colors, is today considered among the most accessible and appealing of the members of The Eight, he was in his own day perceived to be the most radical member of the group. Critics reviewing the debut exhibition of The Eight found his work puzzling and odd, his surfaces like an "explosion in a color factory."[96] Others, not knowing how to categorize his work, and unable to place it in an art-historical tradition, conferred a "native" pedigree, judging the tapestry-like quality of his surfaces as analogous to "the patchwork quilts of our country ancestors."[97]

Though he attracted few patrons throughout his career, Prendergast came to the attention of Sarah Choate Sears, who had been advised by Cassatt to purchase his work (see pl. 18). Subsequently his greatest benefactor, Sears made possible Prendergast's third trip to Europe, during which he painted a series of watercolors in Venice that are among his most enduring creations. The luminous *Riva San Biagio, Venice* (1898, pl. 69) dates from this period in Venice when Prendergast, like Sargent, painted not only the major monuments of the city but also its unknown streets and alleys. Selecting a high vantage point from which to survey the colorful crowds of pedestrians, Prendergast delights in the patterned effects the flattened surface creates: the diagonal stretch of pavement balanced by the colorful waters, and the street lamp protruding from an unseen building at right. Like Homer and Sargent before him, Prendergast worked with equal fluency in watercolor and in oil. Moving from Boston to New York in 1914, Prendergast frequently returned to New England towns such as Marblehead and New Bedford for summer holidays, and there he painted the outdoor activities of its residents. In both *New England Village* (Marblehead, 1918–23, pl. 70) and *New England Village (New Bedford Village)* (1918–23, pl. 71), a sense of spontaneity and transience collide with the quality of monumentality that Prendergast exploits by composing his figures as in an ancient frieze.

At the time Prendergast created his late tapestry-like paintings, other American artists such as John Marin (1870–1953) and Marsden Hartley (1877–1943) experimented with newer forms of European modernism, particularly the work of the Cubists Pablo Picasso and Georges Braque. Still others, such as the photographer and dealer Alfred Stieglitz (1864–1946), promoted the rhythmic abstractions of Georgia O'Keeffe (1887–1986) as well as works by other American artists seeking to understand and participate in newer modes of European modernism. Not until the Depression years of the late 1920s and 1930s did American artists, in general, cast aside their allegiance to European trends, preferring instead to explore the regional flavor of much American life in images that betray their interest in defining national identity. By then, the bright lights of American Impressionism had dimmed, giving way to artistic modes that articulated the social and political anxieties of the early to mid-twentieth century. Relatively speaking, however, Impressionism flourished in America for a long time. Here, the movement energized American art until nearly fifty years after the French Impressionists disbanded as a group, making it among the most viable modes of artmaking since the Hudson River School artists defined the American landscape.

NOTES

1. *Indianapolis Star* (January 14, 1899), quoted in John Wilmerding, *American Art* (New York: Penguin Books, 1976), 144.

2. *New York Tribune* (March 12, 1898), quoted in Gordon Hendricks, *The Life and Work of Winslow Homer* (New York: Harry N. Abrams, Inc., 1979), 235–36. *New York Times* (February 1, 1879), quoted in Helen A. Cooper, *Winslow Homer Watercolors* (London and New Haven: Yale University Press, 1986), 62, 64 n. 26.

3. Moussa M. Domit, *American Impressionist Painting*, exh. cat. (Washington, D.C.: National Gallery of Art, 1973), 12. See Henry Adams, "Winslow Homer's 'Impressionism' and Its Relationship to His Trip to France," *Studies in the History of Art* 26, ed. Nicolai Cikovsky, Jr. (Washington, D.C.: Center for Advanced Study in the Visual Arts, National Gallery of Art, 1990), 61–89.

4. Adams, "Winslow Homer's Impressionism," 63, and 84–85 n. 13.

5. The Mavis P. and Mary Wilson Kelsey Collection of Winslow Homer Graphics at the Museum of Fine Arts, Houston includes over three hundred examples of his work in popular print.

6. Nicolai Cikovsky, Jr., "Winslow Homer's *School Time*: 'A Picture Thoroughly National,'" *Essays in Honor of Paul Mellon, Collector and Benefactor*, ed. John Wilmerding (Washington, D.C.: National Gallery of Art, 1986):47–69, specifically, 63–67.

7. Cikovsky, "Winslow Homer's *School Time*," 63–67.

8. Cooper, *Winslow Homer Watercolors*, 32 and 55–60.

9. *Galaxy* (July 1875):90, 93–94, quoted in Hendricks, *The Life and Work of Winslow Homer*, 115–17.

10. Homer was not the only artist, however, to find inspiration in the villages of England. Just four years later, John Singer Sargent (1856–1925) and some of his contemporaries isolated themselves near Broadway in the Cotswolds of England. Here Sargent boldly experimented with plein-air painting in the Impressionist mode.

11. *Boston Evening Transcript* (December 6, 1883), quoted in Cooper, *Winslow Homer Watercolors*, 119, 123 n. 53.

12. Cooper compares Homer's watercolors of the women of Cullercoats to Jules Breton's *The Gleaners*, 93–94.

13. Cooper, *Winslow Homer Watercolors*, 162.

14. *New York Tribune* (March 12, 1898), quoted in Hendricks, *The Life and Work of Winslow Homer*, 124. Regarding Homer, one critic said, "He seems to be seldom or never bothered with the consideration of side issues but hits straight at the mark and leaves the unimportant in a picture to take care of itself. This is being an impressionist in the true and broad sense. . . . the one [Homer] has become so [an Impressionist] through independent search," (*New York Times* [February 1879], quoted in Hendricks, 139).

15. For an overview of Barbizon painting, see Robert L. Herbert, *Barbizon Revisited*, exh. cat. (Boston: The Museum of Fine Arts, Boston, 1962). For a history of Barbizon painting and its relationship to American art, see Peter Bermingham, *American Art in the Barbizon Mood*, exh. cat. (Washington, D.C.: National Collection of Fine Arts, Smithsonian Press, 1975).

16. "A Painter on Painting," reprinted from *Harper's New Monthly Magazine* 56 (February 1878):458–61 in Nicolai Cikovsky, Jr. and Michael Quick, *George Inness*, exh. cat. (Los Angeles: Los Angeles County Museum of Art, 1985), 209.

17. Ibid., 205.

18. Achille Segard, *Un peintre des enfants et des mères—Mary Cassatt* (Paris: Librairie Ollendorf, 1913), 8.

19. See, for example, Susan Fillin Yeh, "Mary Cassatt's Images of Women," *Art Journal* 35 (Summer 1976):359–63, Griselda Pollock, *Vision and Difference: Femininity, Feminism, and Histories of Art* (London and New York: Routledge, 1988), and Nancy Mowll Mathews, "Mary Cassatt and the 'Modern Madonna' of the Nineteenth Century" (Ph.D. diss., New York University, 1980). For the issue of the gaze and its relationship to urban detachment, see also Herbert, *Impressionism: Art, Leisure, and Parisian Society*, and Timothy J. Clark, *The Painting of Modern Life, Paris in the Art of Manet and his Followers* (New York: Knopf, 1985).

20. See Alice Cooney Frelinghuysen, Gary Tinterow et al., *Splendid Legacy: The Havemeyer Collection*, exh. cat. (New York: The Metropolitan Museum of Art, 1993), 203, which reassigns the date of the Degas purchase to 1877 rather than 1875 as other scholars have suggested.

21. Frederick A. Sweet, *Miss Mary Cassatt, Impressionist from Philadelphia* (Norman: University of Oklahoma Press, 1966), 150–51.

22. Ibid., 82–83, 151.

23. Christian Brinton, *Modern Artists* (New York, 1908), 155–56, quoted in Gary A. Reynolds, "Sargent's Late Portraits" in Hills et al., *John Singer Sargent*, 147.

24. John S. Sargent to James Abbott McNeill Whistler, n.d., Glasgow University Library, Glasgow, quoted in Stanley Olson, "On the Question of Sargent's Nationality," in Patricia Hills et al., *John Singer Sargent*, exh. cat. (New York: Whitney Museum of American Art in association with Harry N. Abrams, Inc. Publishers, 1987), 24, 25 n. 24.

25. On the subject of American artists' interest in the seventeenth-century Dutch master, Frans Hals, see D. Dodge Thompson, "Frans Hals and American Art," *The Magazine Antiques* 136 (November 1989):1170–83.

26. Evan Charteris, *John Sargent* (New York: Charles Scribner's Sons, 1927), 160.

27. See Sweet, *Miss Mary Cassatt*, 180–81, for a brief description of the seances Sears organized in Paris. For further information on Sears, see also Trevor J. Fairbrother, *The Bostonians, Painters of an Elegant Age, 1870–1930*, exh. cat. (Boston: Museum of Fine Arts, Boston, 1986), 225; Weston J. Naef, *The Collection of Alfred Stieglitz* (New York: The Metropolitan Museum of Art/The Viking Press, 1978), 428–29; Frelinghuysen, Tinterow et al., *Splendid Legacy*; Estelle Jussim, *Slave to Beauty: The Eccentric Life and Controversial Career of F. Holland Day* (Boston, David R. Godine, 1981), 140–43; Erica Hirshler, "The Great Collectors: Isabella Stewart Gardner and her Sisters" in Alicia Faxon and Sylvia Moore, eds., *Pilgrims and Pioneers: New England Women in the Arts* (New York: Midmarch Arts Press, 1987), 25–31; Stephanie Mary Buck, "Sarah Choate Sears: Artist, Photographer, and Art Patron," (MFA thesis, Syracuse University, 1985).

28. Sweet, *Miss Mary Cassatt*, 196.

29. Brinton, 160. Quoted in Reynolds, Hills et al., *John Singer Sargent*, 173–74.

30. In a letter to the author dated 10 September 1994, Margaretta M. Lovell suggested that the facade in *View of Venice* may represent the fourteenth-century church of S. Maria del Carmelo on the Campo dei Carmini.

31. Mary Newbold Patterson Hale, "The Sargent I Knew," *World Today* 50 (November 1927); reprinted in Carter Ratcliff, *John Singer Sargent* (New York, 1982), 237, quoted in Hills et al., *John Singer Sargent*, 195. Hale, Sargent's second cousin, wrote, "Other travellers wrote their diaries; he painted his. . . ."

32. Cecilia Beaux, *Background with Figures* (Boston and New York: Houghton Mifflin, 1930), 122, quoted in Weinberg, *The Lure of Paris*, 224.

33. For the impact of the Academy in Düsseldorf on American art, see William H. Gerdts and Mark Thistlethwaite, *Grand Illusions: History Painting in America*, Ann Burnett Tandy Lectures in American Civilization, no. 8 (Fort Worth: Amon Carter Museum, 1986), 125–68.

34. Rose V.S. Berry, "Joseph DeCamp: Painter and Man," *The American Magazine of Art* 14, no. 4 (April 1923):182.

35. See Nicolai Cikovsky, Jr., "William Merritt Chase's Tenth Street Studio," *Archives of American Art Journal* 16, no. 2 (1976):2–14.

36. Katharine Metcalf Roof, *The Life and Art of William Merritt Chase* (New York: Charles Scribner's Sons, 1917), 153. An archival photograph of *Mother and Child (The First Portrait)* belonging to the Museum of Fine Arts, Houston includes a signed and dated inscription by Mrs. Chase: "Painted by my husband Wm. M. Chase. Always hung in our house. Myself and my oldest daughter 'Cosy.'" I thank A. Thereza Crowe for identifying the archival photograph showing *Mother and Child (The First Portrait)* in Chase's studio.

37. Kenyon Cox, "William M. Chase, Painter," *Harper's New Monthly Magazine* 78 (March 1889):555.

38. I am grateful to Dr. Ronald Pisano for suggesting a c. 1889 date for the San Antonio pastel, as well as a c. 1886–89 for Chase's *Seashore*. On the basis of an archival installation photograph in which the pastel appears (The Parrish Art Museum, Southampton, New York, 83.Stm.40), Pisano speculates that the exhibition pictured is the 1889 Chicago Inter-State Industrial Exhibition. The San Antonio pastel may be the one titled "I am going to see Grandma" in the Chicago exhibition catalogue. Pisano further speculates that the interior may suggest the Chase's Manhattan home where the young family lived until 1890. Chase's mother lived in Brooklyn at the time and, presumably, Mrs. Chase is pictured preparing their first-born Alice Dieudonnée (1887–1971) for the excursion. Alice (nicknamed "Cosy") is pictured in *Mother and Child, Mrs. Chase and Child*, and *The Japanese Book* (pls. 26 and 31–32). I am also grateful to George T.M. Shackelford for identifying the San Antonio pastel in the archival photograph, and to Nicolai Cikovsky, Jr. at the National Gallery of Art for providing additional information.

39. Alastair Gordon, "Village Voice," *Art and Antiques* (May 1991), 93.

40. "Louise Cox at the Art Students League: A Memoir," *Archives of American Art Journal* 27, no. 1 (1987):16.

41. Cox, "William M. Chase, Painter," 549.

42. Barbara Novak, *Nineteenth-Century American Painting, The Thyssen-Bornemisza Collection* (New York: The Vendome Press, 1986), 288 [catalogue entry by Kenneth W. Maddox].

43. William H. Gerdts and Russell Burke, *American Still-Life Painting* (New York: Praeger Publishers, 1971), 204.

44. Emil Carlsen, "On Still-Life Painting," *Palette and Bench* I (October 1908):7.

45. See William Hosley, *The Japan Idea: Art and Life in Victorian America*, exh. cat. (Hartford: Wadsworth Atheneum, 1990), especially 29–79; also, Klaus Berger, *Japonisme in Western Painting from Whistler to Matisse*, trans. David Britt (Cambridge: Cambridge University Press, 1980).

46. Dallas Museum of Art catalogue notes, Eleanor Jones Harvey, Associate Curator of American Art.

47. Theodore Robinson Diaries, entry for November 30, 1893, quoted in Julia Meech-Pekarik, "Early Collectors of Japanese Prints and The Metropolitan Museum of Art," *Metropolitan Museum Journal* 17 (1982):106.

48. Nelson C. White, "The Art of Thomas W. Dewing," *Art and Archaeology* 27, no. 6 (June 1929):255.

49. Mary Ellen Hayward, "The Influence of the Classical Oriental Tradition on American Painting," *Winterthur Portfolio* 14, no. 2 (Summer 1979):126. See also Thomas Lawton and Linda Merrill, *Freer: A Legacy of Art* (Washington, D.C.: Freer Gallery of Art, Smithsonian Institution in association with Harry N. Abrams, Inc., Publishers, 1993).

50. Hiesinger, "Impressionism and Politics: The Founding of The Ten," 785.

51. Elizabeth De Veer and Richard J. Boyle, *Sunlight and Shadow: The Life and Art of Willard L. Metcalf* (New York: Abbeville Publishers in association with Boston University, 1987), 201.

52. Ibid., 110.

53. Sona Johnston, *Theodore Robinson, 1852–1896*, exh. cat. (Baltimore: The Baltimore Museum of Art, 1973), 44. The three paintings noted in Robinson's diary are now located at the Addison Gallery of American Art, Phillips Academy; the Corcoran Gallery of Art; and Randolph-Macon Woman's College, as of 1974.

54. Lilla Cabot Perry, "Reminiscences of Claude Monet from 1889 to 1909," *The American Magazine of Art* (March 1927), reprinted in Charles F. Stuckey, ed., *Monet: A Retrospective* (New York: Hugh Lauter Levin Associates, Inc., 1985), 181.

55. The issue of American Impressionists seeking to paint their native country has been explored, more recently, in H. Barbara Weinberg, Doreen Bolger, and David Park Curry, *American Impressionism and Realism: The Painting of Modern Life, 1885–1915* (New York: The Metropolitan Museum of Art, 1994), particularly 55–87.

56. Eliot Clark, *John Twachtman* (New York:1924), 58, quoted in Lisa N. Peter, "Twachtman's Greenwich Paintings: Context and Chronology," in Deborah Chotner, Lisa N. Peters, and Kathleen A. Pyne, *John Twachtman: Connecticut Landscapes*, exh. cat. (Washington, D.C.: National Gallery of Art, 1989), 20.

57. Clarence Cook, 1890, cited in Allison Eckardt Ledes, "Current and Coming," *The Magazine Antiques* 136, no. 5 (November 1989):942.

58. Dorothy Weir Young, *The Life and Letters of J. Alden Weir* (New Haven: Yale University Press, 1960), 123, quoted in Gerdts, *American Impressionism*, 105.

59. Albert Gallatin, "Childe Hassam: A Note," *Collector and Art Critic* 5 (January 1907):101–4, quoted in Gerdts, *American Impressionism*, 91.

60. I.E. Ives, "Talks with Artists: Mr. Childe Hassam on Painting Street Scenes," *Art Amateur* 27 (October 1892):116–17, reprinted in Ulrich W. Hiesinger, *Childe Hassam: American Impressionist* (Munich and New York: Prestel, 1994), 179–80.

61. "New York Beautiful," *Commercial Advertiser* (January 15, 1898), reprinted in Hiesinger, *Childe Hassam*, 181.

62. "New York, the Beauty City," *The Sun* (February 23, 1913, section 4), reprinted in Hiesinger, *Childe Hassam*, 181. Dale Neighbors, assistant curator of photography, New-York Historical Society, has noted that in photographs of Dewey Arch taken before its dismantling in 1900, photographers have also manipulated the image to obscure the prominent billboard.

63. Celia Thaxter, *An Island Garden* (Boston and New York: 1894), 102, cited in David Park Curry, *Childe Hassam: An Island Garden Revisited*, exh. cat. (Denver: The Denver Art Museum in association with W.W. Norton and Company, London and New York, 1990), 59.

64. Curry, *Childe Hassam: An Island Garden Revisited*, 14.

65. David Park Curry has confirmed that *The Sonata* in the collection of the Museum of Fine Arts, Houston, is suggestive of but does not represent Thaxter's parlor. *The Sonata* is a later copy by Hassam of *Improvisation*, 1899, in the collection of the National Museum of American Art, Smithsonian Institution, gift of John Gellatly, 1929.

66. Clara T. MacChesney, "Frederick Carl Frieseke: His Work and Suggestions for Painting from Nature," *Arts and Decoration* 3 (November 1912):14.

67. Clara T. MacChesney, *New York Times* (June 7, 1914, section 6), cited in Allen S. Weller, "Frederick Carl Frieseke: The Opinions of an American Impressionist," *College Art Journal* 28 (Winter 1968):162.

68. Clipping from *Everybody's Magazine* in Frederic Remington Diary, March 26, 1909, Frederic Remington Art Museum, Ogdensburg, New York, quoted in Doreen Bolger Burke, "In the Context of his Artistic Generation," in Michael Edward Shapiro and Peter H. Hassrick, *Frederic Remington: The Masterworks*, exh. cat. (Saint Louis: The Saint Louis Art Museum in conjunction with the Buffalo Bill Historical Center, Cody and Harry N. Abrams, Inc., Publishers, 1988), 60.

69. See Dewey F. Mosby, Darrell Sewell, and Rae Alexander-Minter, *Henry Ossawa Tanner*, exh. cat. (Philadelphia: Philadelphia Museum of Art, 1991).

70. See Chapter 12, "Regional Schools," in Gerdts, *American Impressionism*, 1984, for the most comprehensive treatment of the subject to date.

71. J. Nilsen Laurvik, "Edward W. Redfield-Landscape Painter," *International Studio* 41, no. 162 (August 1910):xxxvi.

72. Charles V. Wheeler, "Redfield," *The American Magazine of Art* 16 (January 1925). Reprinted privately, Washington, D.C.

73. *Commercial Advertiser* (January 8, 1898), quoted in Hiesinger, *Impressionism in America: The Ten American Painters* (Munich: Prestel-Verlag, 1991), 18.

74. Edward Simmons, *From Seven to Seventy: Memories of a Painter and a Yankee*, New York and London, 1922, 221 ff, quoted in Hiesinger, *Impressionism in America: The Ten American Painters*, 232.

75. "Louise Cox at the Art Students League: A Memoir," 18.

76. Christian Brinton, "Robert Reid: Decorative Impressionist," *Arts and Decoration* 2 (November 1911), 13–15, 34. See also, H. Barbara Weinberg, "Robert Reid: Academic 'Impressionist,'" *Archives of American Art Journal* 15:1 (1975), 2–11; Martha Banta, *Imaging American Women: Ideas and Ideals in Cultural History* (New York: Columbia University Press, 1987); and Bailey Van Hook, "From the Lyrical to the Epic: Images of Women in American Murals at the Turn of the Century," *Winterthur Portfolio* 26, no. 1 (Spring 1991):63–80, for discussions that account for the preponderance of images of women in late nineteenth-century America.

77. Sadakichi Hartmann, "The Tarbellites," *Art News* 1 (March 1897):3–4.

78. H. Winthrop Peirce, *The History of the School of the Museum of Fine Arts* (Boston, Museum of Fine Arts, 1930), 43, quoted in Patricia Jobe Pierce, *Edmund C. Tarbell and the Boston School of Painting, 1889–1980* (Boston: Pierce Galleries, 1980), 60.

79. Bernice Kramer Leader, "The Boston School and Vermeer," *Arts Magazine* 55, no. 3 (November 1980):175–76.

80. *The New York Times Magazine* (September 16, 1917), quoted in Leader, "The Boston School and Vermeer," 175–76.

81. Edward Simmons in Hiesinger, *Impressionism in America: The Ten American Painters*, 232.

82. The term "Ashcan School" was coined by Holger Cahill and Alfred Barr in the 1930s. See Elizabeth Milroy, *Painters of a New Century: The Eight*, exh. cat. (Milwaukee: Milwaukee Art Museum, 1991), 15–19.

83. *New York Daily Tribune* (January 29, 1911), quoted in Marianne Doezema, "The New York City of George Bellows," *The Magazine Antiques* 141, no. 3 (March 1992):480.

84. Oliver Larkin, *Art and Life in America* (New York: Rinehart, 1949), 336, quoted in Milroy, *Painters of a New Century: The Eight*, 16.

85. "Revolutionary Figures in American Art," *Harper's Weekly* 51 (April 13, 1907), 534, quoted in Doezema, "The New York City of George Bellows," 483.

86. "Art and Artists: The Eight," Philadelphia *Press* (March 9, 1909), Pennsylvania Academy of the Fine Arts Scrapbooks, Archives of American Art, Smithsonian Institution, Washington, D.C., microfilm roll no. P54, frame 842, quoted in Judith Zilczer, "The Eight on Tour, 1908–1909," *The American Art Journal* 16, no. 3 (Summer 1984):29.

87. *New York Telegram* (June 22, 1925), Papers of William MacBeth, Archives of American Art microfilm #NMC–46, frames 163–547, cited in Weller, "Frederick Carl Frieseke," 163.

88. *La Neige* (1899) was purchased for the Musée du Luxembourg, now in the Musée National d'Art Moderne, Paris.

89. Robert Henri, *The Art Spirit*, comp. Margery Ryerson (Philadelphia and London: J.B. Lippincott Company, 1923), 58.

90. William Glackens, "The American Section: The National Art; an Interview with the Chairman of the Domestic Committee, Wm. J. Glackens," *Arts and Decoration* 3 (March 1913):159, quoted in Richard J. Wattenmaker, "William Glackens's Beach Scenes at Bellport," *Smithsonian Studies in American Art* 2, no. 2 (Spring 1988):84.

91. Guy Pène du Bois, *William J. Glackens* (New York: American Artists Series, Whitney Museum of American Art), 12–13.

92. James Gibbons Huneker, quoted in Henry and Sidney Berry-Hill, *Ernest Lawson: American Impressionist, 1873–1939* (Leigh-on-Sea, England: F. Lewis, Publishers, Limited, 1968), 29, 31.

93. Doezema, "The New York City of George Bellows," 483, passim.

94. "What is the matter with our National Academy?," *Harper's Weekly* 56 (April 6, 1912):8, quoted in Doezema, "The New York City of George Bellows," 488–89.

95. George Bellows to Joseph Taylor, January 15, 1914, Bellows Papers (Box 1, Folder 12), Amherst College Library, quoted in Jane Myers, "'The Most Searching Place in the World': Bellows and Portraiture," in Michael Quick, Jane Myers et al., with an introduction by John Wilmerding, *The Paintings of George Bellows*, exh. cat. (New York: Harry N. Abrams, Inc. Publishers, Amon Carter Museum, Fort Worth, Los Angeles County Museum of Art, 1992), 177.

96. Arthur Hoeber, *New York Globe and Commercial Advertiser* (February 5, 1908), "The Eight" file, Whitney Museum of American Art, Archives of American Art, Smithsonian Institution, Washington, D.C., microfilm roll no. N655, frame 258, quoted in Zilczer, "The Eight on Tour, 1908–1909," 35. See also Carol Clark, Nancy Mowll Mathews, Gwendolyn Owens, *Maurice Brazil Prendergast, Charles Prendergast: A Catalogue Raisonné* (Munich: Prestel-Verlag in association with Williams College Museum of Art, Williamstown, Mass.), 1990.

97. "Paintings on View at Academy of Fine Arts," Philadelphia *Public Ledger* (March 8, 1908, 16), quoted in Zilczer, "The Eight on Tour, 1908–1909," 35.

"*Indigenous*" and "*Emotional*" Impressionists

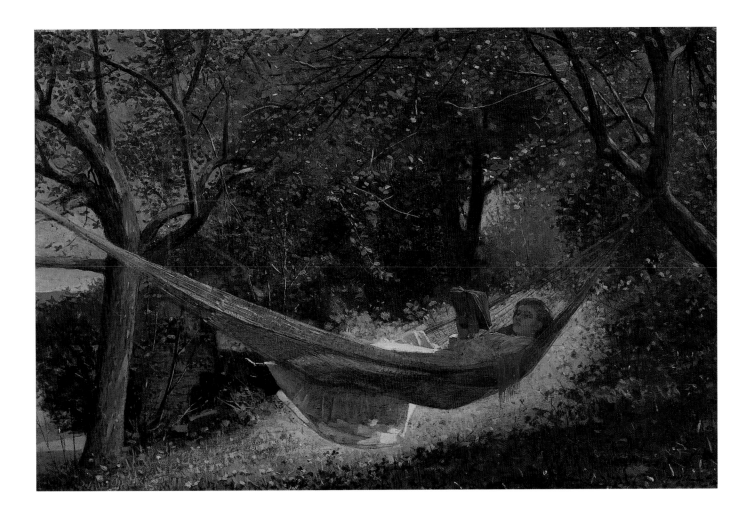

1. WINSLOW HOMER
Girl in a Hammock, 1873

Oil on canvas, 13 1/2 x 19 3/4 in. (32.4 x 50.2 cm).
Private collection.

Winslow Homer stands alone, and is, on the whole, as rare a figure as Millet, or Delacroix, or Fortuny, or Whistler . . . He broke new ground, painted familiar subjects as no one had ever painted them before him, so that he seems to move in a world of his own.

Tribune, 1898

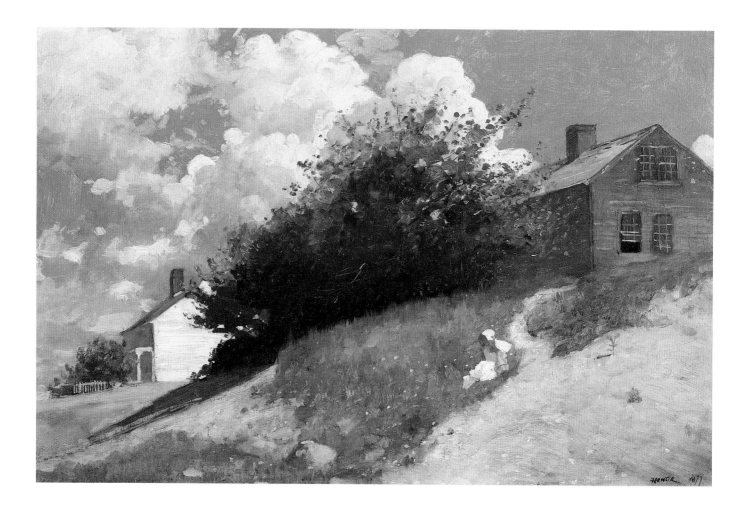

2. WINSLOW HOMER
Houses on a Hillside, 1879

Oil on canvas, 15 7/8 x 22 5/8 in. (40.3 x 57.5 cm).
Private collection.

I prefer every time a picture composed and painted outdoors. This making studies and then taking them home to use them is only half right. You get composition, but you lose freshness; you miss the subtle and, to the artist, the finer characteristics of the scene itself.

Winslow Homer, 1880

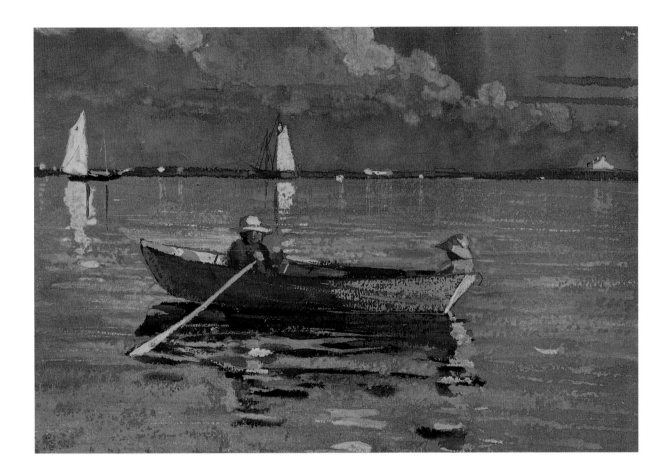

3. WINSLOW HOMER
Gloucester Harbor, 1873

Watercolor on paper, 9½ x 13 in. (24.1 x 33 cm).
Private collection.

Impressionists are here from Rome and Munich, but there is one Impressionist who is entirely homemade, and to American soil, indigenous . . . His pictures have a vivid, fresh originality, . . . childlike directness and naivete . . .

New York Times, February 1, 1879

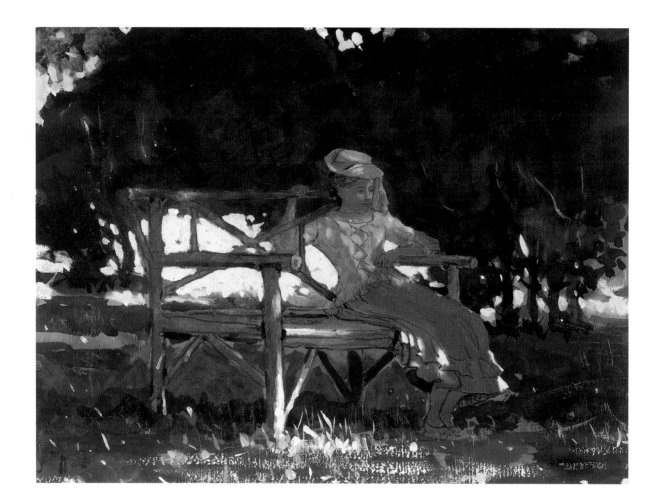

4. WINSLOW HOMER
Girl on a Garden Seat, 1878

Watercolor on paper, 6¾ x 8¼ in. (17.1 x 22 cm).
McNay Art Museum, The Mary and Sylvan Lang
Collection.

'The Girl on a Garden-Seat' is another brilliant bit of light and shade. . . . running one's eye along the line of pictures in this exhibition, the impression received from his colour is of its being the result of a robust and healthy eye and taste. With a little of the flavour to the mental palate of the pickle or perhaps of olives, one may require time to relish it, but when once liked it is heartily enjoyed.

Susan N. Carter, 1879

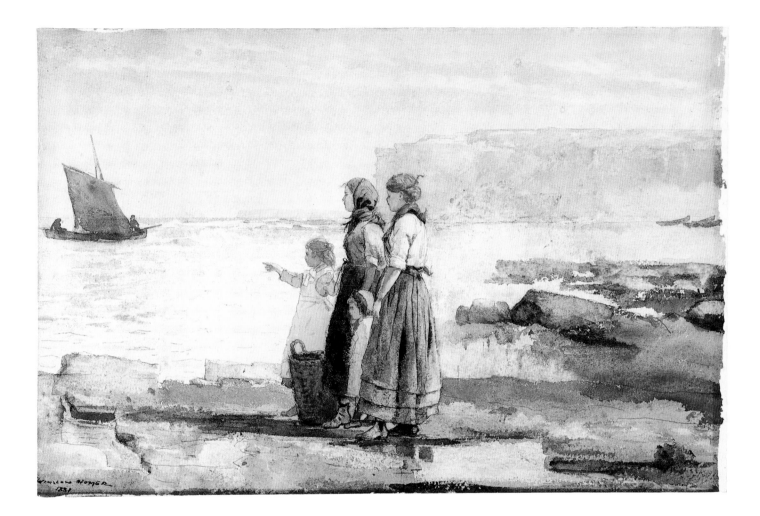

5. WINSLOW HOMER
Waiting for the Return of the Fishing Fleet,
1881

Watercolor on paper, 13⅛ x 19½ in. (33.3 x 49.5 cm).
Private collection.

Homer is both the historian and poet of the sea and sea-coast life . . . The whole gamut of watercolor power, from the richness of elemental life depth and vividness to the density of storm darkness and human woe, and thence again to life light, joyousness, delicacy and subtle glow, is here run with a strength and accuracy that few not seeing will believe it capable of.

Boston Evening Transcript, December, 1883

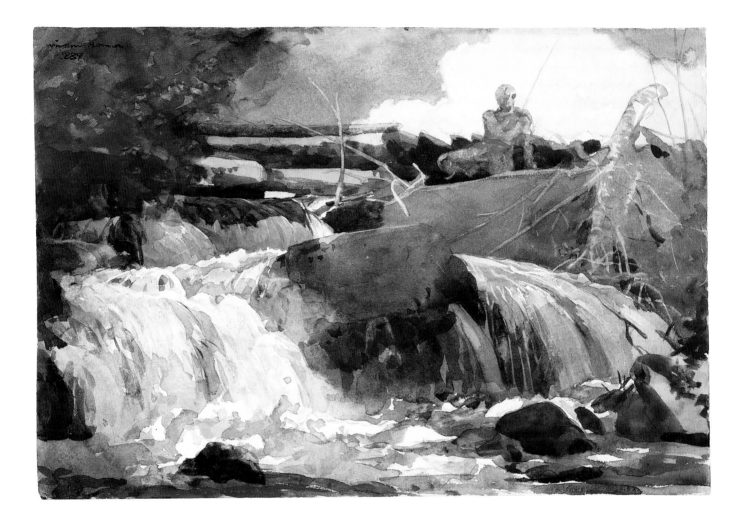

6. WINSLOW HOMER
Casting in the Falls, 1889

Watercolor on paper, 13¹⁵/₁₆ x 19¹⁵/₁₆ in.
(35.4 x 50.6 cm).
Dallas Museum of Art, Dallas Art Association
Purchase.

So it would seem that this admirable painter is actually becoming popular. His
work used to be regarded as "caviare to the general." His prices are certainly
extremely moderate and the purely American character of his subjects no
doubt helped their sale.

Art Amateur, April, 1890

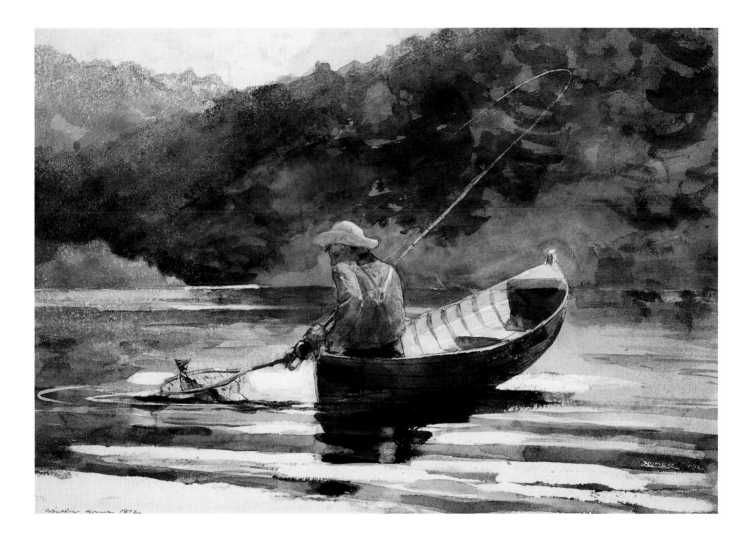

7. WINSLOW HOMER
Boy Fishing, 1892

Watercolor on paper, 14⅝ x 21 in. (37.2 x 53.3 cm).
Courtesy of the San Antonio Museum of Art.

We may, in all justice to every other famous American name, attribute to these two men, Inness and Homer, the distinction of being the ones that would first come to mind if we were asked by a foreigner what we have that is individual and great in art. There is something in the work of both that is national, something that belongs to us.

New York Sun, 1898

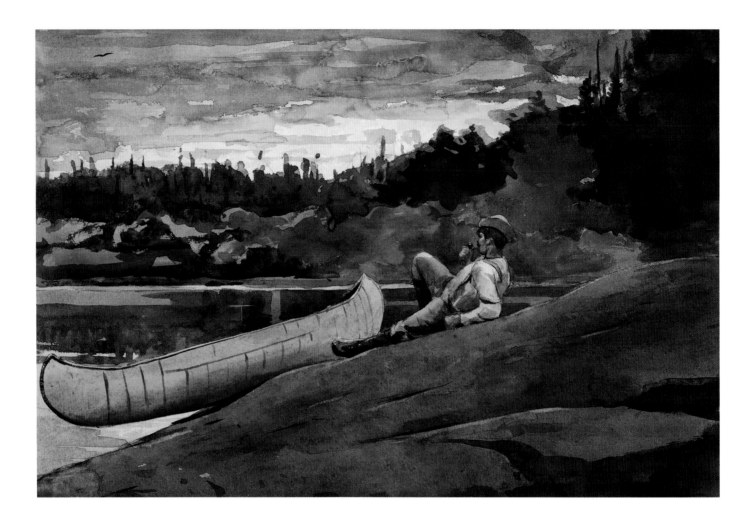

8. WINSLOW HOMER
The Guide, 1895

Watercolor on paper, 13⅝ x 19⅝ in. (34.6 x 49.9 cm).
The collection of Mr. and Mrs. James W. Glanville.

The life that I have chosen gives me my full hours of enjoyment for the balance
of my life. The sun will not rise, or set, without my notice, and thanks.

Winslow Homer, 1895

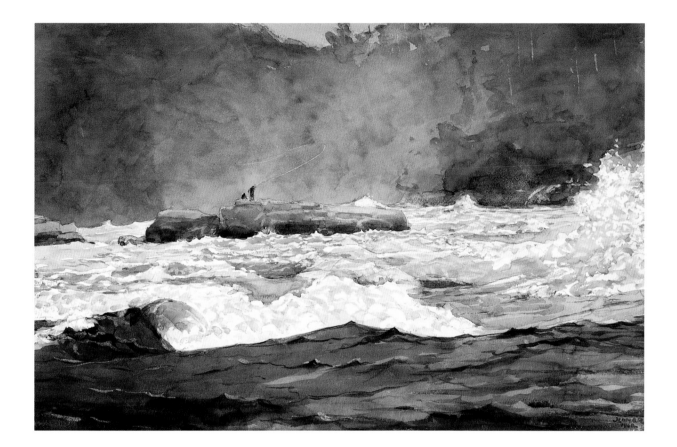

9. WINSLOW HOMER
Fishing the Rapids, Saguenay, 1902

Watercolor on paper, 13½ x 20¾ in. (34.3 x 49.8 cm).
Private collection.

Mr. Homer goes as far as anyone has ever done in demonstrating the value of watercolors as a serious means of expressing dignified artistic impressions, and does it wholly his own way.

Frank Jewett Mather, Jr., 1911

10. GEORGE INNESS
Sunset at Etretat, c. 1875

Oil on canvas, 20¼ x 30¼ in. (51.4 x 76.8 cm).
Mr. and Mrs. Fayez Sarofim.

A work of art does not appeal to the intellect. It does not appeal to the moral sense. Its aim is not to instruct, not to edify, but to awaken an emotion. This emotion may be one of love, of pity, of veneration, of hate, of pleasure, or of pain; but it must be a single emotion, if the work has unity . . . and the true beauty of the work consists in the beauty of the sentiment or emotion which it inspires. Its real greatness consists in the quality and the force of this emotion.

George Inness, 1878

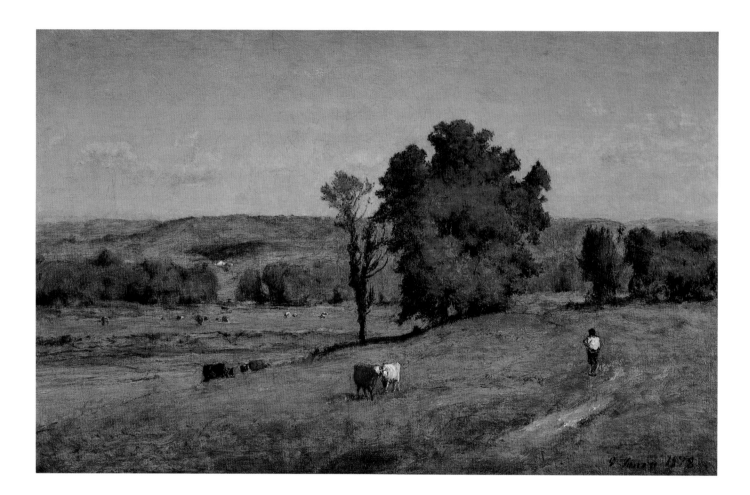

11. GEORGE INNESS
Landscape, 1878

Oil on canvas, 11⅞ x 18 in. (30.18 x 45.7 cm).
The Museum of Fine Arts, Houston, gift of Mr.
and Mrs. Meredith Long in memory of Mrs. Agnes
Cullen Arnold.

Every act of man, every thing of labor, effort, suffering, want, anxiety, neces-
sity, love, marks itself wherever it has been. In Italy I remember frequently
noticing the peculiar ideas that came to me from seeing odd-looking trees that
had been used, or tortured, or twisted—all telling something about humanity.
. . . everything in nature has something to say to us.

George Inness, 1878

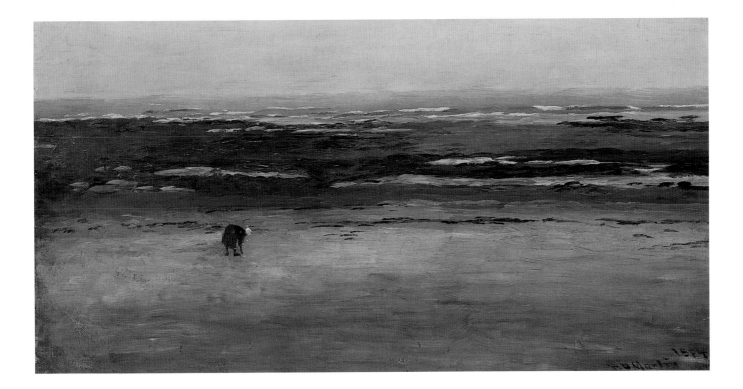

12. HOMER DODGE MARTIN
Low Tide, Villerville, 1884

Oil on canvas, 18⅞ x 29⅛ in. (48 x 74 cm).
The Museum of Fine Arts, Houston, Wintermann
Collection of American Art, gift of Mr. and Mrs.
David R. Wintermann.

. . . Martin changed his whole manner of painting and produced a series of
works which seem at first glance scarcely the work of the same man. The
paint is laid on heavily, sometimes with the palette knife; the drawing, while
true and subtle, is generalized and simplified to the last degree; the sky and
water instead of smooth, thin, single tints are a mass of heavy, interwoven
strokes of different tones. . . . under every change of surface remains the same
deep, grave melancholy, sobering but not saddening, which is the keynote of
Martin's work.

Samuel Isham, 1927

The Expatriate Americans

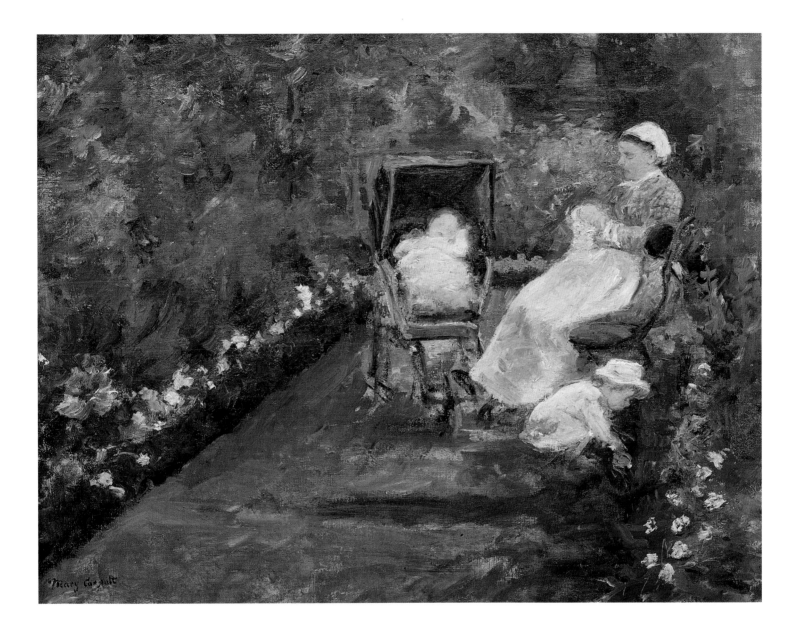

13. MARY CASSATT
The Nurse, 1878

Oil on canvas, 28⅞ x 36¼ in. (73.3 x 92.1 cm).
Private collection.

I accepted with joy [Degas's invitation to exhibit with the Impressionists].
Now I could work with absolute independence without considering the opinion
of a jury. I had already recognized who were my true masters. I admired
Manet, Courbet, and Degas. I took leave of conventional art. I began to live.

Mary Cassatt, 1913

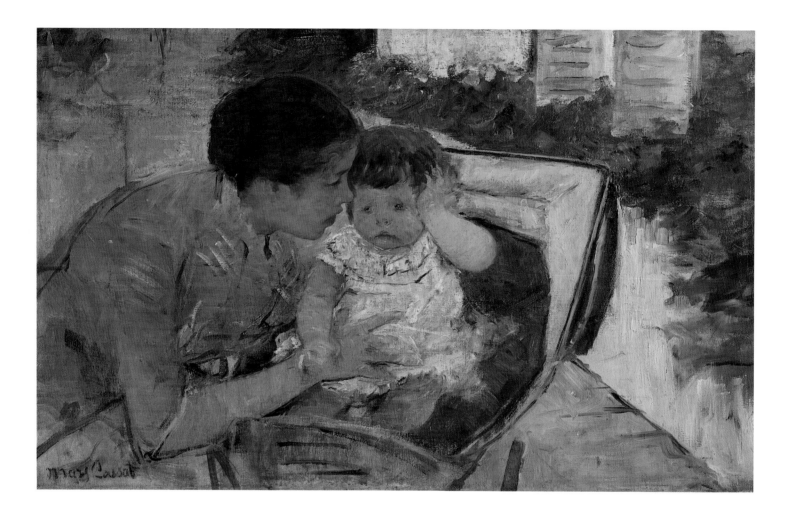

14. MARY CASSATT
Susan Comforting the Baby, c. 1881

Oil on canvas, 25⅝ x 39⅜ in. (65.1 x 100 cm).
The Museum of Fine Arts, Houston, The John A.
and Audrey Jones Beck Collection.

Her exhibition is composed of portraits of children, interiors, gardens . . . in these subjects, so much cherished by the English, Miss Cassatt has known the way to escape from sentimentality on which most of them have foundered . . . One thinks at once of the discreet interiors of Dickens . . . [There is] an effective understanding of the placid life, a penetrating feeling of intimacy . . .

J.K. Huysmans, 1880

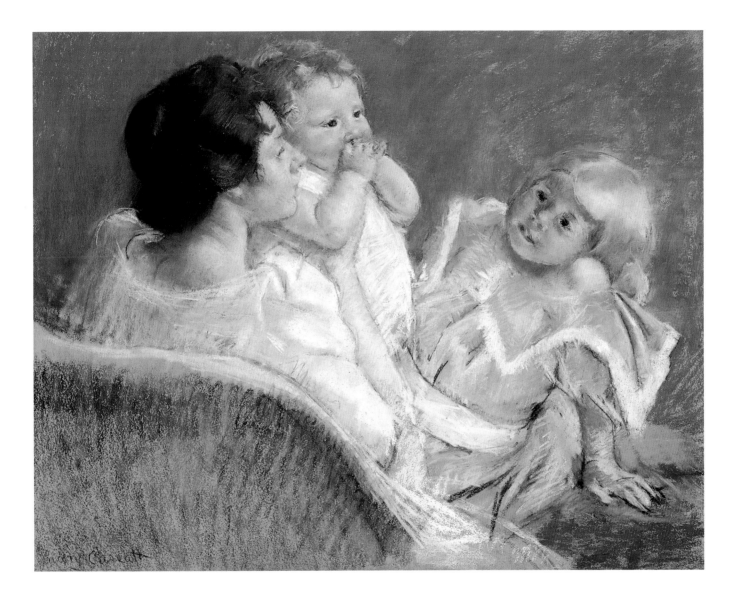

15. MARY CASSATT
Mother and Children, 1901

Pastel on paper, 25¼ x 31½ in. (64.1 x 80 cm).
Lent by an Anonymous Lady.

How well I remember . . . seeing for the first time Degas' pastels in the window of a picture dealer on the Boulevard Haussmann. I used to go and flatten my nose against that window and absorb all I could of his art.

Mary Cassatt, 1873

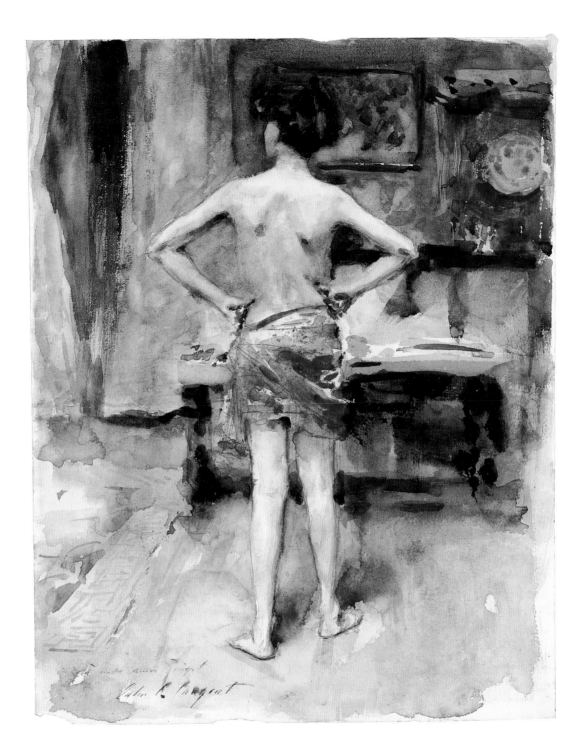

16. JOHN SINGER SARGENT
The Model: Interior with Standing Figure,
c. 1876

Watercolor on paper mounted on board, 11 ⅝ x 9 in.
(29.5 x 22.9 cm).
The Museum of Fine Arts, Houston,
gift of Miss Ima Hogg.

Having a foundation in drawing which none among his new comrades could equal, this genius—surely the correct word—quickly acquired the methods then prevalent in the studio, and then proceeded to act as a stimulating force which far exceeded the benefits of instruction given by Carolus himself.

Will H. Low, 1935

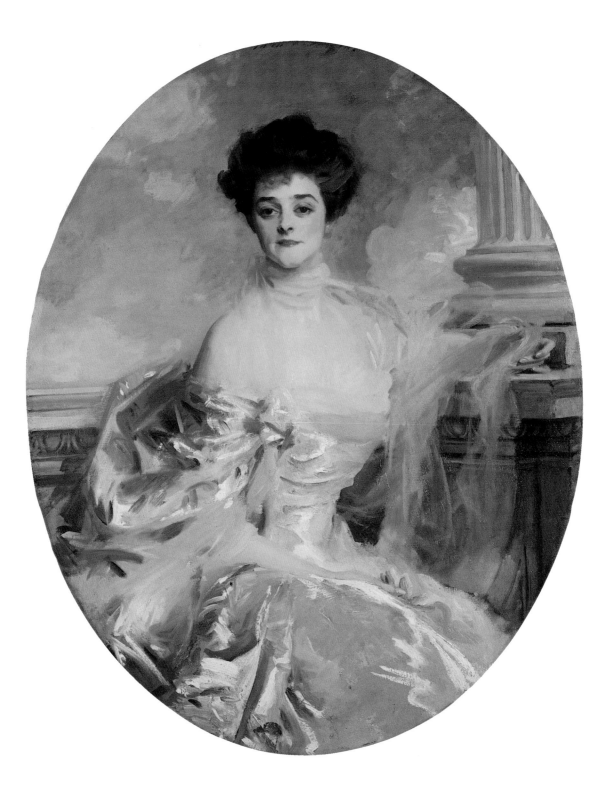

17. JOHN SINGER SARGENT
Countess of Essex, c. 1906–07

Oil on canvas, oval: 49½ x 38¼ in. (125.7 x 97.2 cm).
Mr. and Mrs. James L. Ketelsen.

A succès d'estime such as Sargent produces when he is really enjoying his own composition [Countess of Essex] . . . The dress of the sitting dark-haired woman is of sheeny white satin. From this the artist has worked into the light and reflections of the satin an overskirt of pale blue; from this into the smoky blue chiffon of the half floating scarf, and from this into the blue and white sky framing the head.

Christian Science Monitor, 1917

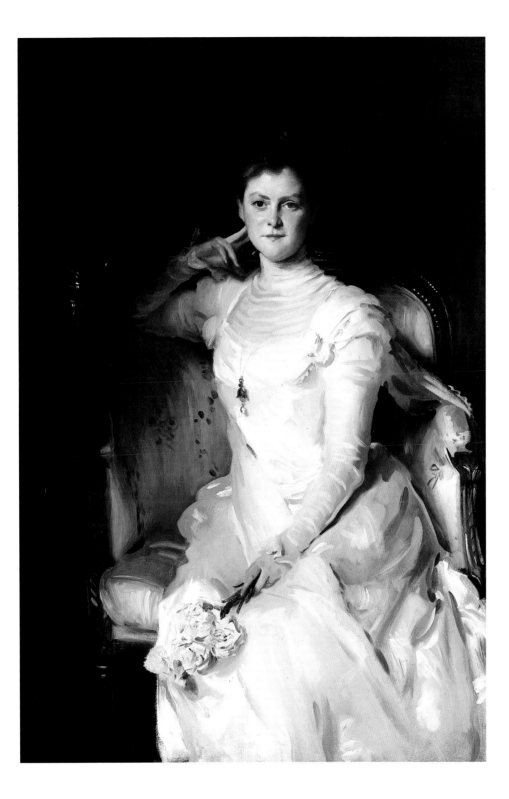

18. JOHN SINGER SARGENT
Mrs. Joshua Montgomery Sears, 1899

Oil on canvas, 68⅜ x 48⅝ in. (174.1 x 123.7 cm).
The Museum of Fine Arts, Houston, museum
purchase with funds provided by George R. Brown
in honor of his wife, Alice Pratt Brown.

We worked very hard—he with his magical brush, I with my determination to
control fidgets and the restless instincts to which sitters are prone when forced
to remain still for any length of time, for the most part we were silent. Occa-
sionally I heard him muttering to himself. Once I caught: "Gainsborough
would have done it! . . . Gainsborough would have done it!"

Account of an unknown sitter's experience with Sargent, 1902

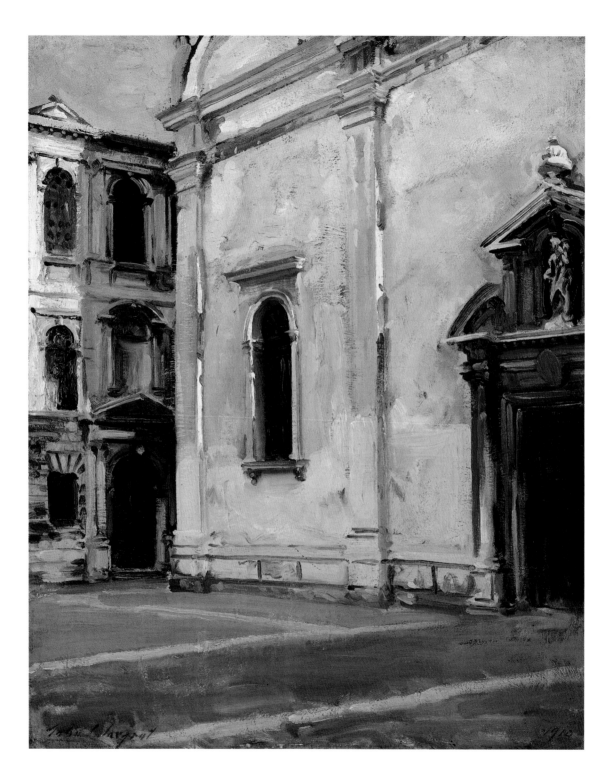

19. JOHN SINGER SARGENT
View of Venice, 1910

Oil on canvas, 28¹/₈ x 22¹/₄ in. (71.4 x 56.5 cm).
Estates of James and Ella Winston.

[The Venetian scenes] have as distinct a *cachet* of their own as a Vermeer or a Chardin. In other words, they are in their kind of a perfection that leaves little to be desired. Slight, sketchy, almost casual these scenes seem at first glance, yet as they are examined they impress and charm us more and more, and in the end convince us that no painter succeeds better than he in attaining, through the unity of form and color, the very aspect of life itself.

William Howe Downes, 1925

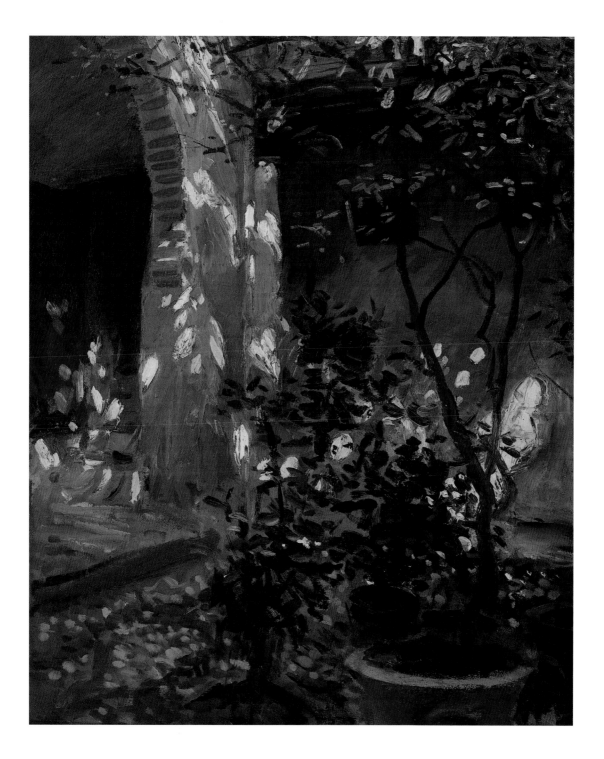

20. JOHN SINGER SARGENT
Granada, Sunspots, 1912

Oil on canvas, 27½ x 21½ in. (69.8 x 54.6 cm).
Private collection.

Other travellers wrote their diaries; he painted his . . . Palestine, the Dolomites, Corfu, Italy, Spain, Portugal, Turkey, Norway, Greece, Egypt, France, and the Balearic Islands are on record.

Mary Newbold Patterson Hale (Sargent's second cousin), 1927

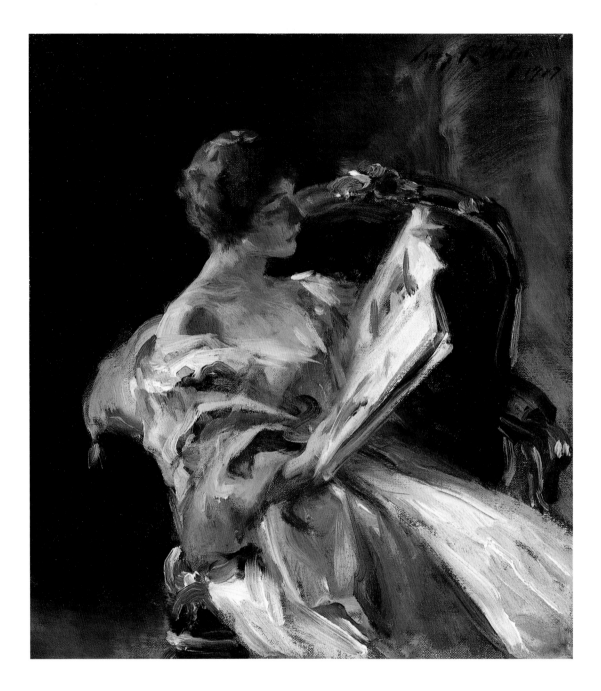

21. IRVING RAMSAY WILES
The Storybook, 1917

Oil on canvas, 14 x 12¼ in. (36.5 31.1 cm).
Frank Hevrdejs Collection.

To the average layman portrait painting in its highest sense is usually misunderstood. He believes the likeness to be the sole purpose of a portrait and the more celebrated the painter he employs, the better likeness he expects to acquire, which is a reasonable expectation, but to the painter the making of a work of art, a noble canvas, is the goal he strives to reach. This is why the portraitist is always enthusiastic in his work whether or not his sitters are in themselves particularly interesting as subjects.

Irving Ramsay Wiles, 1909

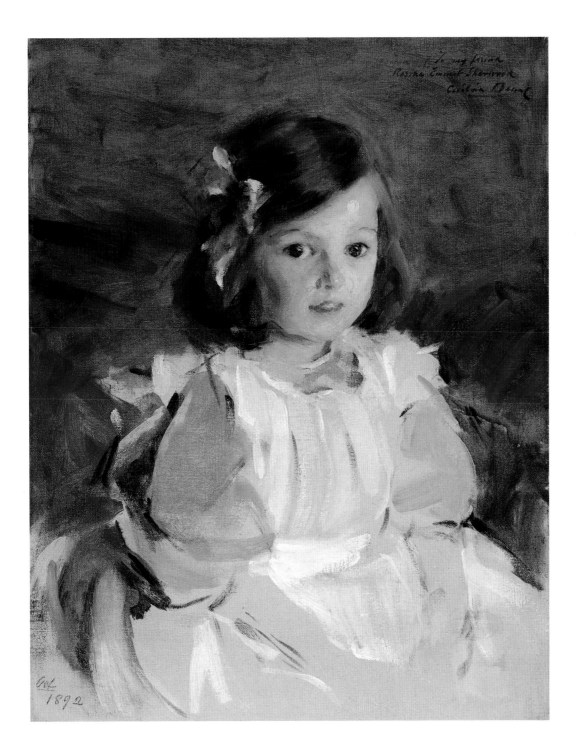

22. CECILIA BEAUX
Cynthia Sherwood, 1892

Oil on canvas, 24 x 18 in. (61 x 45.7 cm).
Frank Hevrdejs Collection.

My dear—you and Cynthia were the lions of the Exhibition yesterday. Really, much as I admired the picture, I was startled at its brilliancy and force . . . The artists are all moved about it . . . Mr. Chase said he would give anything to own it and Robert Reid . . . said he liked Cynthia's portrait much the best.

Rosina Sherwood to Cecilia Beaux, 1895

The "Painter Gods"

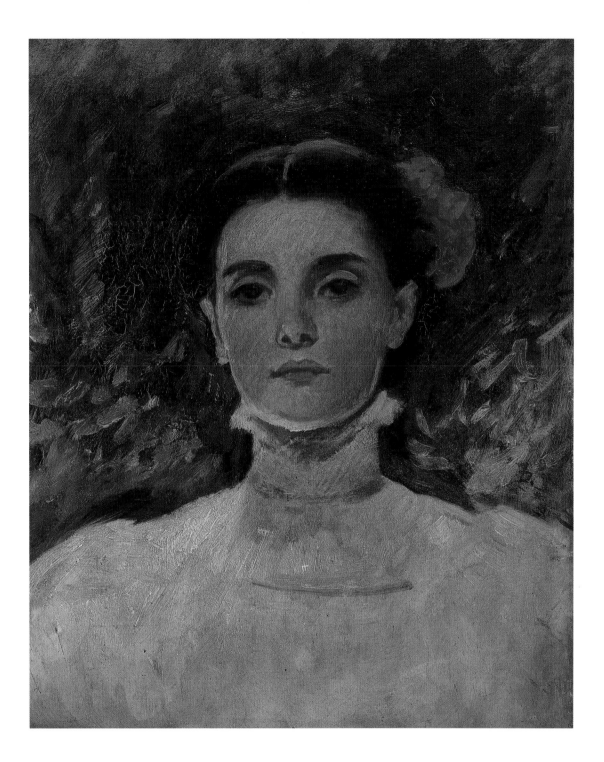

23. FRANK DUVENECK
Portrait of Maggie Wilson, 1898

Oil on board, 15 x 12 in. (38.1 x 30.5 cm).
The Museum of Fine Arts, Houston, Wintermann
Collection of American Art, gift of Mr. and Mrs.
David R. Wintermann.

Like painter-gods they [the Duveneck Boys] descended upon the Munich
exhibitions, with work so fine that it stood out as noteworthy production even
there . . . They counted their sacrifices not at all as a deprivation, but as the
price they willingly expended to meet the exacting demands of the profession
which they elected to follow. They stand for much in America's artistic
achievement; they were the force behind a great forward-moving epoch . . .

Rose V. S. Berry, 1923

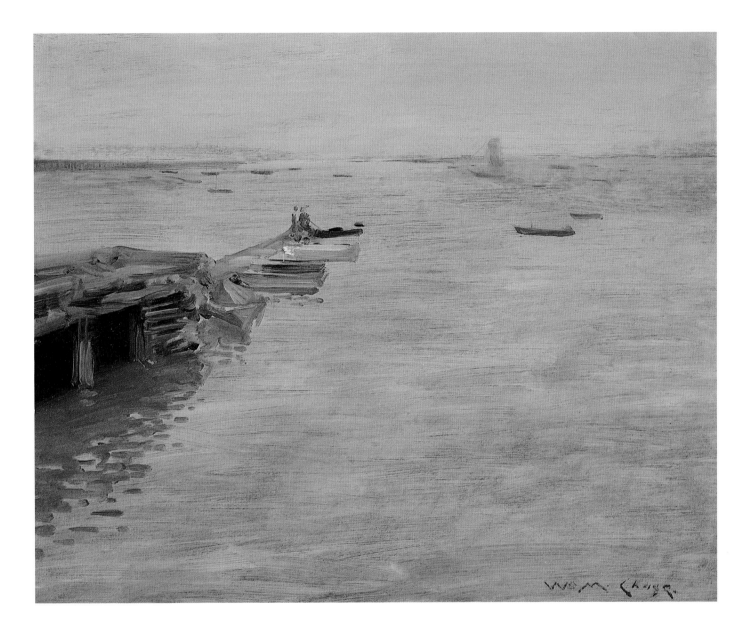

24. WILLIAM MERRITT CHASE
Seashore, c. 1886–89

Oil on panel, 22 x 26 7/8 in. (55.9 x 68.3 cm).
The Museum of Fine Arts, Houston, gift of Mr. and
Mrs. Ralph E. Mullin.

In this country, if anywhere, we should be superior to narrowing notions of
schools and styles. The individual merit of a picture is the only final standard.
William Merritt Chase, 1892

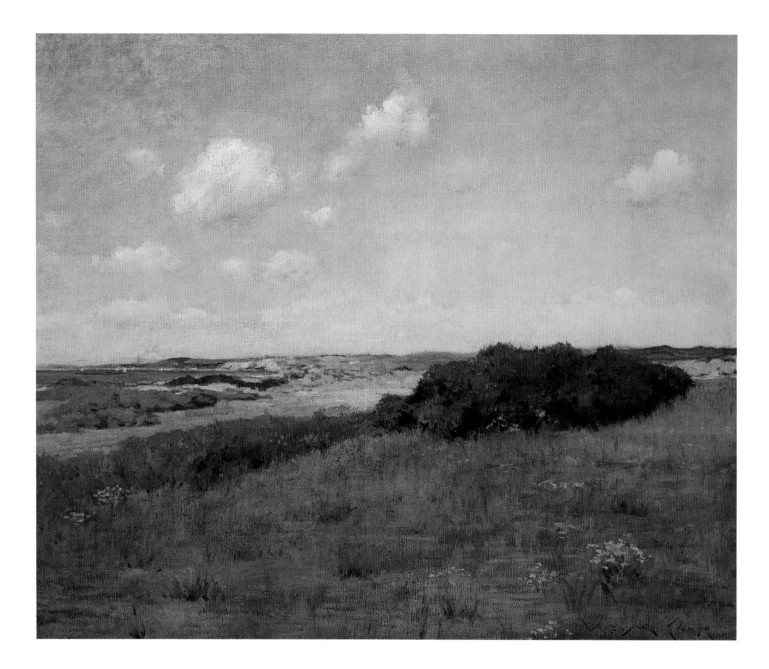

25. WILLIAM MERRITT CHASE
Sunlight and Shadow, Shinnecock Hills,
c. 1895

Oil on canvas, 35 x 40 in. (89 x 102 cm).
The collection of Mr. and Mrs. James W. Glanville.

I don't believe in making pencil sketches and then painting your landscape in your studio. You must be right under the sky. You must try to match your colors as nearly as you can to those you see before you, and you must study the effects of light and shade on nature's own hues and tints.

William Merritt Chase, 1891

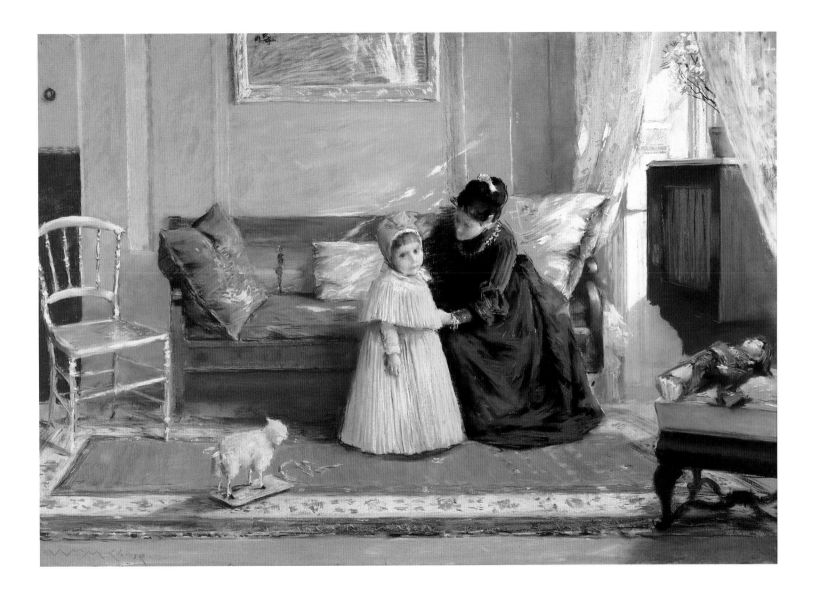

26. WILLIAM MERRITT CHASE
Mrs. Chase and Child, c. 1889

Pastel on paper, 29 x 41 in. (73.7 x 104.1 cm).
Courtesy of the San Antonio Museum of Art.

He is, as it were, a wonderful human camera—a seeing machine—walking up and down in the world, and in the humblest things as in the finest discovering and fixing for us beauties we had else not thought of.

Kenyon Cox on William Merritt Chase, 1889

27. WILLIAM MERRITT CHASE
Still Life, c. 1915

Oil on canvas, 18⅛ x 29¼ in. (46 x 74 cm).
The Museum of Fine Arts, Houston, gift of
Mrs. George R. Brown.

It may be that I will be remembered as a painter of fish . . . in the infinite
variety of these creatures, the subtle and exquisitely colored tones of the flesh
fresh from the water, the way their surfaces reflect the light, I take the greatest
pleasure.

William Merritt Chase, 1889

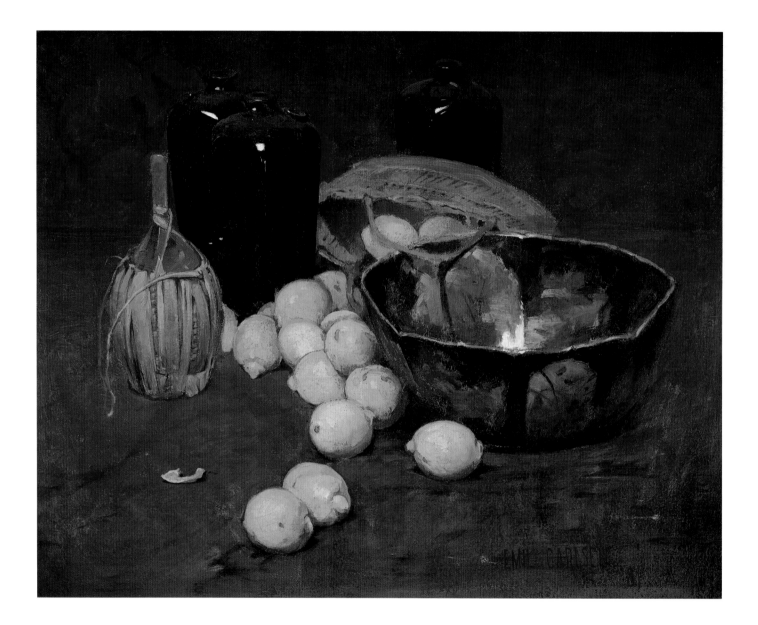

28. EMIL CARLSEN
Still Life with Lemons, 1881

Oil on canvas, 25⅛ x 30⅛ in. (63.8 x 76.5 cm).
Mr. and Mrs. James L. Ketelsen.

The study of still life should be made interesting from the beginning; . . .
a well-painted earthen pipkin and a lemon or two is an infinitely better work of
art, than an ill painted Madonna, however greatly conceived. . . . Still life paint-
ing must be of a well understood simplicity, solid, strong, vital, unnecessary
details neglected, salient points embellished, made the most of, every touch full
of meaning and for the love of beauty.

Emil Carlsen, 1908

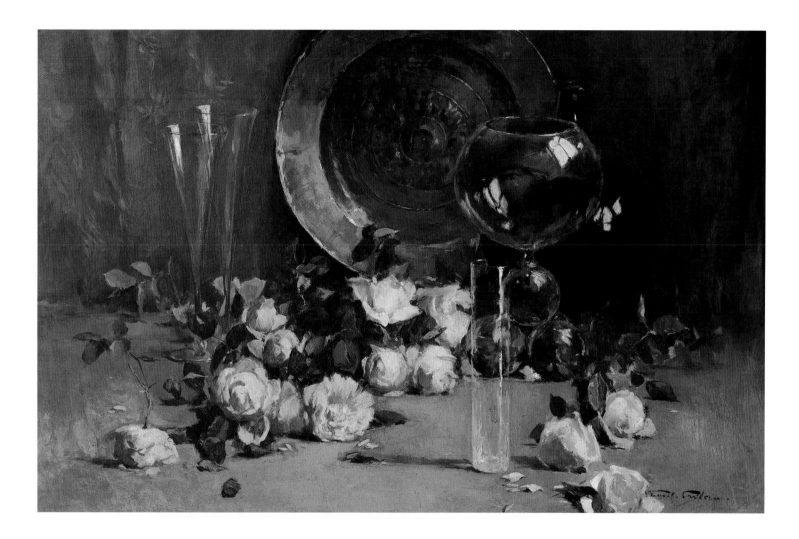

29. EMIL CARLSEN
Still Life with Yellow Roses, c. 1885

Oil on canvas, 27⅛ x 40½ in. (69 x 102.9 cm).
The Museum of Fine Arts, Houston, Wintermann
Collection of American Art, gift of Mr. and Mrs.
David R. Wintermann.

Carlsen's compositions have a spaciousness that make them seem always large
. . . As he shows them to us they are not literal things, dead, prosaic . . . They
[the objects] are forms which we cannot define; they elude us, mystify us . . .

Arthur E. Bye, 1921

Japanism and the Exotic

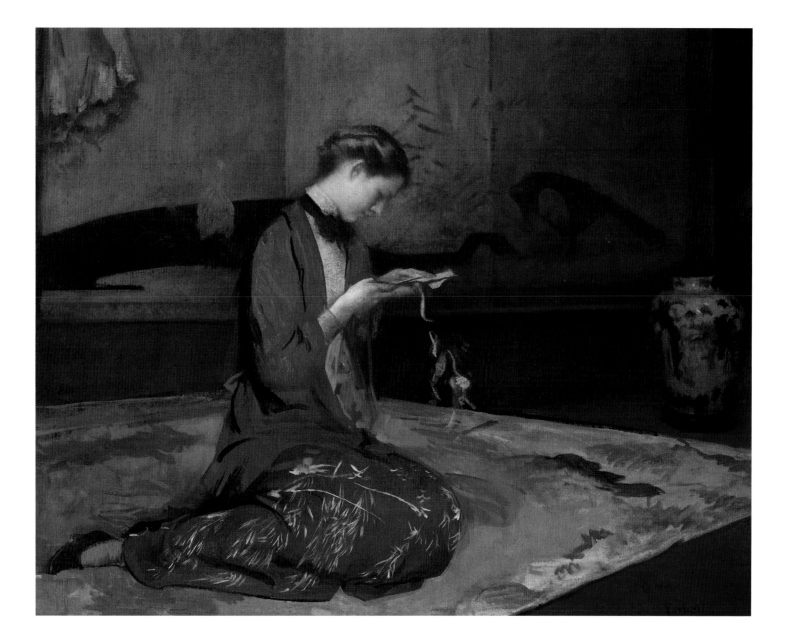

30. EDMUND C. TARBELL
Girl Cutting Patterns, 1907–08

Oil on canvas, 25 x 30 in. (63.5 x 76.2 cm).
Private collection.

The principles of composition can be taught scientifically. This does not mean mere academic formula, but the knowledge of certain fundamentals that underlie all art forms, from the subtleties of design shown in the Japanese prints and Chinese paintings, the men of the Italian Renascence (sic) and such moderns as Degas, who was a master in composition, yet whose canvases appear so spontaneous and free.

Edmund C. Tarbell, 1924

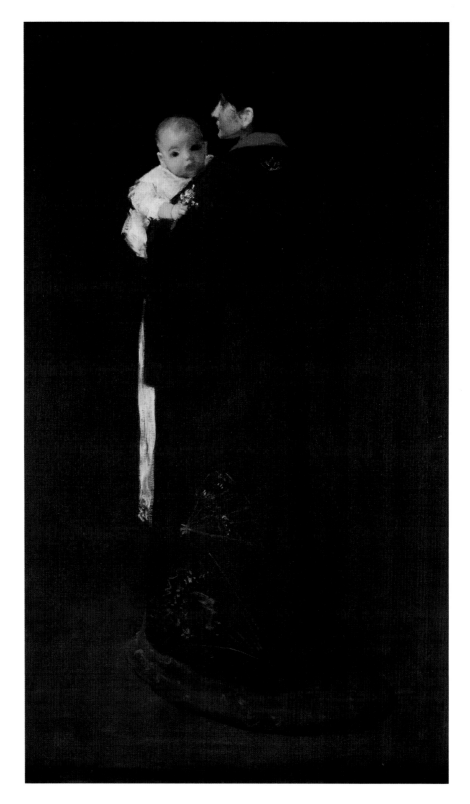

31. WILLIAM MERRITT CHASE
Mother and Child (The First Portrait),
c. 1888

Oil on canvas, 70 1/8 x 40 1/8 in. (178.1 x 101.9 cm).
The Museum of Fine Arts, Houston, gift of
Newhouse Gallery, New York.

In the *Mother and Child*, for instance, the main beauty of the canvas is inde-
scribable . . . How shall you be made to feel . . . the beauty of two tones of
black, one upon the other, the charm of the pearly flesh of the child against the
warmer carnation of the mother, or the tingling pleasure that one receives from
the one note of vivid scarlet that cuts through this quiet harmony like a knife?
How shall you be made to understand the sense of power that is conveyed by
these broad, sure sweeps of the brush . . . ?

Kenyon Cox, 1889

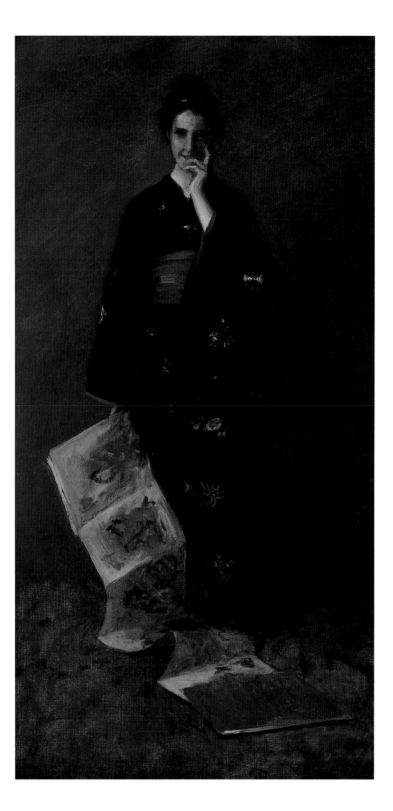

32. WILLIAM MERRITT CHASE
The Japanese Book, c. 1900

Oil on canvas, 72 x 37 in. (182.9 x 94 cm).
Frank Hevrdejs Collection.

The lesson he drew from Japanese art became part and parcel of his own. Its direct influence is obvious in his . . . introduction of Japanese objects into his composition; the indirect influence is found in his sense of elimination and color composition . . . In this day when Japanese prints of a sort are a commonplace to the shop-girl, it is difficult for us to realize that they stood as a veritable entrance to a new world to the painters of the seventies and eighties, for now we are all familiar with their influence upon modern art.

Katherine Metcalf Roof, 1917

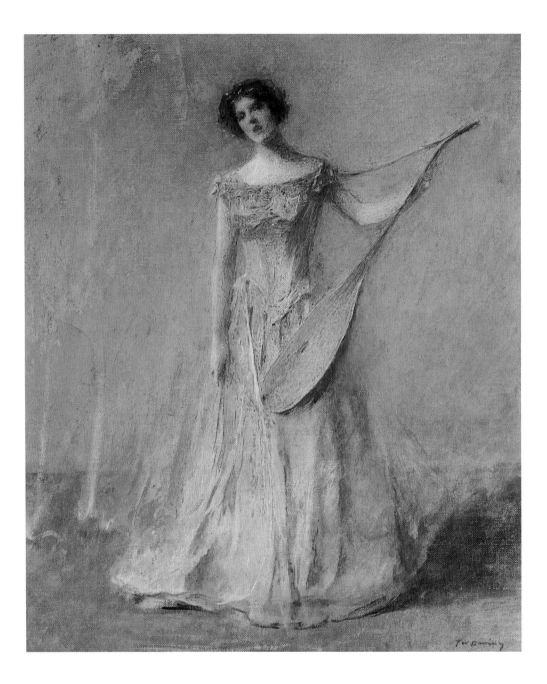

33. THOMAS WILMER DEWING
The Singer, date unknown (1890s)

Oil on canvas, 12 x 10 in. (30.5 x 25.4 cm).
Dallas Museum of Art, bequest of Joel T. Howard.

My decorations [paintings] belong to the poetic and imaginative world, where a few choice spirits live.

Thomas Wilmer Dewing, 1901

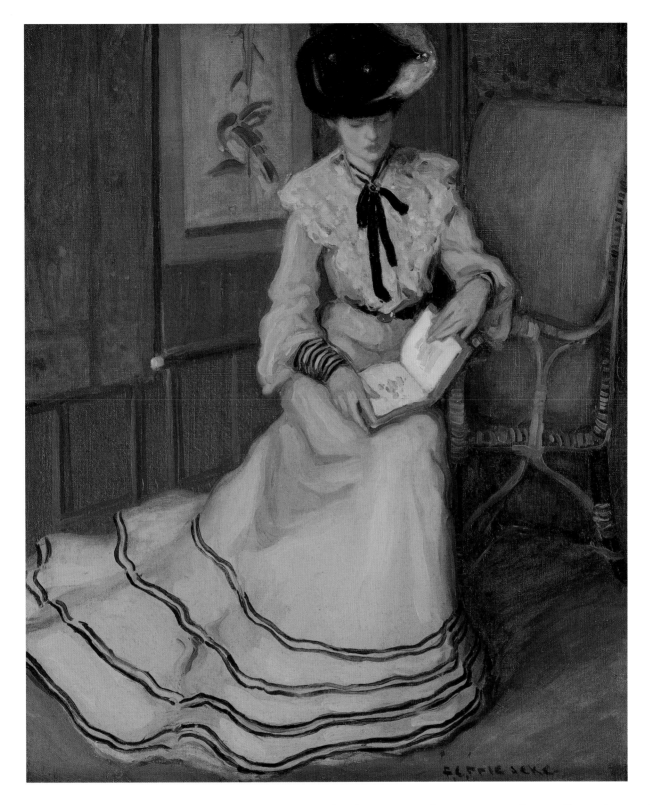

34. FREDERICK FRIESEKE
Girl Reading, c. 1900

Oil on canvas, 42³⁄₈ x 35³⁄₄ in. (107.6 x 90.8 cm).
The Museum of Fine Arts, Houston, Wintermann
Collection of American Art, gift of Mr. and Mrs.
David R. Wintermann.

On the other hand, portraiture does not interest him at all, nor the search for
and the interpretation of human character, and he never uses the figure but as
an incident or a spot in a picture.

Clara T. MacChesney, 1912

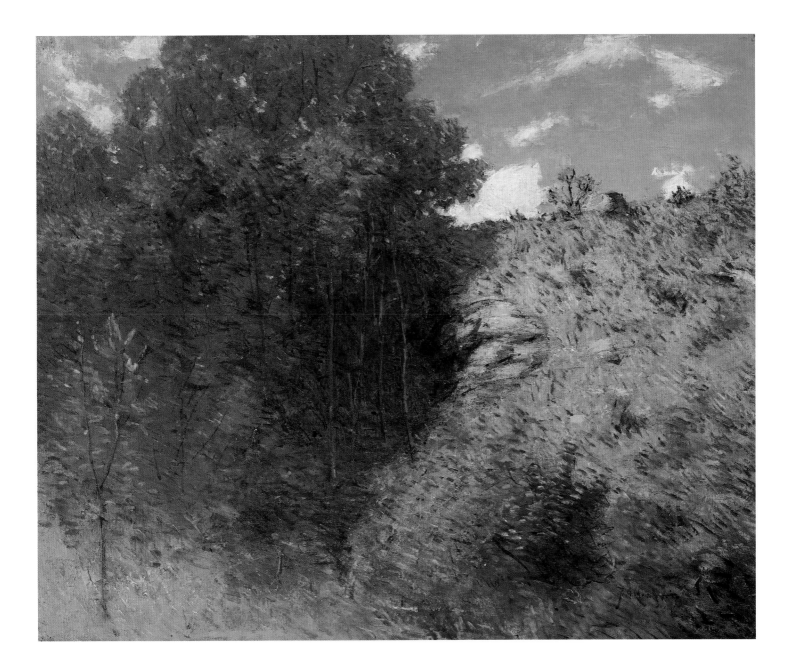

35. J. ALDEN WEIR
Ravine near Branchville, c. 1905–15

Oil on canvas, 25 x 30½ in. (63.5 x 77.5 cm).
Dallas Museum of Art, bequest of Joel T. Howard.

It is very pleasant to sit with Weir at a table and look over proofs, etchings, or Japonaiseries together. . . . I imagine the best men have been influenced for the better by Japanese art, not only in arrangements, but in their extraordinary delicacy of tone and color . . .

Theodore Robinson, 1893

The "Monet Gang"

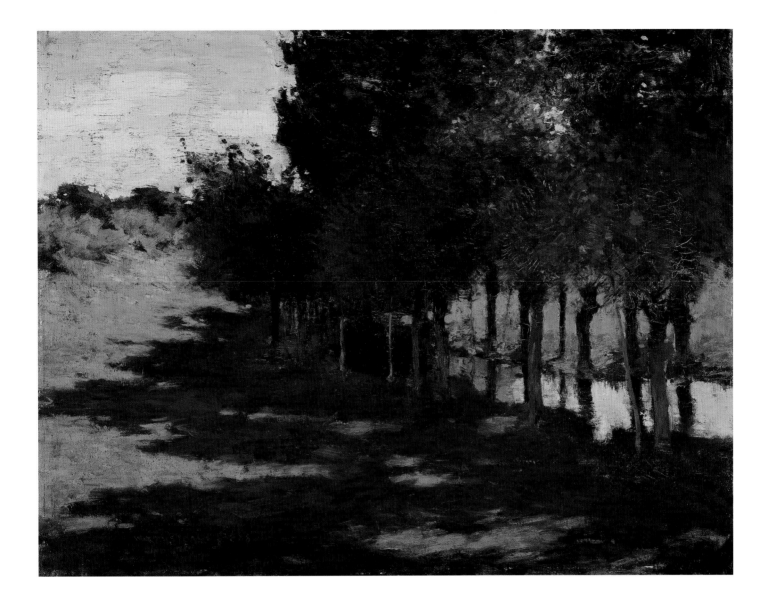

36. WILLARD LEROY METCALF
Sunlight and Shadow, 1888

Oil on wood panel, 12 3/4 x 16 1/8 in. (32.4 x 41 cm).
The Museum of Fine Arts, Houston,
gift of Miss Ima Hogg.

Always an artist susceptible to beauty in its most modest and delicate mani-
festations, he has fed his eyes with color everywhere. . . . In a certain delicate
gamut, of which he thoroughly comprehends the possibilities, he is perfect.
William Howe Downes, *Boston Evening Transcript*, March 21, 1889

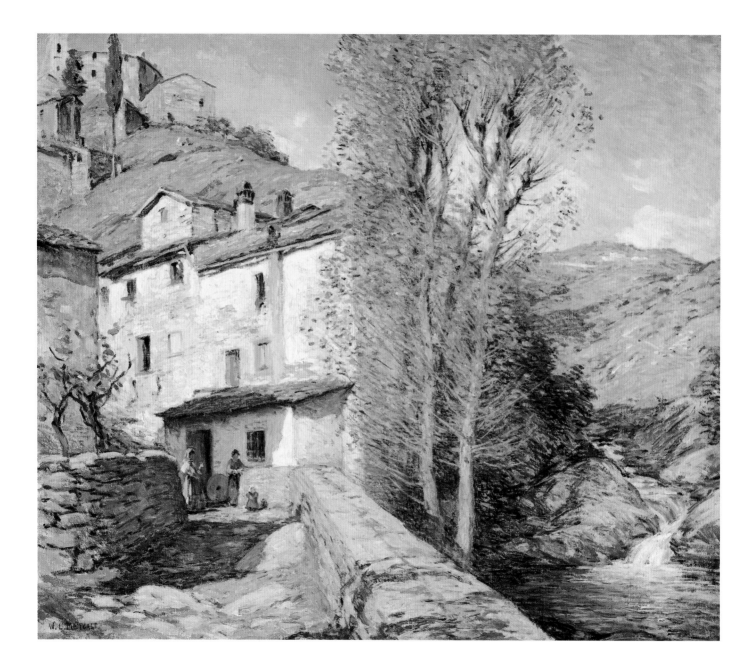

37. WILLARD LEROY METCALF
Old Mill, Pelago, Italy, 1913

Oil on canvas, 26 x 29¼ in. (66 x 74.3 cm).
Mr. and Mrs. Pat Rutherford.

Here and there remaining notes of antiquity in the masonry and architecture—quaint old bell towers—doors of heavy carved oak and sculptured entrances to old tumbling dwellings. . . . The people very actively engaged in the harvesting—and when the sun did shine the exposed side of the narrow little streets would be a solid line of women of all ages working away at looms—weaving straw and making lace—all chattering—and quite a medley of color.
Willard Leroy Metcalf in Italy, November 10, 1913

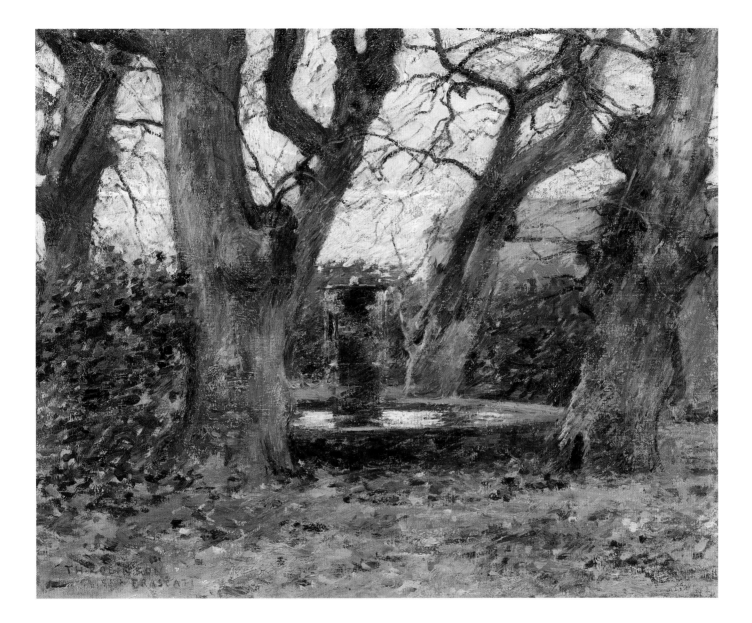

38. THEODORE ROBINSON
Italian Landscape with a Fountain, c. 1891

Oil on canvas, 18¼ x 22⅜ in. (46.4 x 56.8 cm).
Private collection.

Altogether the possibilities are very great for the moderns, but they must draw without ceasing or they will get left, and with the brilliancy and light of real outdoors, combine the austerity, the sobriety, that has always characterized good painting.

Theodore Robinson

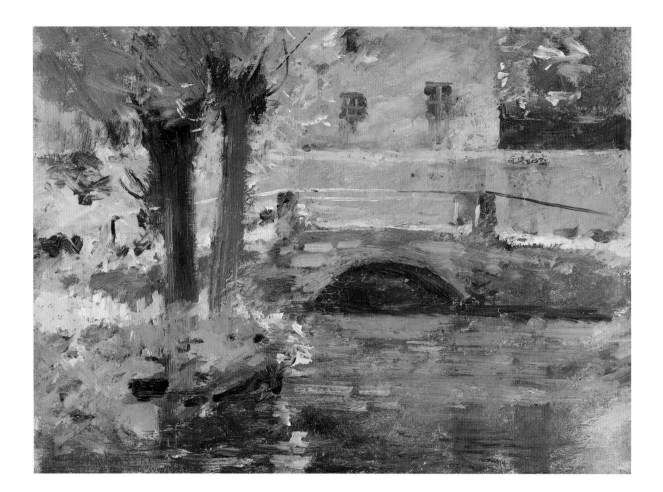

39. THEODORE ROBINSON
The Bridge at Giverny, 1891

Oil on canvas, 10⅜ x 13⅞ in. (26.4 x 35.3 cm).
The Museum of Fine Arts, Houston, Wintermann
Collection of American Art, gift of Mr. and Mrs.
David R. Wintermann.

To my mind no one has yet painted out-of-doors quite so truly. He [Claude Monet] is a realist, believing that nature and our own day give us abundant and beautiful material for pictures: that, rightly seen and rendered, there is as much charm in a nineteenth-century girl in her tennis- or yachting-suit, and in a landscape of sunlit meadows or river-bank, as in the Lefebvre nymph with her appropriate but rather dreary setting of "classical landscape"; that there is an abundance of poetry outside of swamps, twilights, or weeping damosels.

Theodore Robinson, 1896

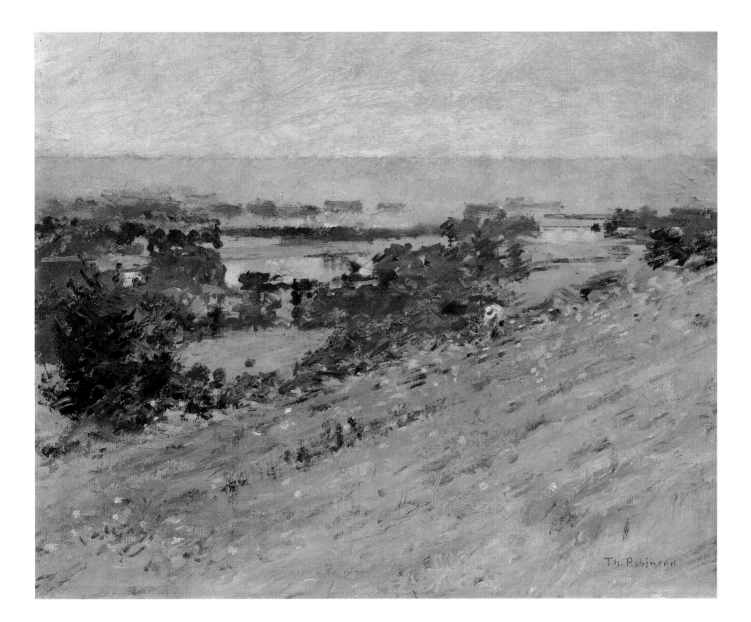

40. THEODORE ROBINSON
View of the Seine, c. 1892

Oil on canvas, 18 x 21 ¾ in. (45.7 x 55.25 cm).
Private collection.

Quite an American colony has gathered, I am told, at Givernay (sic), seventy miles from Paris on the Seine, the home of Claude Monet, including our Louis Ritter, W.L. Metcalf, Theodore Wendell (sic), John Breck, and Theodore Robinson of New York. A few pictures just received from these young men show that they have got the blue, green color of Monet's impressionism and 'got it bad.'

The Art Amateur, October 1887

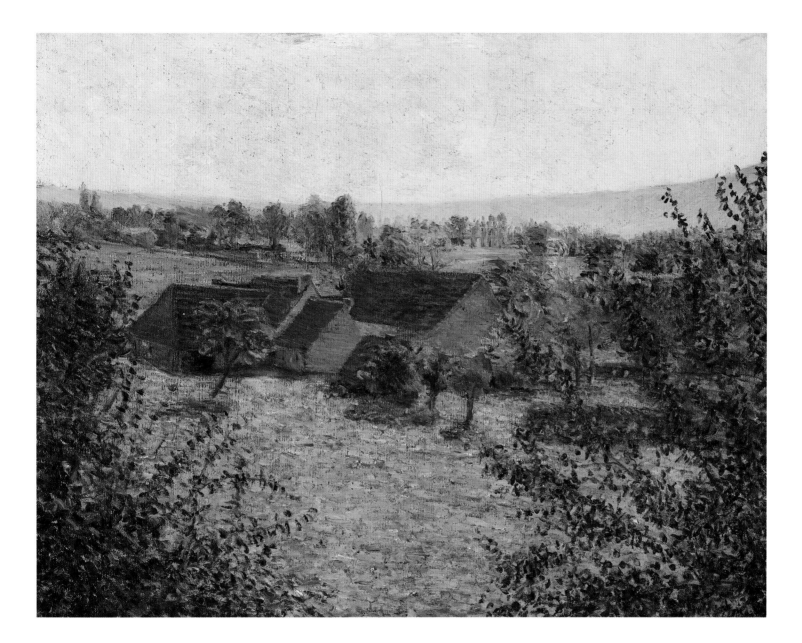

41. LILLA CABOT PERRY
The Old Farm, Giverny, 1900

Oil on canvas, 25 ⅝ x 32 in. (65.1 x 81.3 cm).
Meredith Long and Company.

I remember his (Claude Monet) saying to me: 'When you go out to paint, try to forget what objects you have before you, a tree, a house, a field or whatever. Merely think here is a little square of blue, here an oblong of pink, here a streak of yellow, and paint it just as it looks to you, the exact color and shape, until it gives your own naive impression of the scene before you.'

Lilla Cabot Perry, 1927

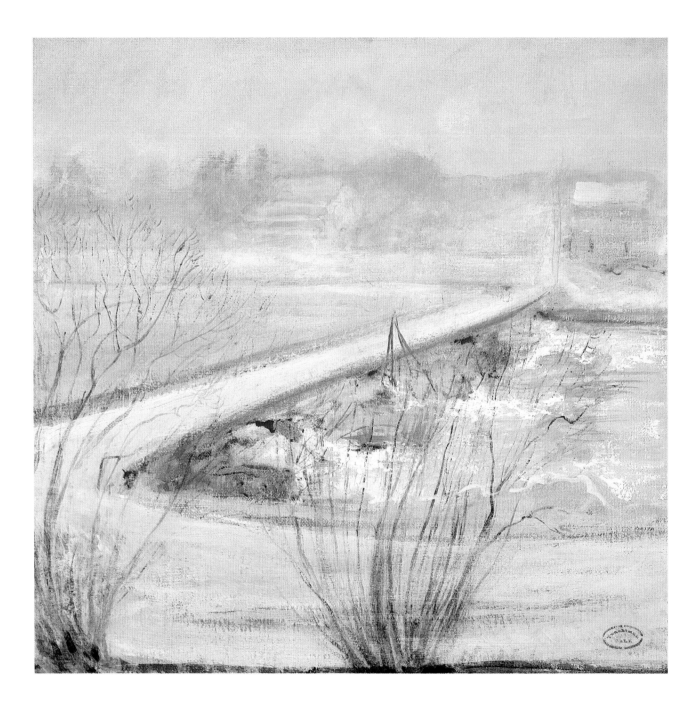

42. JOHN HENRY TWACHTMAN
Winter, c. 1898

Oil on canvas, 25 x 25 in. (63.5 x 63.5 cm).
Mr. and Mrs. Fayez Sarofim.

We must have snow and lots of it. Never is nature more lovely than when it is snowing. Everything is so quiet and the whole earth seems wrapped in a mantle . . .

John Henry Twachtman to J. Alden Weir, 1891

43. LOWELL BIRGE HARRISON
A Puff of Steam, before 1914

Oil on canvas, 20 x 24 in. (50.8 x 61 cm).
The Museum of Fine Arts, Houston, museum
purchase with funds provided by the Houston Art
League.

If he [Harrison] had not been a painter he would have been a poet; in all his
recent work one finds bigness of theme, combined with simplicity of presen-
tation, and through it all runs a deep current of sentiment governed by an
appreciation of the mechanical limitations of his medium which makes for
proper restraint. Always there is strong reserve in color and always beautiful
balance in composition—indeed, one feels that it is the picturesque unity of
his canvases that gives them their strongest hold upon his audiences.

John E. D. Trask, *Scribner's Magazine*

44. CHILDE HASSAM
Dewey Arch, 1900

Gouache and watercolor on board, 18½ x 22½ in.
(47 x 57.1 cm).
Mr. and Mrs. Pat Rutherford.

I believe the man who will go down to posterity is the man who paints his own time and the scenes of everyday life around him. . . . There is nothing so interesting to me as people. I am never tired of observing them in every-day life, as they hurry through the streets on business or saunter down the promenade on pleasure. Humanity in motion is a continual study to me.

Childe Hassam, 1892

45. CHILDE HASSAM
Evening in New York, 1890s

Oil on canvas, 22¼ x 18¼ in. (56.5 x 46.4 cm).
The Museum of Fine Arts, Houston, partial gift of
Mrs. Langdon Dearborn.

I paint from cabs a good deal. I select my point of view and set up my canvas,
or wooden panel, on the little seat in front of me, which forms an admirable
easel. . . . there is no end of material in the cabbies. Their backs are quite as
expressive as their faces. They live so much in their clothes, that they get to
be like thin shells, and take on every angle and curve of their tempers as well as
their forms. They interest me immensely.

Childe Hassam, 1892

46. CHILDE HASSAM
At Gloucester, 1890

Watercolor on board, 14¹/₈ x 20 in. (35.6 x 50.8 cm).
MacNay Art Museum, bequest of Marion Koogler
McNay.

As the artist practices his peaceful profession he can hold himself aloof from the rabble without the least danger or damage to his work. He is alone. If this is happiness, he has it. . . . He has what saints sought for in the desert.

Childe Hassam

47. CHILDE HASSAM
Hollyhocks, Isles of Shoals, 1902

Pastel on pastel, 18 1/2 x 22 in. (50 55.9 cm).
Private collection.

[An encounter with Hassam] is like taking off a pair of black spectacles that
one has been compelled to wear out of doors, and letting the full glory of
nature's sunlight color pour in upon the retina.

A reviewer of Hassam's exhibition, c. 1891

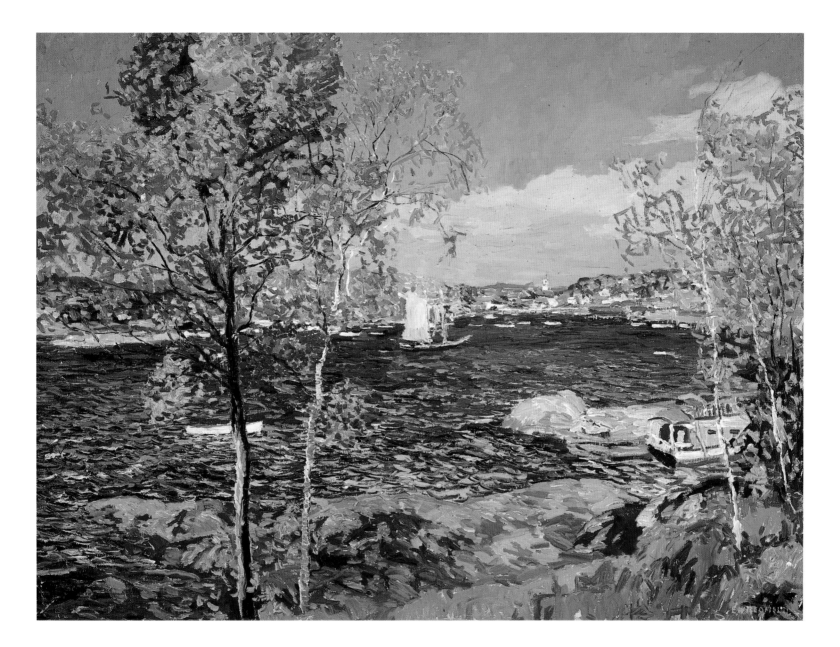

48. EDWARD REDFIELD
October Breeze, c. 1928

Oil on canvas, 38 x 50 in.(96.5 x 127 cm).
Edward Redfield Richardson.

His work is highly objective. Always and everywhere his eye is on the ever-
changing face of nature, noting the ever-varying aspects of sky and land, which
he has recorded with unerring precision . . .

J. Nilsen Laurvik, 1910

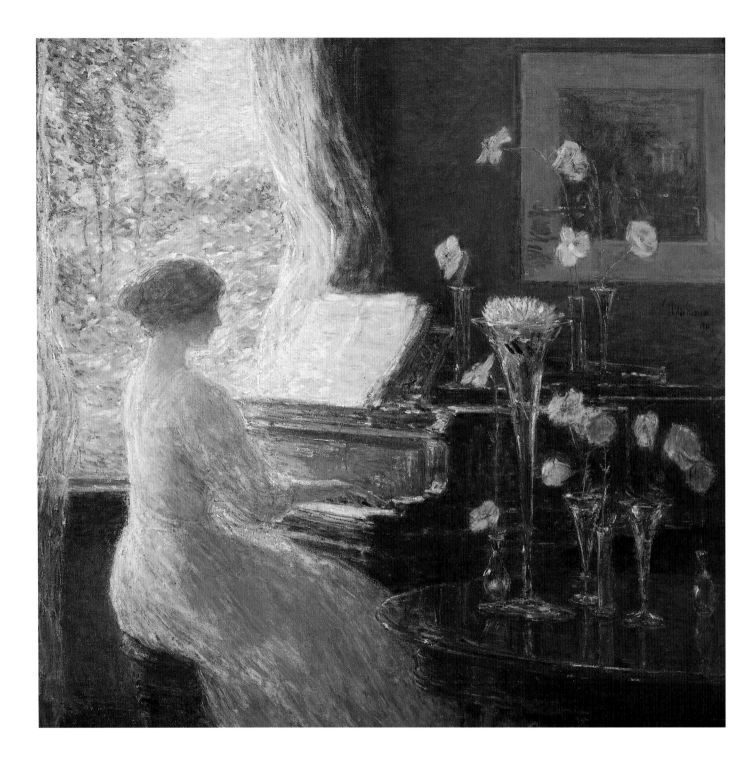

49. CHILDE HASSAM
The Sonata, 1911

Oil on canvas, 33⅛ x 33⅜ in. (84.3 x 84.8 cm).
The Museum of Fine Arts, Houston, Wintermann
Collection of American Art, gift of Mr. and Mrs.
David R. Wintermann.

The word "impression" as applied to art has been abused, and in the
general acceptance of the term has become perverted. It really means the only
truth because it means going straight to nature for inspiration, and not allow-
ing tradition to dictate to your brush, or to put brown, green or some other
colored spectacles between you and nature as it really exists . . .

Childe Hassam, 1892

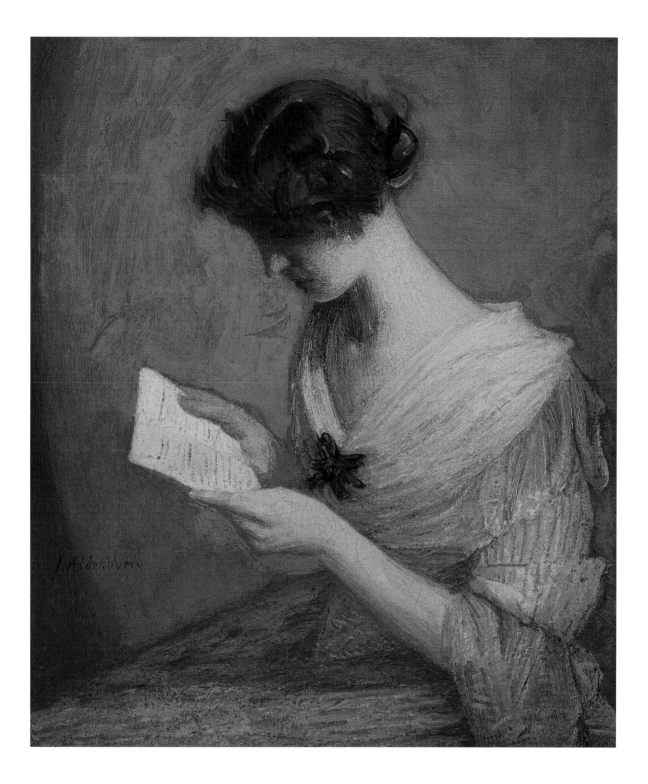

50. J. ALDEN WEIR
The Letter, c. 1910–19

Oil on canvas, 30 x 25 1/8 in. (76.2 x 63.8 cm).
Private collection.

If Weir's painting lacks the sense of exhilarated discovery conveyed by the Frenchmen's rainbow palette, he avoids the worship of surface which often acted to obliterate lines and objects. Weir's paintings retain the solidity of fact and a concern for what lies behind surfaces.

Dorothy Weir Young, 1960

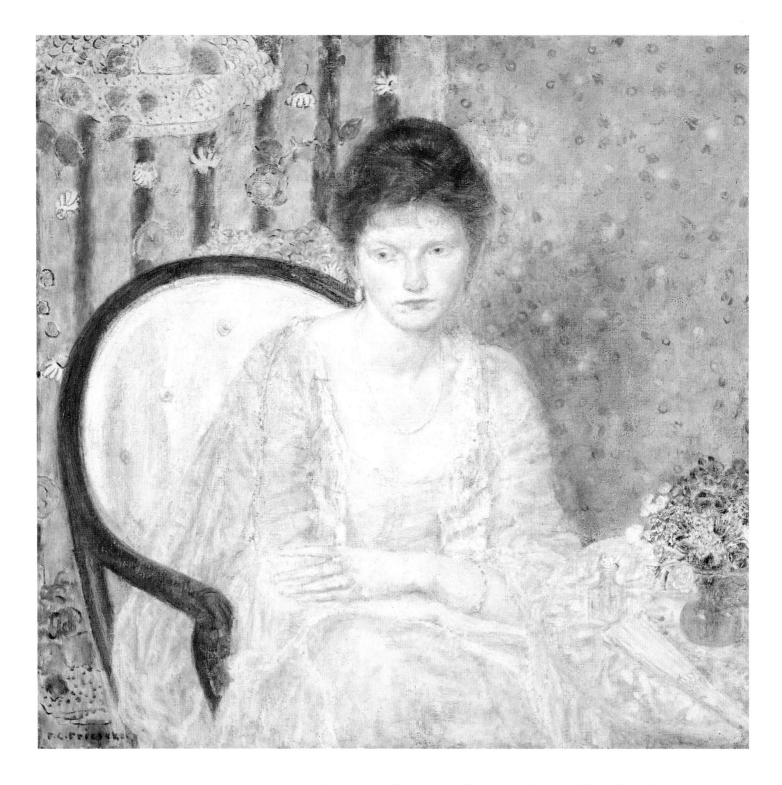

51. FREDERICK FRIESEKE
Lady in Rose, c. 1910–15

Oil on canvas, 32⅜ x 32⅜ in. (82.2 x 82.2 cm).
William Hill Land and Cattle Company.

He is par-excellence a mural decorator; he sees all his effects from that point
of view . . .

Clara T. MacChesney, 1912

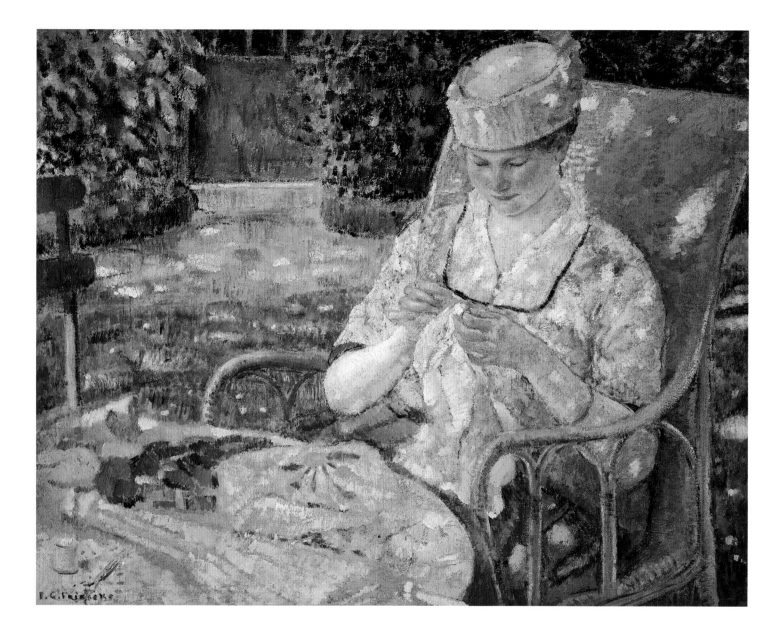

52. FREDERICK FRIESEKE
Sewing in the Garden, c. 1915

Oil on canvas, 29³/₈ x 36⁵/₈ in. (74.6 x 93 cm).
Ann Gordon Trammell.

. . . It is sunshine, flowers in sunshine, girls in sunshine, the nude in
sunshine, which I have principally been interested in for eight years, and if I
could only reproduce it exactly as I see it I would be satisfied . . .

Frederick Frieseke, 1914

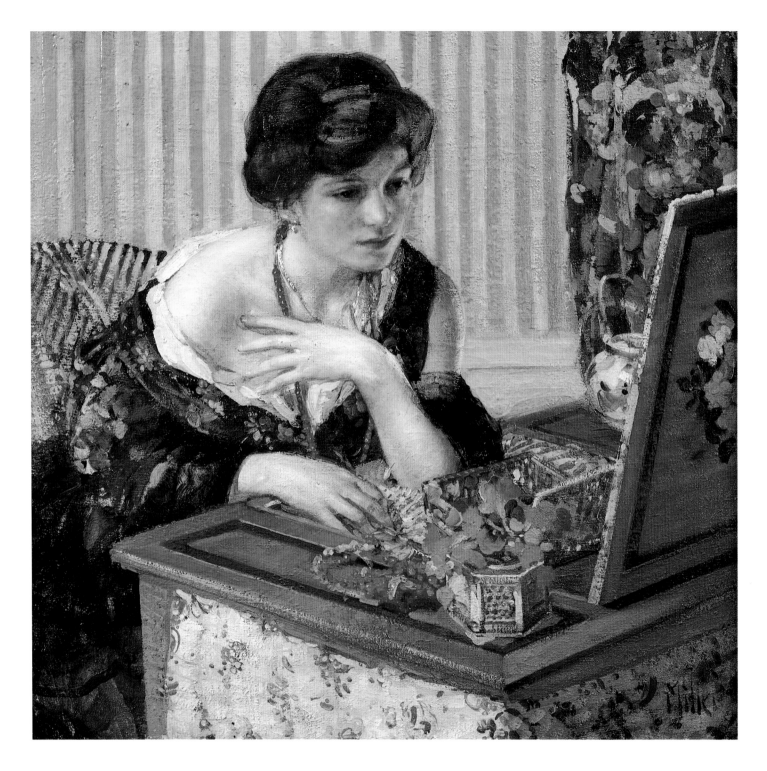

53. RICHARD EMIL MILLER
The Scarlet Necklace, c. 1906

Oil on canvas, 32 x 32 in. (81.3 x 81.3 cm).
Frank Hevrdejs Collection.

[His] interiors are cool and graceful, his women delicate and mysterious.
James Huneker, 1911

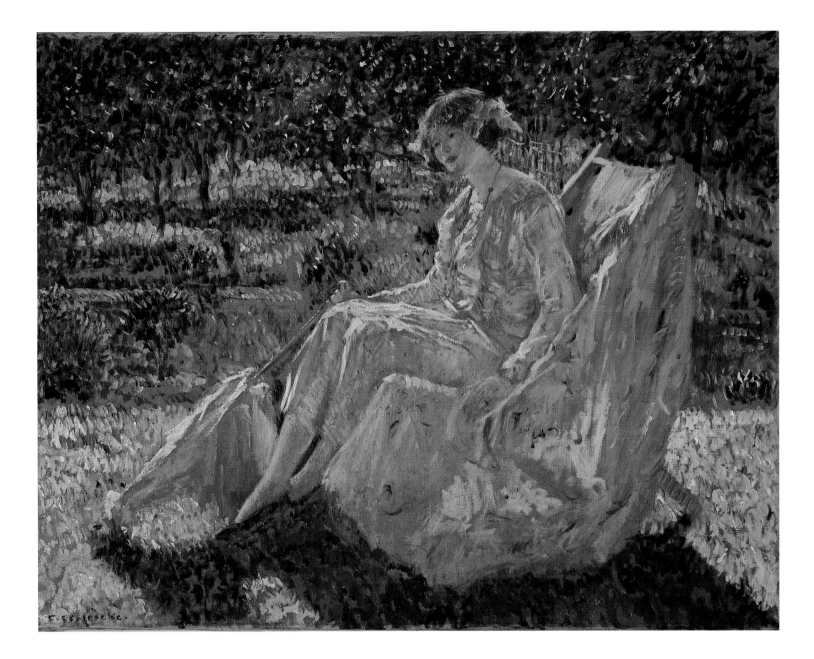

54. FREDERICK FRIESEKE
Sunbath, c. 1910

Oil on canvas, 28⅞ x 36½ in. (73.4 x 92.7 cm).
The Museum of Fine Arts, Houston, gift of Mr. and
Mrs. Isaac Arnold, Jr. in memory of Mrs. Agnes
Cullen Arnold.

I stay on here because I am more free and there are not the Puritanical restrictions which prevail in America. Not only can I paint a nude out of doors, but I can have a greater choice of subjects.

Frederick Frieseke, in France, 1914

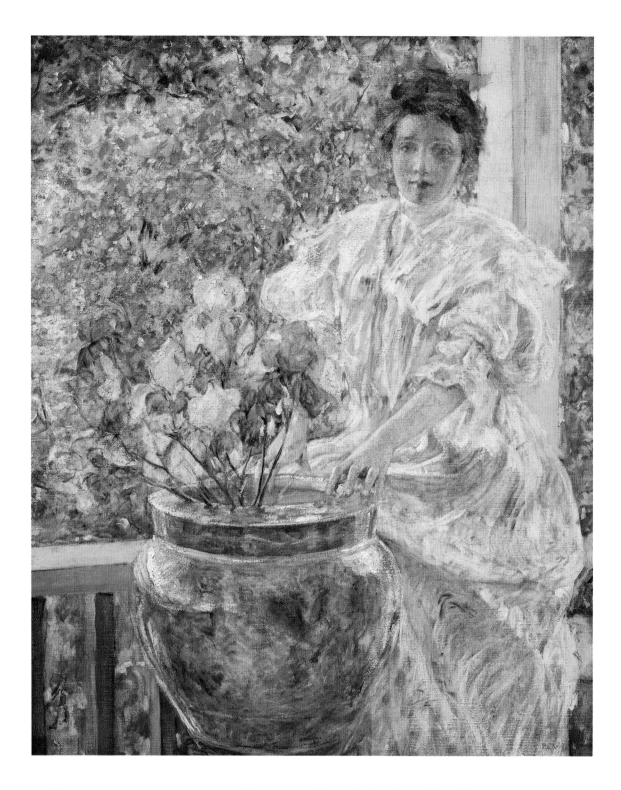

55. ROBERT REID
Woman on a Porch with Flowers, c. 1906

Oil on canvas, 34 x 26 in. (86.4 x 66 cm).
Private collection.

If you want to know the loveliest effect of nature: go out into some lovely
scene and when there is a lovely glow in the sky, turn you (sic) head
(& body) *away* from that glow—and look before you—what will you see?
Just the most exquisite "scheme" you ever dreamt of—so delicate and subtle . . .
Robert Reid, 1887

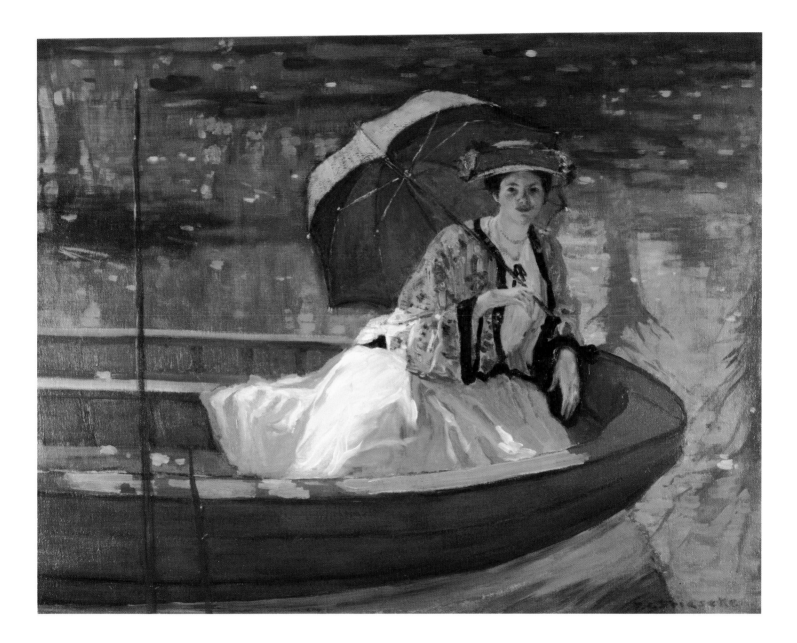

56. FREDERICK FRIESEKE
Lady with a Parasol, c. 1908

Oil on canvas, 25½ x 32 in. (64.8 x 81.3 cm).
Private collection.

Nor do I believe in constructing a picture from manifold studies which have been made in *"plein air."* One is in a nervous tension, then . . . One should think always of the impression the picture will produce indoors, and to do this correctly one must always exaggerate the impression and heighten the color.

Frederick Frieseke, 1912

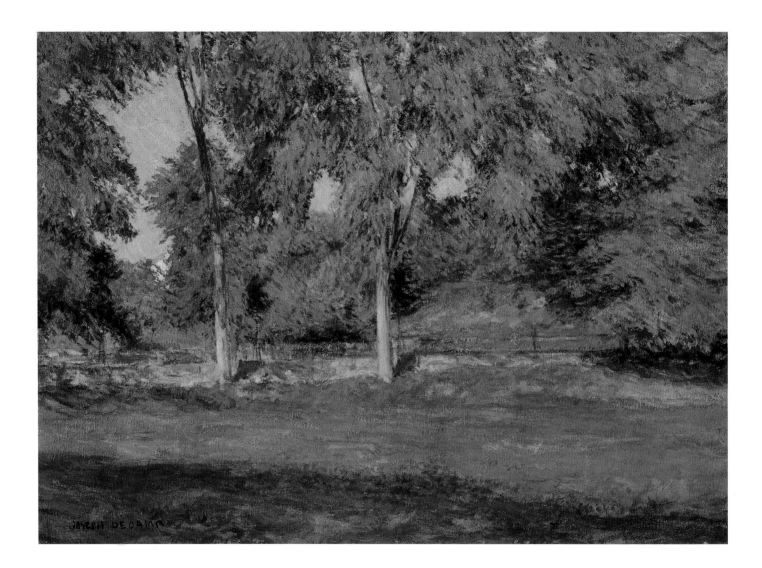

57. JOSEPH DeCAMP
September Afternoon, 1894

Oil on canvas, 20 x 27 in. (50.8 x 68.6 cm).
Frank Hevrdejs Collection.

Impressionism had long tempted him [DeCamp] to play with the varying light, which . . . was done with reserve but with great charm. . . . he never resorts to mannerisms or tricks of technique, nor does he ever worry the observer with the detailed, painstaking evidence of his well-thought-out plan . . . Those who knew him best feel that it was a serious loss to the American landscape lovers that DeCamp left so few of his delightful out-of-door compositions.

Rose V.S. Berry, 1923

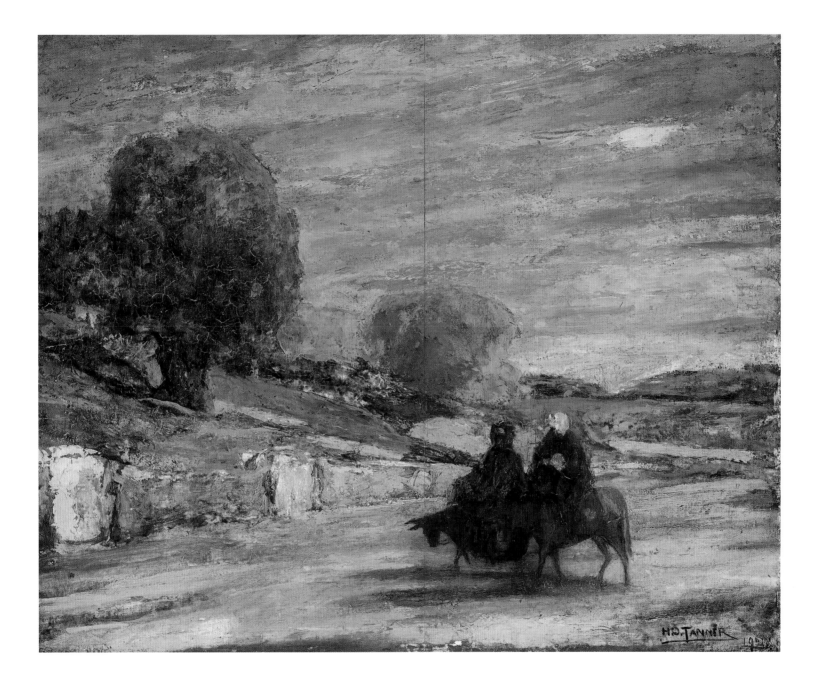

58. HENRY OSSAWA TANNER
Flight into Egypt, 1921

Oil on board, 20 x 23⅞ in. (50.8 x 60.7 cm).
The Museum of Fine Arts, Houston, gift of Mrs.
Evan R. Burris.

Mr. Tanner told me that one of his aims was to present the simple domestic side of biblical personages. He said that the Bible was full of suggested domesticity. He is not painting actual incidents, as they have a thousand times been represented, but that quiet suggestion of Bible characters as we might imagine them to be.

F. J. Campbell, 1911

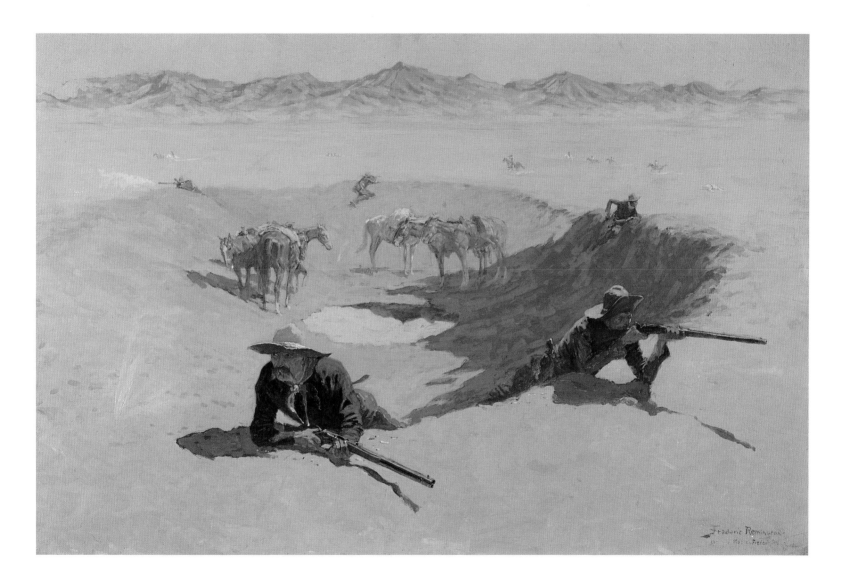

59. FREDERIC REMINGTON
Fight for the Waterhole, 1903

Oil on canvas, 38 1/2 x 51 1/2 in. (97.8 x 130.8 cm).
The Museum of Fine Arts, Houston, The Hogg
Brothers Collection, gift of Miss Ima Hogg.

Big art is a process of elimination . . . cut down and out—do your hardest
work outside the picture, and let your audience take away something to think
about—to imagine. . . . What you want to do is just create the thought—
materialize the spirit of a thing, and the small bronze—or the impressionist's
picture—does that.

Frederic Remington, 1903

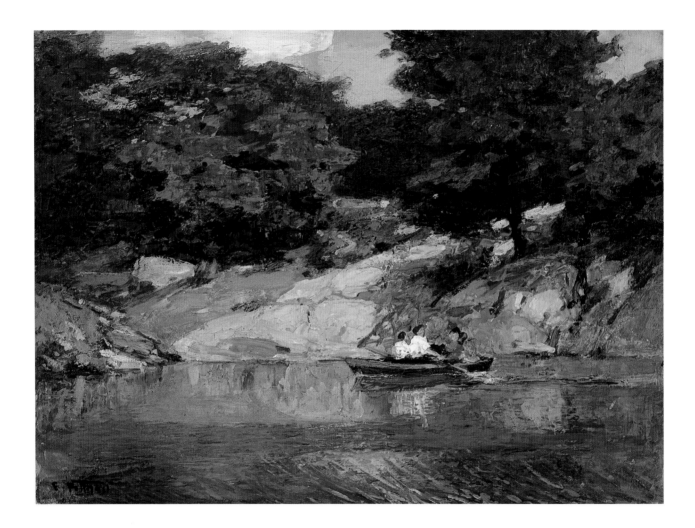

60. EDWARD HENRY POTTHAST
Boating in Central Park, c. 1900–05

Oil on board, 12 x 15⅞ in. (30.5 x 40.3 cm).
The Museum of Fine Arts, Houston, Wintermann
Collection of American Art, gift of Mr. and Mrs.
David R. Wintermann.

His tools are rather unusual and apparently thoroughly practical. He has
pasted canvas onto board, resulting in a sketch board as easily carried and
convenient as the various sketching boards the painters use, but with all the
advantage of the lasting quality of paint on canvas . . .

New York Times, October 19, 1924

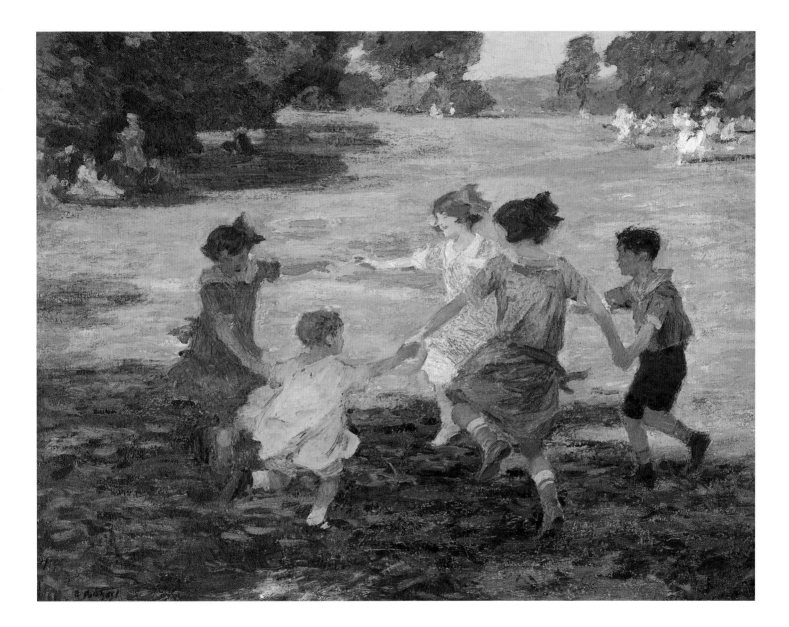

61. EDWARD HENRY POTTHAST

Ring Around the Rosie, c. 1910-15

Oil on canvas, 33¾ x 39½ in. (85.7 x 100.5 cm).
The Museum of Fine Arts, Houston, Wintermann
Collection of American Art, gift of Mr. and Mrs.
David R. Wintermann.

One dry Saturday we cruised on Fifth Avenue with good results and saw something that made up for the lack of—well, the general lack of everything in summer in New York. It was a small oil painting . . . by Edward Potthast. It was so vivid that it took your mind off prohibition and everything, and gave you an interior laugh that was the next thing to a cocktail . . . Thanks, Mr. Potthast, you say, life isn't so terrible after all.

New York Sun, July 23, 1921

The "Virility" Painters

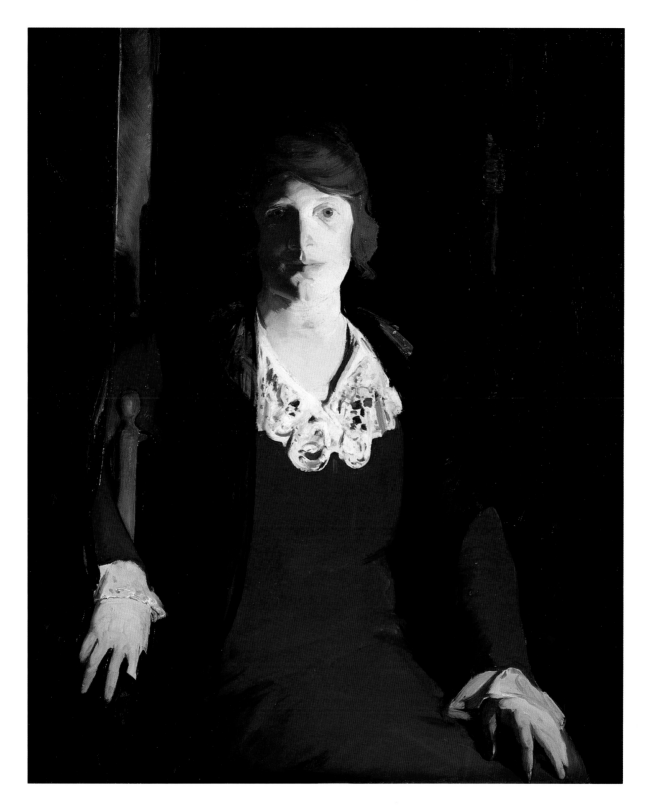

62. GEORGE BELLOWS
Portrait of Florence Pierce, 1914

Oil on canvas, 38 x 30 in. (96.5 x 76.2 cm).
The Museum of Fine Arts, Houston, gift of Mr. and
Mrs. Meredith J. Long in memory of Mrs. Agnes
Cullen Arnold.

I have always regarded and spoken of painting in the perfectly commonplace
and popular sense of using color. In this sense good painting is the emotional
heightening of form by the use of the powers, relations, and significance of
colors.

George Bellows

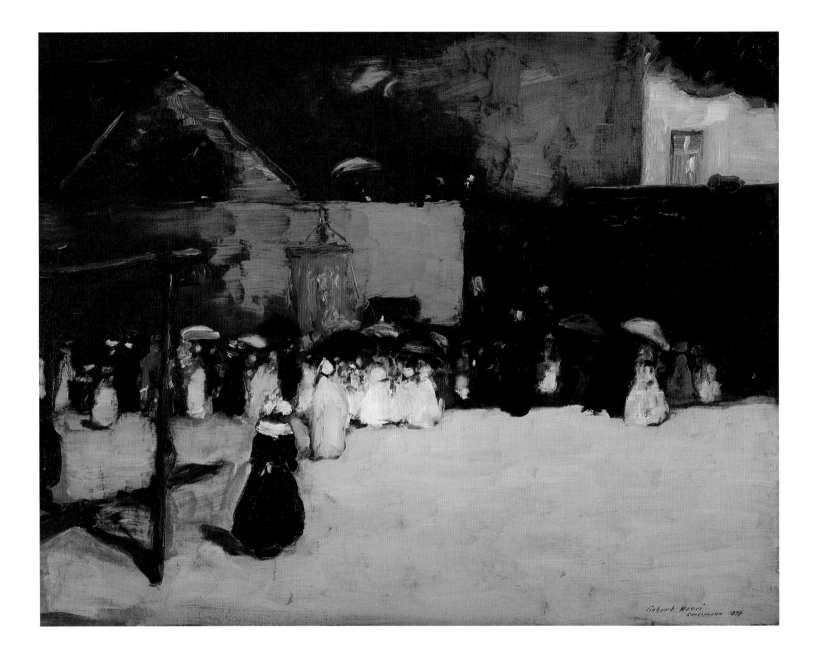

63. ROBERT HENRI
Fête de Dieu–Concarneau, 1899

Oil on canvas, 25 x 32 in. (63.5 x 81.3 cm).
Private collection.

It is the grave colors, which were so dull on the palette that become the living colors in the picture. The brilliant colors are their foil. The brilliant colors remain more in their actual character of bright paint, are rather static, and it is the grave colors, affected by juxtaposition, which undergo the transformation that warrant my use of the word "living." They seem to move—rise and fall in their intensity, are in perpetual motion—at least, so affect the eye. They are not fixed. They are indefinable and mysterious.

Robert Henri, 1923

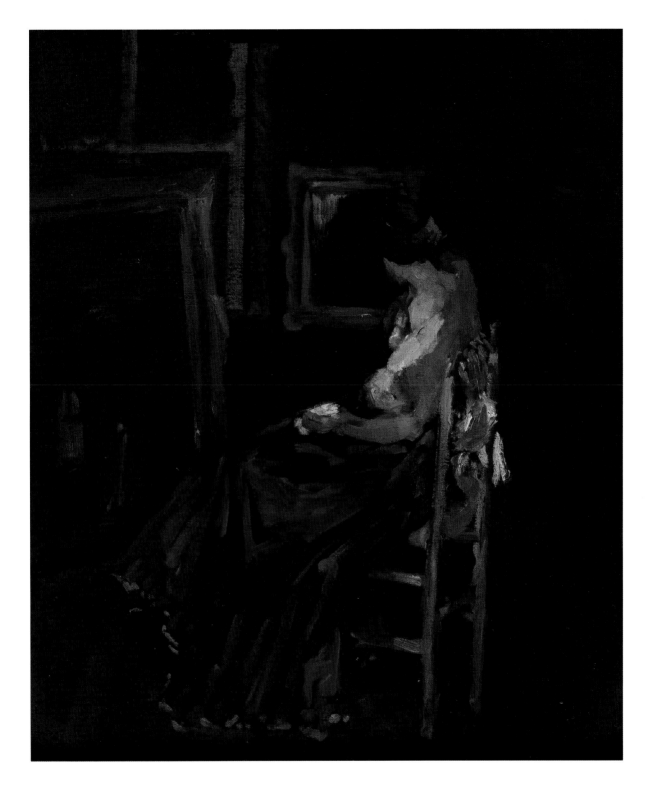

64. ROBERT HENRI
The Model, 1899

Oil on canvas, 41⅛ x 35⅛ in. (104.5 x 89.2 cm).
The Museum of Fine Arts, Houston, Wintermann
Collection of American Art, gift of Mr. and Mrs.
David R. Wintermann.

Your model can be but little more than an indifferent manikin of herself. Her
presence can but recall to you the self she was when she so inspired you . . .
You need great time to paint your picture. It took her a moment, a glance, a
movement, to inspire it. She may never be just as she was again. She changes
momentarily. . . . and imperceptibly the forms and the attitude change to the
expression of the thought, and it gets into the brush of the careless artist and
it comes out in the paint.

Robert Henri, 1923

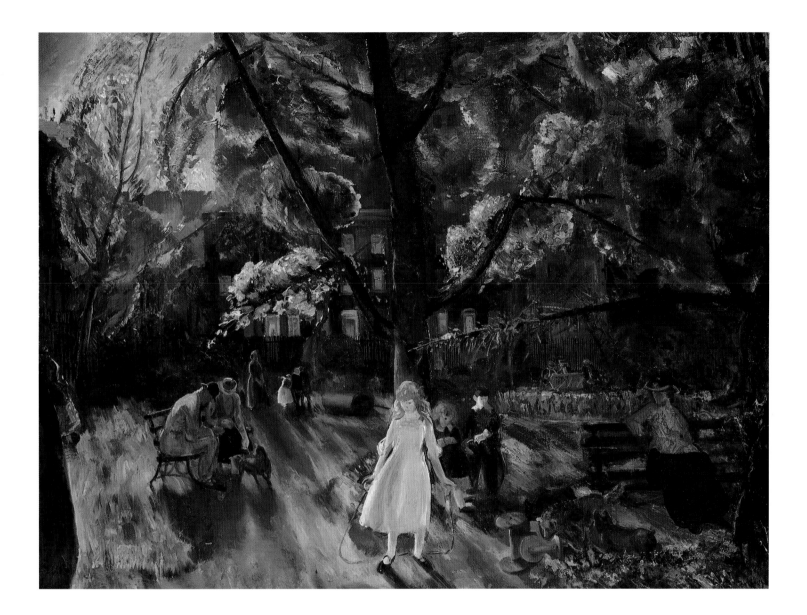

65. GEORGE BELLOWS
Gramercy Park, 1920

Oil on canvas, 34 x 44½ in. (85 x 113 cm).
Private collection.

. . . All the acts of life are the reordering, recognised or not, of phenomena, and the search for a finer reordering. A work of art may be described as an arrangement or ordering of forces with the motive of stimulating the emotions and the receptivity of the mind to aesthetic impression and creation. The ideal artist is he who knows everything, feels everything, experiences everything and retains his experience in a spirit of wonder and feeds upon it with creative lust.

George Bellows

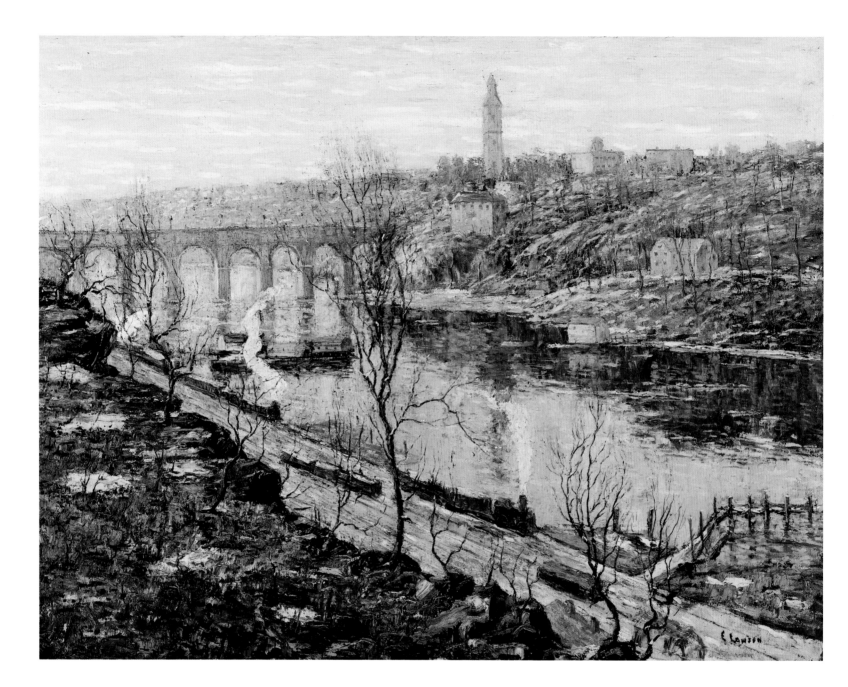

66. ERNEST LAWSON
High Bridge, Harlem River, c. 1910

Oil on canvas, 39½ x 50 in. (100.3 x 127 cm).
Courtesy of the San Antonio Museum of Art.

I would not advise everyone to paint with a palette knife as I do sometimes as one sometimes gets in a mess and seems to cover the whole world with paint. When I was working out of doors at Moret in France, I saw Sisley, the impressionist painter, walking near by . . . and asked him if he would criticize my effort. . . All he said was, after looking over the canvas and then taking in my appearance, 'Put more paint on your canvas and less on yourself.' He would not say that now for I occasionally overload and have to scrape some paint off.

Ernest Lawson

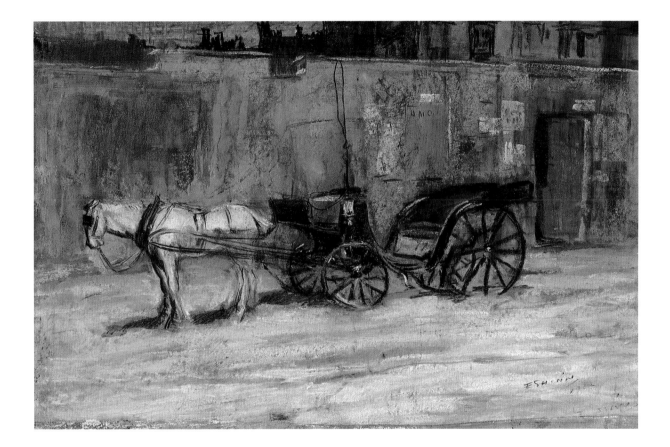

67. EVERETT SHINN
Paris, Horse and Carriage, c. 1900–05

Charcoal and pastel on paper mounted on board,
11 3/4 x 17 5/8 in. in. (29.8 x 44.8 cm).
The Museum of Fine Arts, Houston, Wintermann
Collection of American Art, gift of Mr. and Mrs.
David R. Wintermann.

You went out with a menu, or an envelope or a scrap of paper and a pencil and you had to bring back something. You learned to look and understand how things worked and your mind became the plate of the camera, crammed with a million observations.

Everett Shinn on newspaper illustrations

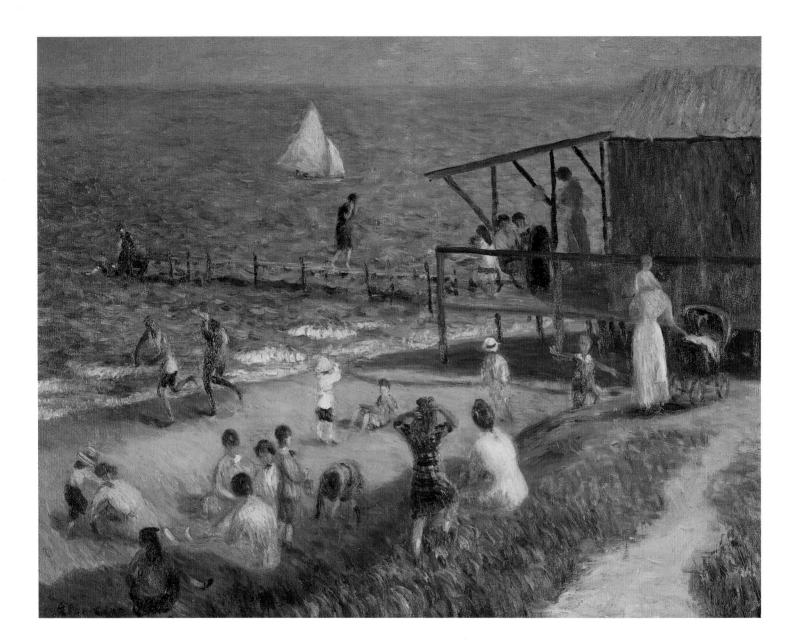

68. WILLIAM GLACKENS
The Captain's Pier, c. 1913

Oil on canvas, 26 x 32 in. (66 x 81.3 cm).
Private collection.

Bellport was a simple place, cottages, nothing showy. Bellport was still an unspoiled town, and life was largely confined to the village street . . . Near the beach stood a huge barnlike "Vacation Home" for New York shopgirls, which supplied subjects for many of my fathers canvases. A ferry every fine day took bathers across the bay to the ocean beach . . . whose rolling white dunes and scraggly bayberries and beach plums saw many picnics.

Ira Glackens

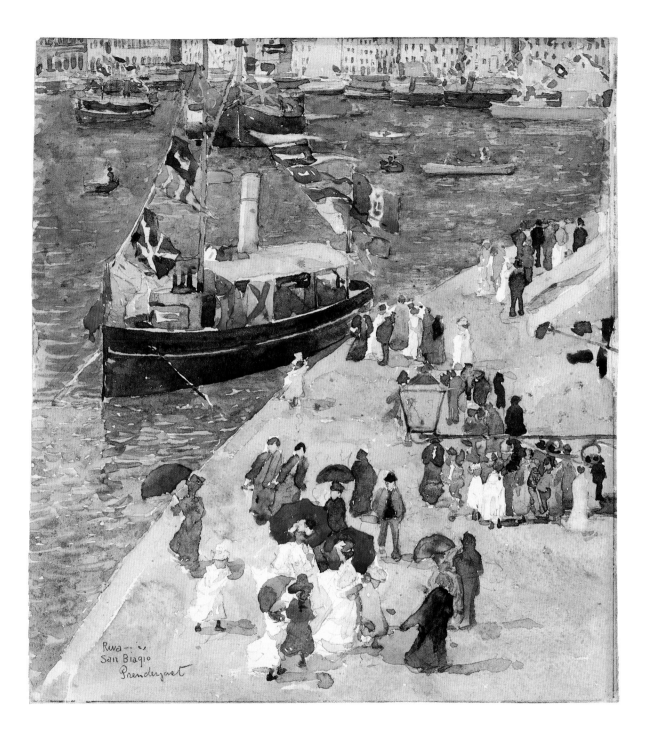

69. MAURICE PRENDERGAST
Riva San Biagio, Venice, 1898

Watercolor and graphite on paper, 12 x 10¹/₂ in.
(30.5 x 26.7 cm).
Private collection.

Mr. Prendergast was born to paint fêtes, and he carries a whole Fourth of July in his color-box. What an irresistible spirit of happy holiday activity pervades his scintillating and Watteau-like scenes! Flags fluttering, waves rippling, sun shining over all, brilliantly dressed throngs of men, women and children, all moving, here and there, in a veritable kaleidoscope of life!

Boston Evening Transcript, March 4, 1899

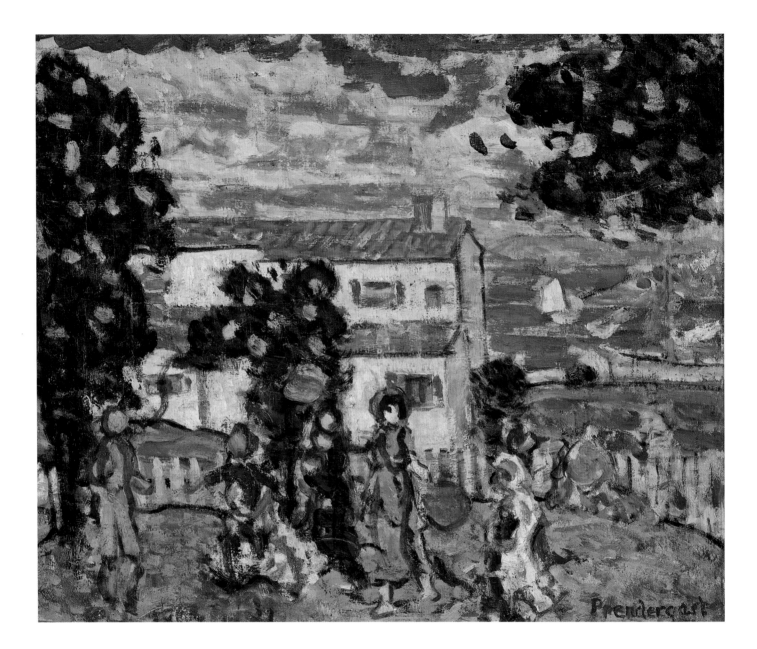

70. MAURICE PRENDERGAST
New England Village, 1918–23

Oil on canvas, 18 x 20¾ in. (45.7 x 52.7 cm).
The Museum of Fine Arts, Houston, Wintermann
Collection of American Art, gift of Mr. and Mrs.
David R. Wintermann.

His gayety and sparkle are fascinating, but the greatest charm of his style, with all its appearance of spontaneity and superficiality, depends upon qualities of color, tone and draughtsmanship which are entirely serious and solid.

Boston Evening Transcript, April 27, 1899

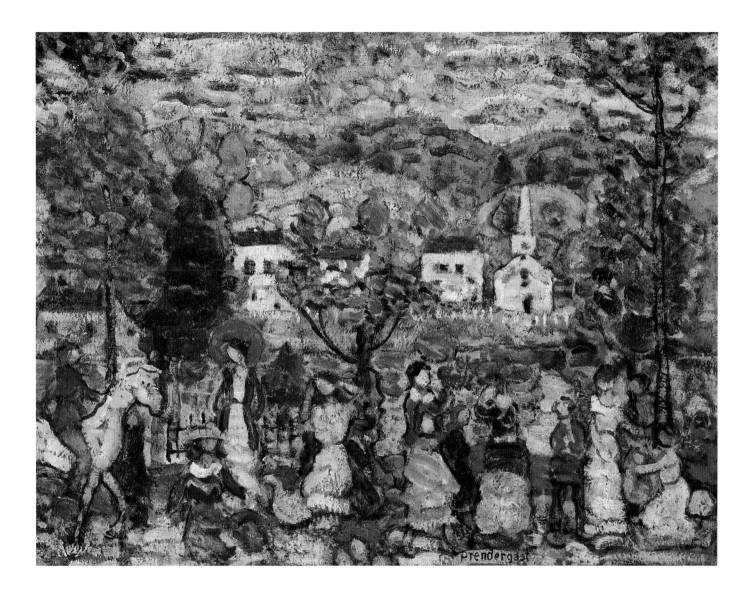

71. MAURICE PRENDERGAST
New England Village (New Bedford Village),
1918–23

Oil on canvas, 21 x 27 in. (58.3 x 68.6 cm).
Private collection.

Mr Prendergast looks modern because he always kept out of the beaten track;
and he will still look modern when a good deal of the present product looks
like the hoopskirts of 1860 . . . His emphasis is upon color, motion, the rela-
tion of objects to each other—not upon many small details.

The Evening Sun, February 10, 1914

1. *Tribune*, March 12, 1898, quoted in Gordon Hendricks, *The Life and Work of Winslow Homer* (New York: Harry N. Abrams, Inc., 1979), 234–35.

2. George W. Shelden, *Hours with Art and Artists* (New York: 1882; facsimile, 1978: 138). The interview was first published in "Sketches and Studies," *Art Journal* (New York) 6 (April 1880): 105–109, quoted in Helen A. Cooper, *Winslow Homer Watercolors*, exh. cat. (Washington, D.C.: National Gallery of Art; New Haven and London: Yale University Press, 1986), 55.

3. *New York Times*, February 1, 1879, quoted in Cooper, *Winslow Homer Watercolors*, 62.

4. Susan N. Carter, "The Water-Colour Exhibition," *The Art Journal* (New York) 5 (1879): 94.

5. *Boston Evening Transcript*, December 6, 1883, quoted in Cooper, *Winslow Homer Watercolors*, 119.

6. *Art Amateur* (April 1890): 93, quoted in Hendricks, *The Life and Work of Winslow Homer*, 201.

7. *New York Sun*, March 11, 1898, quoted in Hendricks, *The Life and Work of Winslow Homer*, 234.

8. Letter of February 23, 1895, at Bowdoin College, quoted in Hendricks, *The Life and Work of Winslow Homer*, 223.

9. Frank Jewett Mather, Jr., "The Art of Winslow Homer," *Nation* (New York), March 2, 1911, quoted in Donelson F. Hoopes, *Winslow Homer Watercolours* (New York: Watson-Guptill Publications, 1969), 18.

10. "A Painter on Painting," *Harper's New Monthly Magazine* 56 (February 1878): 458–61, quoted in Nicolai Cikovsky, Jr. and Michael Quick, *George Inness*, exh. cat. (Los Angeles: Los Angeles County Museum of Art, 1985), 205.

11. "A Painter on Painting," quoted in Cikovsky and Quick, *George Inness*, 209.

12. Samuel Isham, *The History of American Painting* (New York: The MacMillan Company, 1927), 265.

13. Achille Ségard, *Mary Cassatt: Un Peintre des Enfants et des Mères* (Paris, 1913), quoted in E. John Bullard, *Mary Cassatt: Oils and Pastels* (New York: Watson-Guptill Publications and Washington, D.C.: National Gallery of Art, 1973), 13.

14. J.K. Huysmans, *L'Art Moderne* (Paris, 1883), quoted in Bullard, *Mary Cassatt*, 42.

15. Mary Cassatt, 1873, quoted in Bullard, *Mary Cassatt*, 13.

16. Will H. Low, "The Primrose Way," typescript, ed. Mary Fairchild Low with Berthe Helene MacMonnies (Albany: Albany Institute of History and Art, 1935), quoted in H. Barbara Weinberg, *The Lure of Paris: Nineteenth Century American Painters and Their French Teachers* (New York: Abbeville Press Publishers, 1991), 205.

17. *Christian Science Monitor*, 1917.

18. K.C. Chateris, *John Sargent* (New York: Charles Scribner's Sons, 1927), 158.

19. William Howe Downes, *John S. Sargent: His Life and Work* (Boston, 1925), 30, 93, quoted in Patricia Hills, *John Singer Sargent*, exh. cat. (New York: Whitney Museum of American Art in association with Harry N. Abrams, Inc., 1987), 70.

20. Mary Newbold Patterson Hale, "The Sargent I Knew," *World Today* 50 (November 1927), quoted in Hills, *John Singer Sargent*, 195.

21. Irving Ramsay Wiles, "Portrait Painting," *Palette and Bench* (January 1909): 84.

22. Private papers, Houston.

23. Rose V.S. Berry, "Joseph DeCamp: Painter and Man," *American Magazine of Art* 14, no. 4 (April 1923): 182–89.

24. *New York Herald*, September 18, 1892, 30, quoted in Robert W. Rydell and Carolyn Kinder Carr, *Revisiting the White City: American Art at the 1893 World's Fair*, exh. cat. (Washington, D.C.: National Museum of American Art and National Portrait Gallery, Smithsonian Institution, 1993), 98.

25. A. R. Ives, "Suburban Sketching Grounds. 1. Talks with William M. Chase, Mr. Edward Moran, Mr. William Sartain,

and Mr. Leonard Ochtman," *Art Amateur* 25 (September 1891): 80, quoted in Nicolai Cikovsky, Jr. and D. Scott Atkinson, *William Merritt Chase: Summers at Shinnecock 1891–1902*, exh. cat. (Washington, D.C.: National Gallery of Art, 1987), 18.

26. Kenyon Cox, "William Merritt Chase, Painter," *Harper's New Monthly Magazine* 78 (March 1889): 549.

27. W.H. Fox, "Chase on Still Life," *The Brooklyn Museum Quarterly* 1 (January 1915): 198–9, quoted by Kenneth W. Maddox in Elizabeth Garrity Ellis et al., *The Thyssen-Bornemisza Collection: Nineteenth-Century American Painting*, ed. Barbara Novak and Elizabeth Garrity Ellis (New York: The Vendome Press, 1986), 288.

28. Emil Carlsen, "On Still-Life Painting," *Palette and Bench* 1 (October 1908): 6–8.

29. Arthur Edwin Bye, *Pots and Pans or Studies in Still-Life Painting* (Princeton, N.J. and London and Oxford, England: 1921), 215–16.

30. Ada Rainy, "In the Realm of Art . . . ," *Washington Post*, October 5, 1924, quoted in Patricia Jobe Pierce, *Edmund C. Tarbell and The Boston School of Painting, 1889–1980* (Hingham, Mass.: Pierce Galleries, Inc., 1980), 81.

31. Cox, "William Merritt Chase, Painter," 555.

32. Katherine Metcalf Roof, *The Life and Art of William Merritt Chase* (New York: Hacker Art Books, 1975), 280.

33. Thomas Wilmer Dewing to Charles Lang Freer, February 16, 1901, quoted in Thomas Lawton and Linda Merrill, *Freer: A Legacy of Art* (Washington, D.C.: Freer Gallery of Art, Smithsonian Institution in association with Harry N. Abrams, Incorporated, 1993), 168.

34. Clara T. MacChesney, "Frederick Carl Frieseke: His Work and Suggestions for Painting from Nature," *Arts and Decoration* 3 (November 1912): 15.

35. Theodore Robinson diaries, entry for November 30, 1893, quoted in Julia Meech-Pekarik, "Early Collectors of Japanese Prints and The Metropolitan Museum of Art," *Metropolitan Museum Journal* 17 (1982): 106.

36. William Howe Downes, "Boston Evening Transcript," March 21, 1889, quoted in Elizabeth de Veer and Richard J. Boyle, *Sunlight and Shadow: The Life and Art of Willard L. Metcalf* (New York: Abbeville Press, 1987), 50.

37. Willard Metcalf diary entry, November 10, 1913, collection of Rosalind Metcalf Harris, quoted in de Veer and Boyle, *Sunlight and Shadow*, 114.

38. From the unpublished diaries of Theodore Robinson on deposit at the Frick Art Reference Library, quoted in William H. Gerdts, *American Impressionism*, exh. cat. (Seattle: The Henry Art Gallery, University of Washington, 1980), 53.

39. John C. van Dyke, ed., *Modern French Masters: A Series of Biographical and Critical Reviews by American Artists* (New York: The Century Co., 1896), 171.

40. *The Art Amateur* 17, no. 5 (October 1887): 93, quoted in William H. Gerdts, *American Impressionism* (New York: Abbeville Press, 1984), 60.

41. Lilla Cabot Perry, "Reminiscences of Claude Monet from 1889–1909," *The American Magazine of Art* 17, no. 3 (March 1927): 119–125, quoted in Charles F. Stuckey, ed., *Monet: A Retrospective* (New York: Hugh Lauter Levin Associates, Inc., 1985), 183.

42. John Henry Twachtman to J. Alden Weir, December 16, 1891, quoted in Gerdts, *American Impressionism*, 1984, 159.

43. John E.D. Trask, *Scribner's Magazine*, quoted in Arthur Hoeber, "A Twin Exhibition—Alexander and Birge Harrison at the Albright Art Gallery," *Academy Notes* (The Buffalo Fine Arts Academy, Albright Art Gallery), no. 8 (October 1913): 152–73.

44. A.E. Ives, "Talks with Artists: Mr. Childe Hassam on Painting Street Scenes," *Art Amateur* 27 (October 1892): 116–17, quoted in Ulrich W. Hiesinger, *Childe Hassam: American Impressionist* (New York: Prestel-Verlag, 1994), 180.

45. A.E. Ives, "Talks with Artists," 116–17, quoted in Hiesinger, *Childe Hassam*, 179–80.

46. Hassam Papers, roll NAA-1, frame 759, Archives of American Art, quoted in David Park Curry, *Childe Hassam: An Island

Garden Revisited* (New York: W.W. Norton & Company, 1990), 148.

47. Hassam Papers, undated clipping marked "Transcript" (a review of Hassam's exhibition, c. 1891), quoted in Hiesinger, *Childe Hassam*, 86.

48. J. Nilsen Laurvik, "Edward W. Redfield—Landscape Painter," *International Studio* 41, no. 162 (August 1910): xxix.

49. A.E. Ives, "Talks with Artists," 116–17, quoted in Hiesinger, *Childe Hassam*, 180.

50. Dorothy Weir Young, *The Life and Letters of J. Alden Weir* (New Haven: Yale University Press, 1960), xxvi.

51. Clara T. MacChesney, "Frederick Carl Frieseke: His Work and Suggestions for Painting from Nature," *Arts and Decoration* 3 (November 1912): 14.

52. Frederick Frieseke, interview by Clara T. MacChesney, *New York Times*, June 7, 1914, quoted in Allen S. Weller, "Frederick Carl Frieseke: The Opinions of an American Impressionist," *College Art Journal* 28 (Winter 1968): 162.

53. James Huneker, "Seen in the World of Art," *Sun* (New York), January 8, 1911, quoted in William H. Gerdts, *American Impressionism: Masterworks from Public and Private Collections in the United States*, exh. cat. (Einsiedeln, Switzerland: Karl-Ulrich Majer, 1990), 154.

54. Frieseke interview, quoted in Weller, "Frederick Carl Frieseke: The Opinions of an American Impressionist," 162.

55. Robert Reid to Sarah Bigelow Reid, January 23, 1887, quoted in H. Barbara Weinberg, "Robert Reid: Academic Impressionist," *Archives of American Art Journal* 15, no. 1 (1975): 2–11.

56. Quoted in MacChesney, "Frederick Carl Frieseke," 14.

57. Berry, "Joseph DeCamp: Painter and Man," 184.

58. F. J. Campbell, "Henry O. Tanner's Biblical Pictures," *Fine Arts Journal* 25 (March 1911): 165, quoted in Dewey F. Mosby, *Henry Ossawa Tanner*, exh. cat. (Philadelphia: Philadelphia Museum of Art, 1991), 147–48.

59. Quoted in Michael Edward Shapiro et al., *Frederic Remington: The Masterworks*, exh. cat. (New York: Harry N. Abrams Inc., 1988), 134.

60. *New York Times*, October 19, 1924, quoted in Arlene Jacobowitz, *Edward Henry Potthast, 1857 to 1927* (New York: The Chapellier Galleries, 1969), n.p.

61. *New York Sun*, July 23, 1921, quoted in Jacobowitz, *Edward Henry Potthast*, n.p.

62. George Bellows, foreword to *The Paintings of George Bellows*, ed. Emma S. Bellows (New York: Alfred A. Knopf, 1929), viii.

63. Robert Henri, *The Art Spirit* (Philadelphia: J.B. Lippincott Company, 1923), 58.

64. Henri, *Art Spirit*, 76.

65. Bellows, *Paintings of George Bellows*, ix-x.

66. Ernest Lawson, "The Credo: The Power to See Beautifully and Idealistically," quoted in Henry and Sidney Berry-Hill, *Ernest Lawson: American Impressionist, 1873–1939* (Leigh-on-Sea, England: F. Lewis, Publishers, Ltd, 1968), 22.

67. Quoted in Mahonri Sharp Young, *The Realist Revolt in American Painting* (New York: Watson-Guptill, 1973), 144.

68. Ira Glackens to Richard J. Wattenmaker, 1987, quoted in Richard J. Wattenmaker, "William Glackens's Beach Scenes at Bellport," *Smithsonian Studies in American Art* 2 no. 2 (Spring 1988): 75-94.

69. "Twelfth Annual Exhibition of the Water Color Club," *Boston Evening Transcript*, March 4, 1899, quoted in Carol Clark et al., *Maurice Brazil Prendergast, Charles Prendergast: A Catalogue Raisonné* (Williamstown: Williams College Museum of Art, 1990), 61.

70. "Exhibition of Mr. Prendergast's Water Colors," *Boston Evening Transcript*, April 27, 1899, quoted in Clark, *Maurice Brazil Prendergast, Charles Prendergast*, 61.

71. Robert J. Cole, "Quo Vadis, Mr. Davies?," *The Evening Sun*, February 10, 1914, quoted in Clark, *Maurice Brazil Prendergast, Charles Prendergast*, 69.

INDEX OF PLATES

Photography by Thomas R. DuBrock;
E. Irving Blomstrann (fig. 18).

Publications Director: Diane Planer Lovejoy
Editor: Christine Waller Manca
Production Manager: Engeline Tan
Design: Don Quaintance, Public Address Design
Production Assistant: Elizabeth Frizzell
Color separations: Color Separations, Inc.
Printing: The Beasley Co., Inc.
Typography: composed in Monotype Truesdell based
 on designs by Frederic William Goudy